The Best in Contemporary Fantastic Art

S P E C T R U M 10

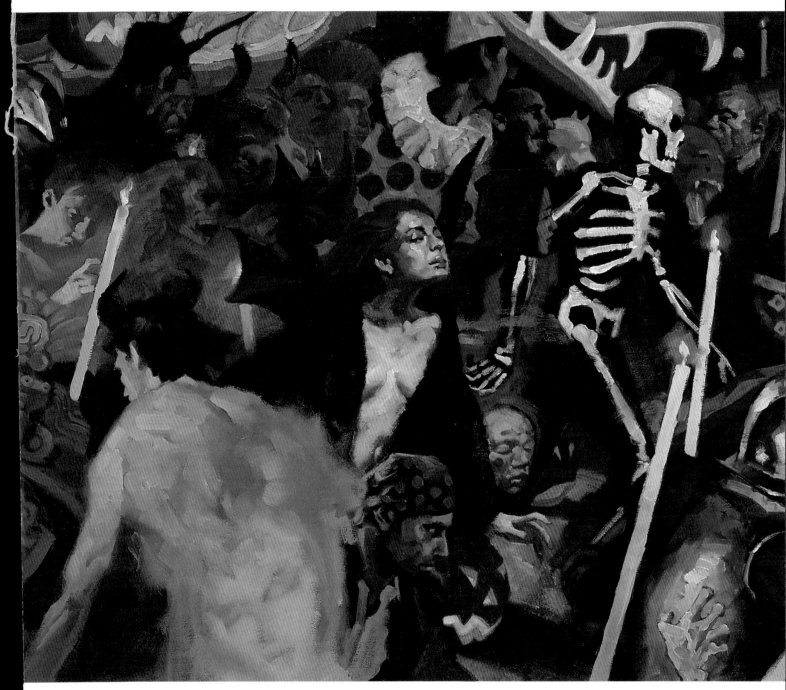

Edited by Cathy & Arnie Fenner

UNDERWOOD BOOKS

Nevada City, CA • 2003

Chairmen's Message

I'm late, I'm late, for a very important date!

Despite our best intentions (and our burning the midnight oil plenty of evenings), circumstances beyond our control always have a way of disrupting even our most carefully laid plans and stringently figured schedules. *Spectrum 9* got caught up in the West Coast dock workers fiasco in 2002: books were left sitting on board a ship in San Francisco harbor for nearly two months. When they finally *did* make it to shore they were lost in L.A. for awhile (how they got there is another story altogether) and it was after Christmas before *Spectrum 9* made it into the hands of the artists and onto the bookshelves. Which, of course, coincided with preparations for *Spectrum 10...*

So if there's not a lot of hoopla surrounding the tenth anniversary of *Spectrum* rest assured that we are astonished and pleased to have been able to do these books for the last decade; if we're not hopping up and down throwing confetti it's because there's still always something else to do. Arnie and I will have to settle for putting our feet up for a few minutes and clinking our martini glasses together (if we don't fall asleep first).

The jury for *Spectrum 10* convened in Kansas City, MO the final weekend in February. Weather was cool but clear and everyone arrived on time (though a snow storm delayed departures for several judges on Sunday). The jury rolled up their collective sleeves and plunged into the hotel ballroom containing just over 3000 works of art divided into seven categories and spread out on tables surrounding the walls. Each juror surveyed the art independently and discussions of the entries during that phase of voting was discouraged. The room was changed out five times in the course of the day with the voting resuming after each change. When votes had been cast in the final category, art that had been marked for award consideration was brought back out; the jury debated the merits of each piece until a consensus was reached and awards presented in each category. It was a long but enjoyable day, though there was one heart-stopping moment. While the jury was taking a break during room re-set at a table in the hotel's open-atrium lobby, someone on one of the floors above dropped or threw a full can of soda—which barely missed Michael Whelan, exploding on the floor near his feet like an artillery round.

I think we'll hold *Spectrum 11*'s judging somewhere else.

Assisting Arnie and I this year in tabulating votes, setting the room, and keeping the proceedings moving along were Armen Davis, Bob Haas, Brian Parsons, and Jennifer Zarrelli.

Just as with every previous volume of *Spectrum*, this book is only made possible by the active participation of the artists (both those selected for the book and of those that unfortunately were not) and to the readers that regularly buy each edition as it's released. This book, this project, belongs to all of you. To everyone we humbly extend our warmest thanks for allowing us to be a part of this community these past ten years.

—Cathy Fenner/Show Co-Chairman

Trade Softcover Edition ISBN 1-887424-72-5
Hardcover Edition ISBN 1-887424-73-3
10 9 8 7 6 5 4 3 2 1

Special thanks to Brom, Rick Berry, Tim Holter Bruckner, Armen Davis, and Bud Plant for their continued help and enthusiasm.

Advisory Board: Rick Berry, Brom, Leo & Diane Dillon, Harlan Ellison, Bud Plant, Don Ivan Punchatz, Tim Underwood, Michael Whelan

Artists, art directors, and publishers interested in receiving entry information for the next Spectrum competition should send their name and address to:
Spectrum Design, P.O. Box 4422, Overland Park, KS 66204
Call For Entries posters (which contain complete rules, list of fees, and forms for participation) are mailed out in October each year.

Spectrum 10 is dedicated to:
Joe DeVito
Gifted painter, wonderful sculptor, trusted friend.

Published by **UNDERWOOD BOOKS**, P.O. BOX 1919, NEVADA CITY, CA 95959
www.underwoodbooks.com
Tim Underwood/Publisher

The Jury

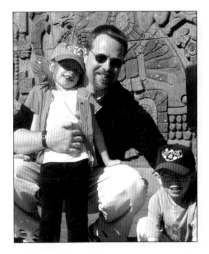

Mark Chiarello *artist/art director DC Comics*

Bob Eggleton *artist*

C.F. Payne *artist*

Bud Plant *illustration historian/publisher/consultant*

Kelley Seda *artist*

Michael Whelan *artist*

Mark Chiarello

Bob Eggleton

C.F. PAYNE

Bud Plant [co-publisher]

Kelley Seda

Michael Whelan

"Like most readers of my generation I discovered Michael Wm. Kaluta through his haunting pulp reinventions, specifically the jaw-dropping work he did on DC's 1970s incarnation of THE SHADOW: I was a callow twelve year old, but in seconds, he went from being someone I'd never heard of to being one of the five coolest people on the planet."

—Neil Gaiman

The Shadow laughs as his twin .45s pronounce his verdict on evil doers; Vampirella coos and licks the blood from her fingertips; False Maria tilts her clockwork head and lures the proletariat to disaster...

And in his New York apartment, Michael William Kaluta cleans his brush, pauses in thought, then plunges back into the fantastic worlds he creates with his art.

Born in 1947 in Guatemala to a military family, Kaluta spent his formative years on a variety of east coast Air Force bases watching Jon Gnagy's "Learn To Draw" TV program. While Gnagy's lessons pricked his interest, it was the art of Roy Krenkel, Frank Frazetta, Al Williamson, and Alphonse Mucha that inspired him to pursue a career in the arts and he enrolled at the Richmond Professional Institute (now Virginia Commonwealth University) in 1966. As Mike reveals he "began doing illustration and comic book work against the advice of instructors."

Michael William Kaluta

Comics fan activity (itself an off-shoot of science fiction fandom) was in its formative stages in the '60s: the professional publishing companys were, for the most part, closed shops. The only opportunity many young artists had to refine their craft was through working for any of the amateur magazines (fanzines). If Jack Kirby was "king" of the mainstream comics, Kaluta and friends Jeff Jones and Bernie Wrightson were the three musketeers. With stories and drawings appearing in numerous publications and his face and name becoming familiar to editors at the increasingly frequent comic conventions, Michael moved to New York in 1969 and was hired to draw stories for a variety of publishers, including Marvel and DC.

It was for DC that he reinterpreted the pulp-era crime fighter The Shadow for a new generation. Though his intricate line art-technique was not conducive to working on a monthly series, Kaluta's brief stint on *The Shadow* is still considered one of the highlights of his career. Over the ensuing thirty years he has periodically returned to the character with various projects and illustrations.

From comics he leapt to book illustration, from books to posters, from posters to theatrical stage design...and back to comics to begin the circle again. Whether he was delineating the heroes of Robert E. Howard or Edgar Rice Burroughs or concepting situations for Elaine Lee or Sam Rami, Kaluta brought a refreshingly original yet vaguely nostalgic flavor to a contemporary audience. The *World Encyclopedia of Comics* astutely describes Mike as an "antiquarian-futurist who visually romances the future with the lyrical lines of the past."

"Comics and illustrations," Kaluta says philosophically. "Each field has its attractions. Comic book drawing allows one to create an entire world, to add the characters, the lighting, the 'camera angles,' the pacing that will involve the reader. Doing that right brings great satisfaction, though it does take a great amount of time to accomplish. Illustration must augment whatever it is illustrating—at best it shouldn't over-power its subject. But doing illustration gives the artist such a huge canvas to devote their vision to, along with certain approaches and techniques that only work when presenting a single image."

Sequential story-telling or the killer single image? Kaluta (fortunately for us) can't make up his mind. He has been on a quest to satisfy his artistic Muse, a Muse that first visited him as he lay on his stomach watching the flickering b&w images of Jon Gnagy smudging charcoal on an oversized drawing pad. And his fans have dutifully (and gleefully) followed him on his journey for the last 34 years. He is unconventional. He's an original. But perhaps fellow Grand Master Frank Frazetta sums him up best when he says:

"Man, that guy can *draw!*"

born 1947 / G u a t e m a l a

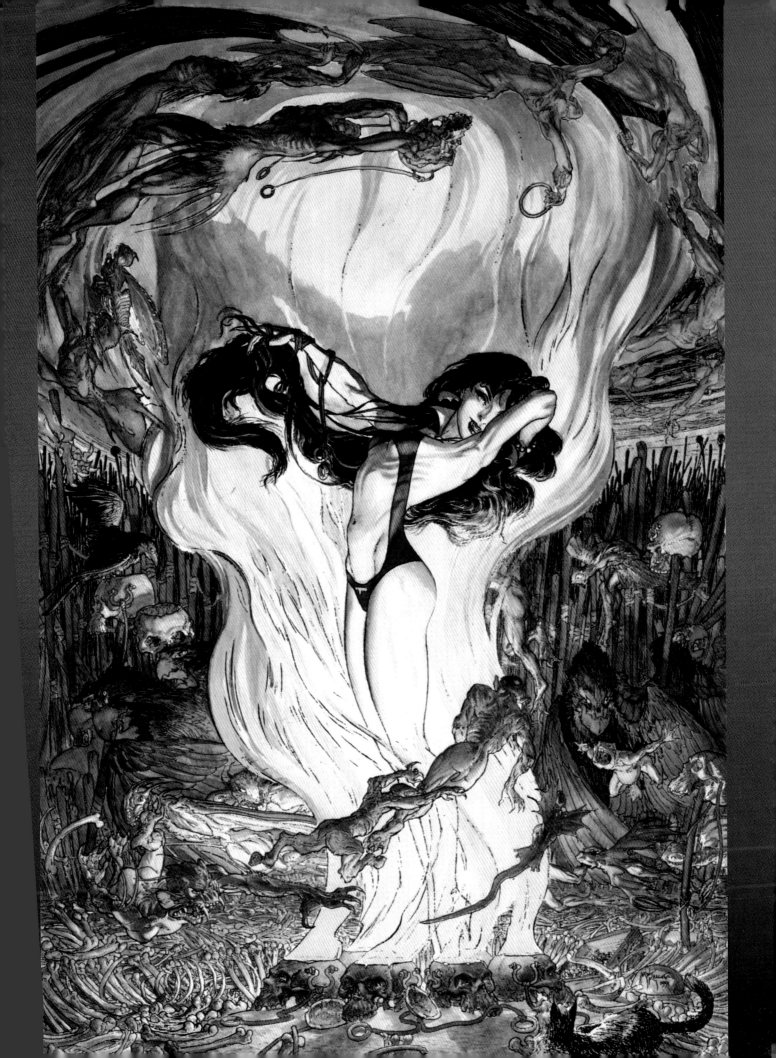

2 0 0 2 : T H E Y E A R I N

ReViEW

Bitter after being snubbed for membership in the "Axis of Evil", Libya, China and Syria today announced that they had formed the "Axis of Just as Evil", which they said would be more evil than that stupid Iran-Iraq-North Korea axis President Bush warned of in his State of the Union address.

Axis of Evil members, however, immediately dismissed the new Axis as having, for starters, a really dumb name. "Right. They are just as evil . . . in their dreams!" declared North Korean leader Kim Jong-il. "Everybody knows we're the best evils . . . best at being evil . . . we're the best."

–from *Axis of Evil Wannabees* by John Cleese

And we thought 2001 was crummy.

The impact of the terrorist attacks of 9/11/01 started to be more fully felt in 2002 as the beat of war drums picked up tempo. The rapid demise of the Taliban in Afghanistan (and the scattering of al-Qaeda) was predictable–neither the British or the Russians had a lot of trouble conquering Afghanistan in the past, it was *staying there* that got sticky–and the justification for invasion seemed pretty clear-cut. But the sudden intense focus on Iraq, Iran, and North Korea as possible threats (and as such, potential new targets for military action) raised questions, prompted protests, and made already jittery economics the world over even more unstable. Arguments on both sides of the war fence seemed equally simplistic and it will undoubtedly be years before the validity or irrationality of actions that took place in 2002 (and *are* taking place in 2003 as I write this essay) will be determined. The one certainty of the previous year is that people were *frightened*. They were afraid of terrorists and afraid to fly. Afraid of the government, afraid of *foreign* governments. Afraid of neighbors, afraid of strangers, afraid to open the mail. If you were a resident of the Washington DC area in 2002, you were fearful that a loon with a rifle might plug you in the grocery store parking lot (fortunately the Beltway snipers were caught). If you had friends or family in the military you feared for their safety as they were deployed to foreign lands. If your 401K was invested in WorldCom and Enron or relied on Arthur Anderson you were concerned for your financial future. If you were employed you were afraid you might lose your position (in light of the record number of bankruptcies and massive lay-offs in 2002); if you had lost your job you were afraid

Why is Tony DiTerlizzi smiling (seen here with Holly Black)? Well, it could be because of his well-deserved Caldecott honors for his children's book The Spider and the Fly. *Or it could be because of all the attention, good reviews, and bestseller status his* The Spiderwick Chronicles *(written by Ms Black) received. 2002 was a good year for Tony and 2003 is looking even better.*

you might not get another. Scandals, gloom, and doom dominated the airways with little respite. Hell, you couldn't even kick back and enjoy the Winter Olympics as a pleasurable distraction without getting depressed by the scandal surrounding crooked judging (the French really took it on the chin last year).

Of course, the psychology of Fear generally breeds more of the same, with a good dollop of suspicion and paranoia mixed into the soup for good measure. With each alert the airlines, hotels, and other industries that are reliant on business and vacation travelers took another devastating financial hit; with each warning from Tom Ridge and the Bureau of Homeland Security, people took on more of a bunker mentality (duct tape sales were *great* though!). Every random act of stupidity from some moron resulted in massive reactions and occasional *over*reactions from law enforcement and federal agencies. (I don't know about you, but I think every time we have to take off our shoes and get patted down by airport security someone should visit shoe-bomber Richard Reed's cell and smack him with a Louisville Slugger.)

And while we were buying emergency supplies and taping plastic over our windows, worrying about getting attacked or getting fired (or—my God, *the horror*—both!), we were inundated with stories of pedophile priests, ridiculous lawsuits ("I didn't *know* eating at MacDonald's everyday and not exercising would make me fat! Pay me!"), and the obscene amounts of lucre heaped in the laps of corporate executives (what a surprise) while the employees got the shaft.

As I said, 2002 left a lot to be desired (and 2003 ain't shaping up so hot neither). But what's this all got to do with

b y A r n i e F e n n e r

fantasy and science fiction art? Everything, I guess.

Just because our passions—and in many cases, our livelihoods—are wrapped up in imaginary places populated by pretend peoples and creatures, we don't *live* in a fantasy world. (Okay, let me qualify that and say *most*

port. Everybody from Toronto (or China) doesn't pose a SARS danger. Though the Catholic Church has done a crappy job policing itself over the years, every priest does not lust after our children. Every corporate CEO isn't an over-paid, heartless crook...

Okay, so maybe I'm not too sure about

dot.com bubble several years ago, the industry wasn't helped by the further down-turn in the economy or the general concern about the possibility of either additional terrorist attacks or war with Iraq. Newspapers, magazines, and television stations found themselves in the uncharacteristic position of having to scramble for clients and in some cases were forced to offer discounts and incentives to help fill empty space and time. Of course, the old adage of having to spend money to make money" holds true and companies that cut back on their advertising budgets found that the fewer people that knew about what they did or what they sold, the fewer people there were who wanted their stuff.

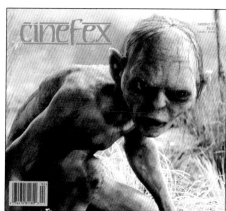

Some of the wonders to be found on the magazine rack. Mad *cover by Roberto Parada;* Juxtapoz *cover by Ron English;* Outré *cover by Vincent Di Fate; and Weta's realization of Gollum for* Cinefex.

of us don't.) The soft economy affects everyone across the board; when people are worrying about their safety or their mortgage other interests and diversions become low priorities. People don't spend, companies don't, either, and work dries up for everyone. The climate of fear is immobilizing; it fosters irrationality and becomes self-perpetuating. But as Franklin Delano Roosevelt (for the history slackers out there: look him up) said, "The only thing we have to fear is fear itself." I alluded to as much in last year's review.

The cycle of gloom is just that: a *cycle.* Blame the current state of affairs on former President Clinton or current President Bush or on Osama bin Laden or McDonalds (always a popular target for domestic lawyers and foreign arsonists) or whomever or whatever you want. Rant, yell, let of steam; get it out of your system. Then hitch up your drawers, have a cup of java, and get on with life. Dealing with reality—with life's scenarios as they *really* are—is surprisingly a lot easier than wrestling with the *perceptions* of reality. While it would be foolish to deny that there are extremists looking for an opportunity to pull off another 9/11, it is likewise silly to think that there are terrorists loitering in every air-

that last bit.

The one thing we can be certain of is *change.* The bad times will pass (sooner or later), the good times will roll (for awhile), then the cycle will begin again. But good times, bad times, don't matter which: artists have to create, fortunately for us all. Because art is an expression of the spirit. Regardless of content–whether dark and horrific or bright and bouncy–art is an act of optimism. Speaking in the broadest terms (knowing that there are always exceptions), art is communication and communication (even if we don't always like the message) is a positive act.

So, while 2002 probably won't be filed in people's memories as particularly "good," there *were* positive aspects to the year, including in the field of fantastic art. Looking back proves that point.

advertising

Though maybe not so positive in the field of advertising.

Probably the best one word description for the year was: flat.

Still suffering from the popping of the

Another disappointing year in the music industry, thanks in part to file sharing and Internet bootlegging, resulted in fewer CD cover assignments and lower fees. Though arguments can be made that retail prices for CDs have always been too high (and of little benefit to most of the recording artists), there's no defense for copyright infringement. Everyone is hurt in the long run, including cover artists. It's questionable, though, if the music moguls will ever be able to tame or come to terms with the Internet beast (and with human nature of wanting something for nothing), at least in the foreseeable future.

As sales softened (either in clothing, cars, or books) discounting became the tool used as an incentive to get consumers spending. Most advertising through the year was fixated more on price and less on the memorable product pitch. The one voracious segment of the ad biz was in unsolicited e-mail marketing. Such unwanted spam (for debt-consolidation, Viagra, credit cards, pornography, etc.) clogged people's computers and got to be so pervasive and annoying that Congress was threatening to step in at year's end to halt the onslaught.

Of course, even if the economy were going gangbusters it's doubtful most traditional artists would be benefiting inordinately. As discussed in previous years, the advertising world is currently the domain of graphic designers, cartoonists, and PhotoShop artists. It's faster, more economical, and easier to design with type and manipulate photos than it is to hire a narrative artist and wait for them to gather research, submit roughs, and create a painting. Not better, necessarily, but

certainly faster. Nor is that to say that the type and digital solutions are inferior—just different (and, of course, easier to change). And, frankly, the work of the best computer artists these days is often more startling and effective than a traditional illustration of the same concept would probably be. Looking at the Turner Movie Classics campaign (particularly the one featuring Margaret Hamilton from *The Wizard of Oz*) reinforces that belief. Though there will undoubtedly always be advertising jobs that rely on painters (thankfully), the good old days of pulling down lucrative commissions to paint Goodyear tires or Coke bottles are over.

Turner Classic Movies launched a clever print campaign featuring manipulated movie stills. Errol Flynn as Robin Hood with a bow and plumber's helper instead of arrows was another favorite.

Every year I bitch about the lack of credits in the advertising field: things haven't changed. I spotted some extremely clever retro-chic Altoids ads, but haven't a clue as to the creatives. I *did* spot some neat theater posters by Scott McKowen for *The Taming of the Shrew* and *Pudd'nhead Wilson* [The Acting Company, NYC] which featured nicely fantastic interpretations of otherwise non-genre plays. And I can always count on spotting distinctive stylings by Bill Mayer, Gary Kelley and Kinuko Craft here and there, but beyond that I'm usually left scratching my head wondering "who?" along with everyone else.

books

I've discussed in previous years how the book industry always has to be in some form of flux: if there's no immediate crisis, one must be created to keep everyone happy. The soft economy naturally had an impact on bookstore sales, but it was not nearly as severe as in other parts of the retail sector: though discounting was common, shops weren't slapping SALE! signs up in their windows. Though consumers may have been a bit more selective in their choices, they *did* buy.

Okay, so they didn't buy electronic books or print-on-demand titles in any significant numbers, but who could blame them? E-books are no more affordable, prevalent, or reliable than they were when I started sneering at them years back. And as for print-on-demand. . . There was a Xerox® commercial that ran on TV throughout the year, the gist

being a student disagrees with his college professor who has just stated that getting into print is difficult. The student informs the Prof that with on-demand publishing, everyone can cheaply get into print: class erupts in applause, teacher is chagrined. Buy Xerox®.

Baloney. Books are complex entities that rely on a whole wide variety of factors (and not a little magic) to reach fruition. Major publishers often have a hard time doing the job right—and even when they do, success is never a guarantee. I don't want to belabor the point other than to say: there's a big difference between printing it yourself and "being in print."

Anyway...sales generally weren't that bad, though specialty bookshops continued to drop by the wayside as the larger chain stores encroached on their once-exclusive territory. Since "graphic novels" suddenly began to be taken seriously in the mass-market it will be interesting to see if comic-shops begin to feel the pinch (again!) that have been driving the f&sf stores out of business. Another wrinkle to retailing appeared with Barnes & Noble's purchase of both Friedman/Fairfax Publishing and Sterling Publishing (U.S. distributor or Paper Tiger's line), which prompted some competitors to announce they would curtail carrying titles from either imprint.

Vivendi Universal lost a billion dollars in the sale of Tolkien-publisher Houghton Mifflin (which they had just bought in 2001), AOL/Time Warner was shopping their publishing imprint (and let's not talk about their problems with massive debt, Ted Turner, and the SEC), and the Bertelsmans conglomerate (owner of Random House and all its varied imprints) spent the year phasing out programs and contending with reports of past links to the Nazis. Thing of it was, virtually all the corporate problems had to do with their other business ventures: publishing were generally the most profitable (if less glitzy) divi-

sions of any of these conglomerates. Publishing and mega-corporations aren't necessarily marriages made in heaven: one's too personal, the other too cold and neither fully understands the other. Unfortunately, that's the nature of the business at the moment.

With that in mind, it'd probably serve me right if the entire industry were changed for the better one day by some guy sitting in his bedroom printing out his new book on his Xerox® printer. But I won't hold my breath.

What did I like this year? Lots of stuff. Though narrative art solutions for book covers still had to compete with graphics, photos, and non-literal treatments, there were still plenty of excellent examples. I was quite taken with Lisa Desimini's painting for the humorous *Living Dead in Dallas* by Charlaine Harris [Ace], and with Daniel Craig's for *The Lady of the Sorrows* by Cecilia Dart-Thorton [Warner-Aspect]. Chris Moore did a great job for *Vinland the Dream and Other Stories* by Kim Stanley Robinson [Voyager], the Dillons were typically wonderful with their mixed-media cover for *Abhorsen* by Garth Nix [Eos], John Howe was suitably evocative with his painting for *Witch's Honour* by Jan Siegel [Voyager], and Stephan Martinere raised the bar for artists who create their work digitally with his electrifying cover to *Engine City* by

Jon Foster's first collection from Cartouche Press was a marvelous addition to any bookshelf. I can hardly wait for Book 2!

Ken MacLeod [Tor]. And what about John Jude Palencar? His paintings for *Kushiel's Chosen* by Jacqueline Carey [Tor] and *Waifs and Strays* by Charles de Lint [Viking] were as good as they come. I spotted other memorable covers by Thomas Canty, Daniel Horne, Gregory Manchess, Kinuko Craft, Todd Lockwood, and Alan Pollack among many, many others.

In the "illustrated books" category, on the "grown-up" side I was suitably impressed with Dave McKean's work in *Landor's Tower* by Iain Sinclair [Granta Books], Rick Berry's paintings for *Black House* by Stephen King and Peter Straub [Donald M. Grant Books], and Tony DiTerlizzi's art for *Dragonflight* by Anne McCaffrey's [Del Rey]. DiTerlizzi was also getting a lot of positive notice in the chil-

dren's book arena with his Caldecott-winning flapper-flavored adaptation of Mary Howitt's classic *The Spider and the Fly* [Simon & Schuster]. Definitely a modern classic. Other illustrated books for younger readers included *Halloween* by Jerry Seinfeld/art by James Bennett [Warner Books], *Pinocchio, The Boy*

Wow! As good as Thomas Canty's covers have been for Ellen Datlow's & Terri Windling's Year's Best Fantasy & Horror series, 2002s was simply breathtaking.

by Lane Smith [Viking], and Sarah Moon's superbly eerie photographic interpretation of *Little Red Riding Hood* by Charles Perrault [Creative Editions].

Despite the infusion of a stack of titles appearing in the States that originated in Germany, there seemed to be slightly fewer single artist collections in 2002–which gave me a slight glimmer of hope that the implosion scenario I mentioned as a concern in last year's review might be delayed a little while longer. Maybe. Stand-out titles included *Goad* by Phil Hale (of course!) [Donald M. Grant Books], *The Science Fiction Art of Vincent Di Fate* [Paper Tiger], *Shadow Maker: The Digital Art of David Ho* [Abaya Studios], *Progressions* by Jon Foster (a real knock-out) [Cartouche Press], and *Pictures That Click* by Dave McKean [Allen Spiegel Fine Arts]. I also greatly enjoyed *Twin Visions* by Boris Vallejo and Julie Bell [Thunders Mouth Press], *Precursor* by Bill Sienkiewicz [Hermes Press], *The Art of Matthew Stawicki* [Cartouche Press], *Steranko: Arte Noir* [Semana Negra], *New Works by Dorian Cleavenger, Fastner & Larson Gallery,* and *The Art of John Bolton* [all three from SQP]. Notable imports included *Manchu Science Fiction* [Delcourt], *Amano: The Complete Prints, Jap Works,* and *Katsuya Terada: Zenbo.* Cathy's and my project in 2002 (besides *Spectrum 9,* of course) was *The Art of Jeffrey Jones* [Underwood Books].

Once again there were some nice "misc." art books last year. *Illustrators 43,* edited by Jill Bossert [HPI], is still the single best overview of the mainstream illustration scene published each year; Dick Jude's *Fantasy Art Masters: The Best in Fantasy and SF Art Worldwide* [Collins] included nice chapters

on Phil Hale, David Seeley, Greg Spalinka, and Keith Parkinson among others; *Beware!,* an anthology edited by R.L. Stine, included art by the Dillons, John Palencar, and Gahan Wilson; *James Bond Movie Posters* by Tony Nourmand [Chronicle Books] showcased all the great paintings by Robert McGinnis and Frank McCarthy; *The Art of The Fellowship of the Ring* by Gary Russell [Houghton Mifflin] beautifully complimented Peter Jackson's classic film; *Mad Art* by Mark Evanier [Watson Guptill] included insightful illustrated profiles of some of the 20th (and 21st) Century's most gifted humorists; and *Ray Bradbury: An Illustrated Life* by Jerry Wiest [Morrow] included, well, pert-near every piece of art based on Ray's work.

Certainly there was plenty of worthwhile work I missed; these days it's impossible to see everything. I shop the chains (critics love to bash them but, boy! look at all the books!) and independent shops and have been known to order a title or two online. For our field of interest, though, for the best selection I've yet to find a better resource than Bud Plant Comic Art. Classic and contemporary art books, pop-culture extravaganzas, statues, posters, and all manner of other neat items regularly fill their catalog pages (which are available for $3 by calling 800-242-6642, writing to P.O. Box 1689, Grass Valley, CA 95945, or checking their website at www.budplant.com). I've happily been giving Bud money for–*oh my God!*–thirty years now: if that doesn't show customer satisfaction, I don't know what does.

comics

It almost seemed like everybody was suing everybody in the comics business in 2002: hockey player Tony Twist sued Todd MacFarlane for appropriating his name for a comic villain (and lost big on appeal), Neil Gaiman sued McFarlane for contractual issues (and won big), Warner Bros. and the proposed director of the proposed *Constantine* film (based on DC's character) sued each other, Marvel sued Disney and Sony while Sony sued right back, retailers sued both Canadian Customs AND Marvel, and, not one to be left out of the game, Stan Lee sued Marvel, too. I can't imagine why the United States is described as a litigious society.

Oh, and while all this was going on, Sam Rami's film version of *Spider-Man* broke box office records, broke DVD sales records, and

helped sell over a billion bucks worth of *Spider-Man* trinkets.

Of course, the popularity of comic-based films (2001's *X-Men* was a smaller but still respectable hit) didn't necessarily translate into increased press-runs and sales of comic *books*: if anything sales remained tepid and may have declined slightly (actual sell-through in the direct market is hard to document). There are any number of reasons that might explain why one hand doesn't seem to wash the other, but it would be fruitless to try to examine them here. *The Comics Journal,* though it's cynical as hell and likes to ruffle feathers, does the best job of analyzing the vagaries of the industry and I would steer interested parties to the newsstand to pick up a few issues (or visit their website: www.tcj.com/journalista).

There was a lot of talk about comics/graphic novels finding a welcome home in the mass market, but the only proven successes were for the publishers of Japanese manga translations. Since bookstores have a return policy for merchandise (as opposed to the you-buy-it-it's-yours practice in comics' direct market) it will be interesting to see what happens if and when all of these GNs start to find their ways back to the distributors' warehouses. (Unless that distributor was LPC, which went bankrupt owing a lot of their independent-publisher clients thousands of dollars—which in-turn created a series of crisises still being felt well into 2003.) Cross your fingers and hope.

Money, money, money: make it, lose it, sue somebody for it. Brand it, license it, take off to Hollywood and hold out for an A-list director. Boy, I'm glad I'm just a casual observer.

One of the things I like about DC is their

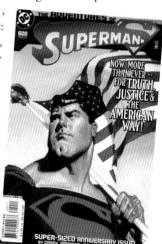

Superman never looked more square-jawed or true-blue than in this great painting by Daniel Adel.

variety. When you can find Dave McKean (various *Sandman* spin-offs), Jon Foster (*Hunter: Age of Magic* covers), Tim Bradstreet (*Hellblazer* covers), Kyle Baker (*King David*), and Ashley Wood (*Automatic Kafka*) working for the same publisher, you know *somebody's* cooking with gas. J.G. Jones did a great job (including a startling cover) on *Wonder*

Woman: Hiketeia, Alex Ross' powerful art helped compensate for the non-story of *JLA: Secret Origins*, and Adam Hughes continued with his string of typically excellent covers for

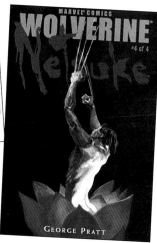

Above: *Gary Gianni's exquisite ink work was well presented in this over-sized collection of stories featuring his ghostly investigator. Gary also spent 2002 drawing fill-in installments of the* Prince Valiant *newspaper strip for John Cullen Murphy as well as illustrating a new Conan collection for Wandering Star.*

the regular *Wonder Woman* series. *Batman: B&W Vol. 2* was a respectable sequel and included stories by Tim Sale and Daniel Torres among a host of other worthy talents. Eye-popping covers were on display by Phil Noto, Glen Orbik, Ryan Sook, John Van Fleet, Brian Bolland, and Bill Sienkiewicz just to name a few. But the series I got swept along with last year was Alan Moore's off-kilter *The League of Extraordinary Gentlemen* (under the America's Best imprint) as illustrated by Kevin O'Neill: a near-perfect blend of art and story.

Marvel, which was feeling its oats again after emerging from bankruptcy (and understandably giddy at the astronomical box office generated by the film adaptations) rode the publicity machine with their precursor to Captain America, *Truth* (in which the "super" drug was tried out on an African American soldier first) and the outing of *The Rawhide Kid*. Both were great for slow-news days, but that was about all. Still, the company boasted a nice variety of titles and creative approaches through the year. Personal favorites included *Wolverine: Netsuke* by George Pratt, *Cage* by Richard Corben, and *Spider-Man: Blue* by Tim Sale. Greg Horn, Tim Bradstreet, Frank Cho, Essad Ribic, and Ariel Olivetti all created some exemplary covers.

Dark Horse continued on its merry way with their lines of licensed and creator-owned comics. Despite taking a sabbatical from sequential art while he worked on the film adaptation of his character, Mike Mignola's *Hellboy* was nonetheless well represented in

2002 with the trade paperback compilation *Hellboy: Conqueror Worm* (easily one of his best stories) and the two-part mini-series, *Hellboy: The Third Wish*. I know I sound like a broken record when it comes to Mignola, but there's an awful lot to like about Mike's writing and art. Treat yourself! Equally enjoyable was Ryan Sook's take on the *Hellboy* cast in the spin-off mini-series *B.P.R.D.: Hollow Earth* and Frazer Irving's spookily rambunctious *Fort!: Prophet of the Unexplained*. P. Craig Russell's two volumes of his adaptations of *The Ring of the Nibelung* were first class all the way while *Completely Pip & Norton* by Dave Cooper and Gavin McInnes was edgy and subversive fun that proved irresistible.

Strolling about in the "other" sections of the funnybook stores revealed good works by Eric Powell (*The Goon*/Albatross Exploding Funny Book), Charles Vess (*Rose*/Cartoon Books), Ashley Wood (*PopBot*/IDW) Gary Gianni (*Corpus Monstrum*/Heironymous Press), Phil Noto (*Beautiful Killer*/Black Bull Comics) Jay Anacleto (*Athena, Inc.*/Image), and Ben Templesmith (*30 Days of Night*/IDW). Both Dawn Brown and Mike Mayew produced some nice covers for *Vampirella* [Harris]. The sudden demise of indy vet Chaos Comics momentarily shocked the community, but really didn't seem to phase either creators or consumers: the shelves were always full of new titles.

Fantagraphics, besides publishing the aforementioned *The Comics Journal* (their over-sized Winter Special spotlighting William Stout was superb), also released *Krazy & Ignatz* by George Herriman (stunningly designed by Chris Ware) and *B. Krigtein*, an excellent retrospective of EC's most expressive stylist by Greg Sadowski.

Other magazines devoted to the field included Jon Cooke's infectiously effusive *Comic Book Artist*, Russ Cochran's stalwart *Comic Book Marketplace*, fanboy favorite *Wizard*, the venerable weekly *Comic Buyer's Guide*, and worthy newcomer *Comic Art* from St. Louis publishers M. Todd Hignite and Daniel Zimmer.

Oh, and the public mudslinging between companies that I commented on last year? Fortunately much less than in 2001: either people were thinking before they talked (or

blogged on messageboards)...or they were letting their lawyers get their message across.

dimensional

Okay, can somebody explain these damn Kubrick things from Japan? I mean, they look like figures from the kids' Leggo® or PlaySkool® sets, but instead of Farmer Bill they're the characters from *Reservoir Dogs, Alien, Planet of the Apes,* and *The Terminator!* People snapped them up so fast that some American comics companies started producing pseudo-Kubrick knock-offs featuring their heroes. Somebody enlighten me! (And while you're at it, clue me in on the painted skirts popular in Japan that give the illusion they're transparent and you're spying the woman's underwear bunched up her ass: where can you wear that? I'm just curious...)

Though I might not have been much of a Kubrick fan (the collectible, not the director) and I didn't get overly-enthused by the pervasiveness of bobbing-head figures (yeah, yeah, everything old is new again), there were plenty of other 3D items last year that *did* get my admiration.

WETA's *Lord of the Rings* busts, statues, and other collectibles were uniformly excellent while the *Star Wars* busts created by Gentle Giant Studios for Dark Horse were more expressive than some of the actors they

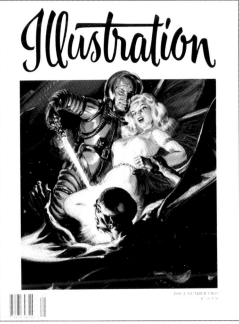

Illustration Magazine quickly became a must-have item for anyone interested in modern illustrators. Issues in 2002 included colorful articles about Stanley Meltzoff, Frank Frazetta, and Norman Saunders.

were based on. DC was well represented in the dimensional market with a cute series of maquettes based on the *Justice League of America* cartoon by Karen Palinko, a very nice

"Aquaman" sculpture by Tim Holter Bruckner, who also created equally nice busts of "The Joker" and "Lex Luthor."

Marvel produced a lot of 3D merchandise in 2002, but I wasn't as impressed with the vast majority of it: there was a general "clunkyness" or crudeness to the faces and figures that didn't compare favorably with the competitors' lines. Certainly the best busts were Gabriel Marquez's "Green Goblin" and Sam Greenwell's "Spider-man."

Dynamic Forces offered "full-sized" sculpted heads of several Marvel superheroes, including "Captain America"... honestly, they creeped me out.

Todd McFarlane took his lumps in 2002, but, boy! his company does some neat-o toys. New series of "Spawn," "Movie Maniacs," and "Monsters" found their way onto the shelves and were eagerly snapped up by collectors. Likewise the action figures based on Ray Harryhausen's creatures from X-Plus proved immensely popular, as were Koto's trio of characters from *Final Fantasy X* (sculpted by "ArtFx").

I was suitably impressed by Thomas Küntz's "Vampira" [Bowen Designs], Yuji Oniki's "Guilstein," Susumu Sugita's "Vampire Hunter D" bust [Diamond Direct], and Chris Achilleos' "The Sentinel" [Iconia].

Fantastic-themed sculpture was well represented in the Fine Art market, of course. The Fuse Gallery in NYC featured an impressive selection of H.R. Giger's recent works while the Lyons Wier Gallery in Chicago hosted Jessica Joslin's "Bestiary" show.

There are several worthwhile magazines devoted to 3D genre work to help keep track of things: personal favorites include *Amazing Figure Modeler* (check out their website: www.amazingmodeler.com), *Kitbuilders* (information can be had via e-mil from: reznhedz@enteract.com) and *Modeler's Resource* (www.modelersresource.com).

editorial

Things weren't looking all that great for the genre's fiction magazines in 2002. Oh sure, they continued to appear regularly and routinely featured top short fiction—all served up in the most bland manner imagina-

ble. I can't help but feel that the magazines have increasingly taken on the appearance of "artifacts" rather than being in tune with contemporary culture. Whether constrained by budgets (almost a certainty) or merely reflecting the stodginess of their owners (a distinct possibility), the fact is that from both a visual and emotional standpoint, most of the fiction magazines are like zombies, devoid of excitement, wit, and life. A magazine should challenge its readers, both intellectually and artistically, for it to maintain its relevance. I always thought *Omni,* though somewhat cold and

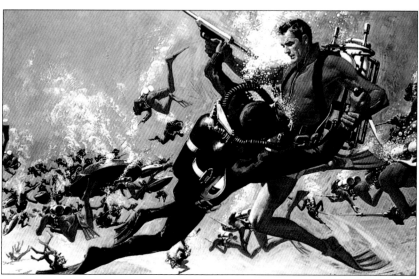

Before he left the illustration field to paint Western art full-time, Frank McCarthy was highly regarded for his action-filled movie posters, like this piece for Thunderball. Formerly a studio partner with Robert McGinnis and Bob Peak, McCarthy was inducted into the Society of Illustrators Hall of Fame in 1997.

aloof, was the best thing that ever happened to f&sf: it's loss is still keenly felt. And let me say, yes, I generally *do* like the look of and art included in *Realms of Fantasy* and, yes, there *were* some nice covers sprinkled here and there among *Asimov's, Analog* (though their announcement that neither would be using interior art anymore shows where *their* priorities are), *F&SF, Weird Tales,* et al—just not enough. For a genre that prides itself on its imagination and sense of wonder, our fiction magazines tend to make the field look like a batch of clueless fuddy-duddys. Their shrinking circulations are the best indication that I'm not the only one with that opinion.

What *did* impress me? Well, Dan Zimmer's *Illustration* just got better with each new issue; Jim Vadeboncoeur, Jr.'s *ImageS* (www.bpib.com/images.htm), devoted to vintage art, was a visual treat; *Communication Arts* and *Print* did impressive jobs keeping track of contemporary illustrators, designers and trends. But if you want to talk personality, *Juxtapoz* (www.juxtapoz.com for info) exhibited it by the yard and was the the *best* place to keep track who and what was hot,

And I can't forget *Playboy.* Though they'd announced they were no longer a market for

science fiction, they're still the most visually imaginative magazine published. Art director Tom Staebler continues to utilize today's best talent. "Stodgy" isn't in their vocabulary.

I still believe that the best way to track the movers and shakers in our field is to read the industry's trade magazine *Locus.* A sample issue is $8 from P.O. Box 13305, Oakland, CA 94661 (website: www.locusmag.com).

institutional

There's not a lot of room left for me to discuss the great variety of the art that appeared in other venues throughout the year so I'll just try to tick off a few highlights. There were prints (by greats like Scott Gustafson, Glenn Barr, Michael Parkes), calendars (including those by Boris Vallejo & Julie Bell, Michael Whelan, Dave Dorman, and Luis Royo), cards, film (let's hear a round of applause for the designers responsible for the look of *TLotRs: The Two Towers, Minority Report, Star Wars II, Spider-man,* and *Harry Potter and the Chamber of Secrets*), game designs, gallery shows (the 8th Juxtapoz Show in Santa Monica had more attitude than a drunken sailor), and more collectibles than even Bill Gates could afford. A mere hint of what 2002 offered can be found in the "institutional" category of this book.

For those yearning to own originals I will quickly steer patrons to these web addresses:
Worlds of Wonder: wow-art.com
Graphic Collectibles: graphiccollectibles.com
Heritage Comics: heritagecomics.com

in passing

In 2002 we said farewell to these notable members of the arts community:
David Berg [b. 1920], comic artist.
John Buscema [b. 1927], comic artist.
Richard Green [b. 1939], comic artist.
Jon Gustafson [b. 1945], sf art historian.
William "Tex" Henson [b. 1924], animator.
Chuck Jones [b. 1916], animator.
Frank McCarthy [b. 1924], artist.
Bill Peet [b. 1915], animator/artist.
Herb Ritts [b. 1952], photographer.
Kurt Schaffenberger [b. 1920], comic artist.
Tom Sutton [b. 1937], comic artist.
Ron Walotsky [b. 1943], artist. †

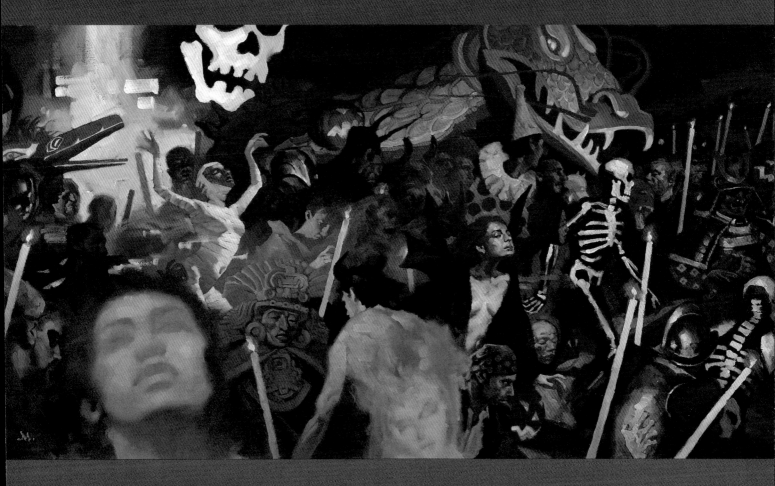

"*...something wicked this way comes.*"

Spectrum 10 Call For Entries poster by Gregory Manchess.

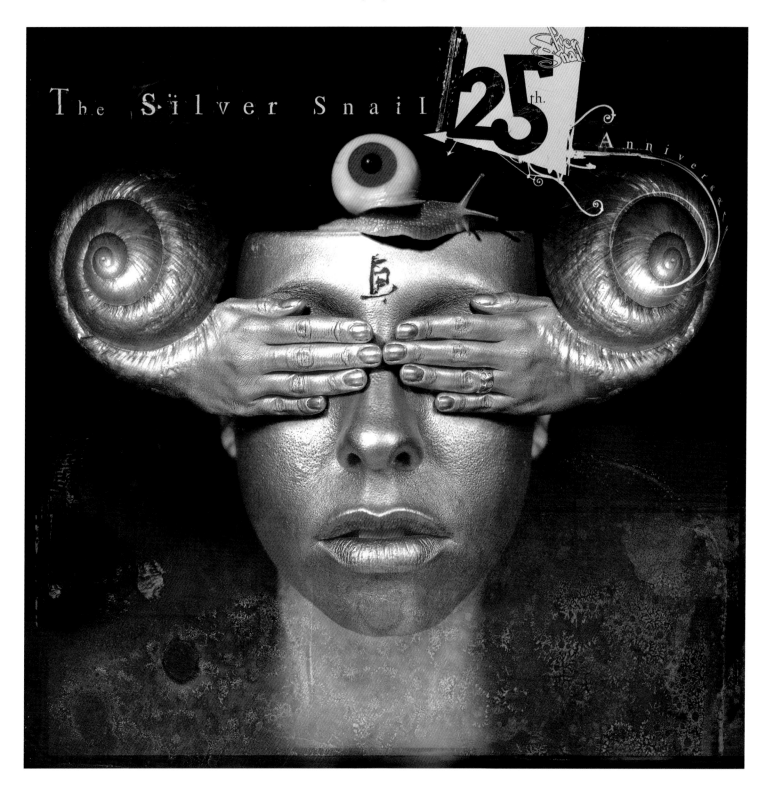

artist: **DAVE McKEAN**

designer: Dave McKean client: Silver Snail title: Silver Snail medium: Mixed

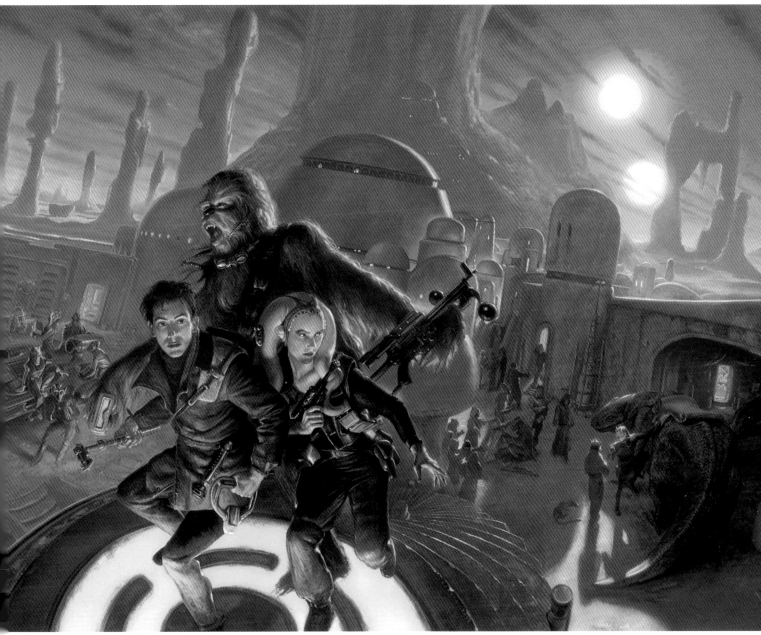

artist: **DONATO GIANCOLA**

art director: Blind Mice Studios *client:* LucasArts *title:* Star Wars Galaxies *medium:* Oil on paper *size:* 45"x33"

1
artist: **John Dickenson**
art director: Josh Sawyer
client: Black Isle Studios
title: Ice Wind Dale/World Map
medium: Digital
size: 10"x8"

2
artist: **Luis Royo**
art director: Luis Royo
client: Xana Records
title: Mother Earth
medium: Acrylics
size: 26"x18"

3
artist: **Justin Thavirat**
art director: Samwise Didier
client: Blizzard Entertainment
title: Orc
medium: Digital

1

2

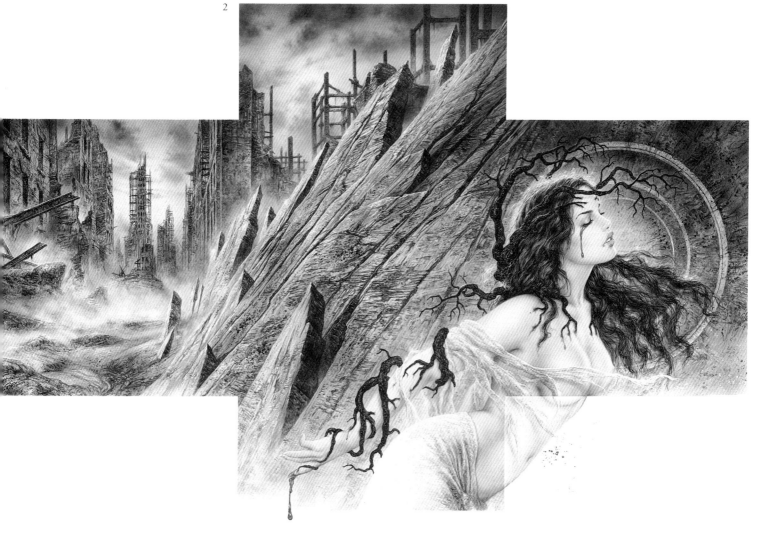

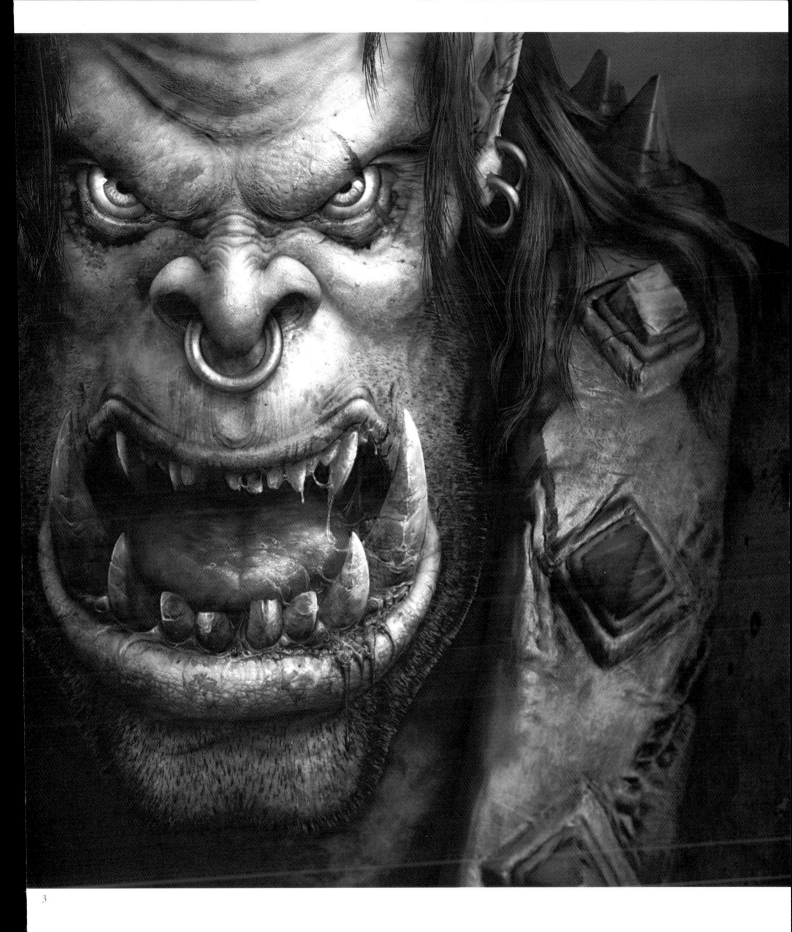

3

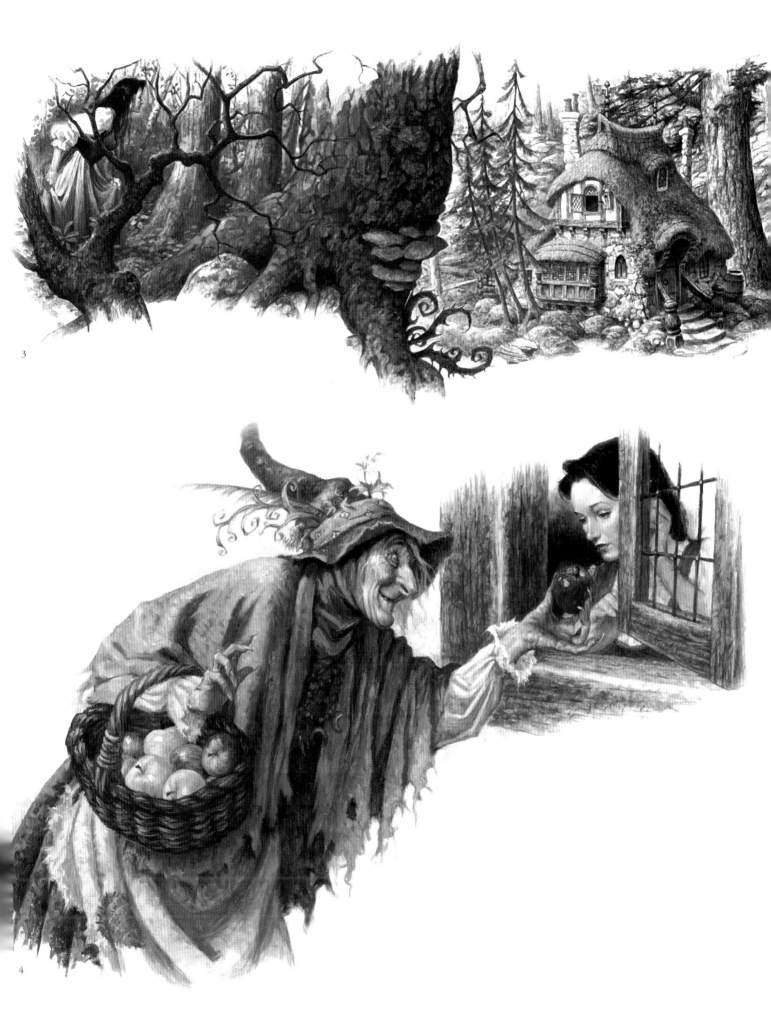

3

4

1
artist: **John Harris**
art director: Irene Gallo
client: Tor Books
title: Saturn
medium: Oil

2
artist: **Tim O'Brien**
art director: Irene Gallo
client: Starscape Books
title: Cyborg From Earth
medium: Oil

3
artist: **Stephan Martiniere**
art director: Kyle Hunter
client: Paizo
title: Polyherron
medium: Digital

4
artist: **Stephan Martiniere**
art director: Irene Gallo
client: Tor Books
title: The Secret Engine
medium: Digital

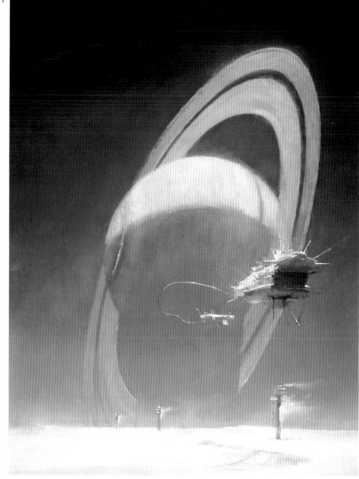

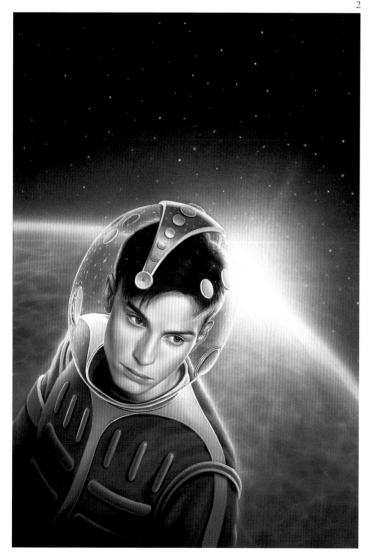

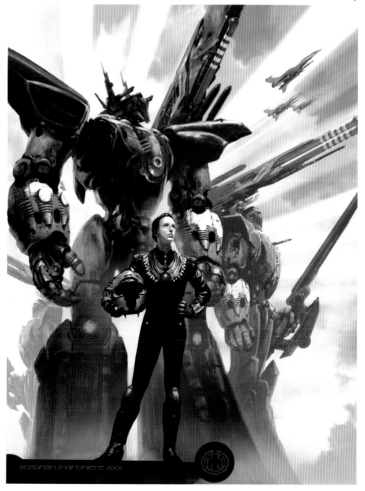

4

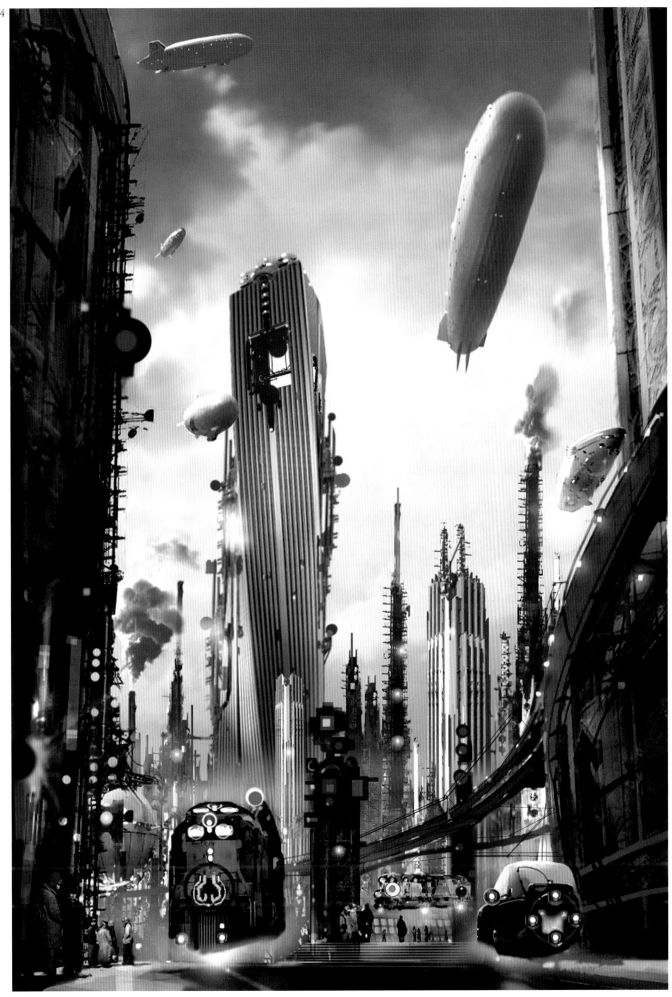

1
artist: **Mark Elliott**
art director: Nick Krenitsky
client: HarperCollins
title: For Biddle's Sake
medium: Acrylic
size: 17"x22"

2
artist: **Kazuhiko Sano**
art director: Irene Gallo
client: Starscape Books
title: Song in the Silence
medium: Oil

3
artist: **Hala Wittwer**
art director: Nick Krenitsky
client: HarperCollins
title: The Winged Cat
medium: Acrylic/oil
size: 10"x14"

4
artist: **Hala Wittwer**
art director: Nick Krenitsky
client: HarperCollins
title: Hippolyta and the Curse of the Amazons
medium: Acrylic/oil
size: 11"x15"

1

2

3

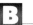

B *o o k*

1
artist: **Rafal Olbinski**
client: Patinae
title: Olbinski Paints Mozart: Don Giovanni
medium: Acrylic
size: 30"x20"

2
artist: **Greg Copeland**
art director: Katy Steinhilber
designer: Greg Copeland
client: Leisure Books
title: Bedbugs
medium: Oil on canvas
size: 12¹/₂"x19"

3
artist: **John Picacio**
art director: Harlan Ellison
client: ibooks
title: Dangerous Visions
medium: Mixed/digital
size: 9¹/₂"x14¹/₄"

4
artist: **Gary Kelley**
art director: Irene Gallo
client: Tor Books
title: Coyote Cowgirl
medium: Pastel

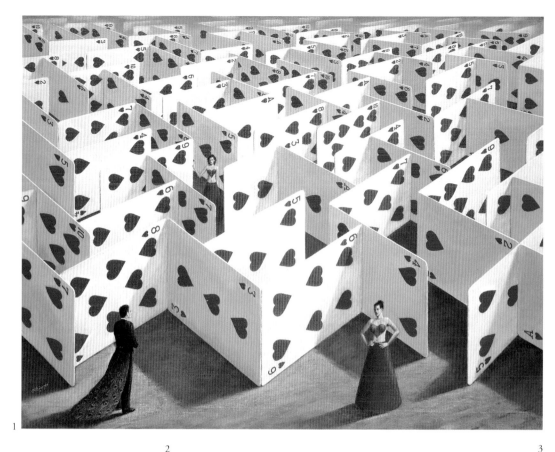

1

2

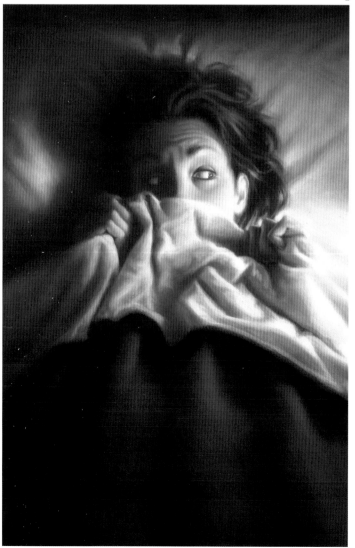

3

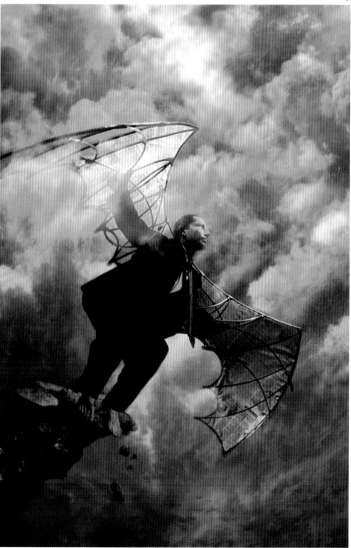

4

1
artist: **Terese Nielsen**
art director: Ryan Sansaver
client: Wizards of the Coast
title: Sembia: Sands of the Soul
medium: Mixed
size: 7"x13"

2
artist: **Vince Natale**
art director: Michael Storrings
client: St. Martins Press
title: Minion
medium: Oil
size: 20"x9"

3
artist: **Gregory Manchess**
art director: Irene Gallo
client: Tor Books
title: Alchemist's Door
medium: Oil/acrylic
size: 17"x29"

4
artist: **Don Maitz**
art director: Melissa Knight
client: Random House
title: Fairy Rebel
medium: Oil on masonite
size: 20"x30"

1

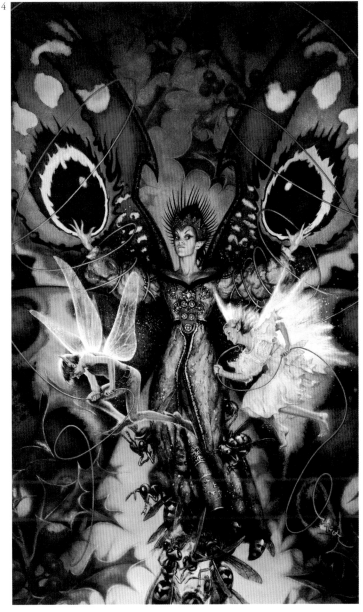

1
artist: **Kiunko Y. Craft**
art director: Paolo Pepe
designer: Paolo Pepe
client: Simon & Schuster
title: Cymbeline
medium: Oil
size: 11"x13"

2
artist: **Terese Nielsen**
art director: David Stevenson
client: Random House
title: Xanth: The Quest for Magic
medium: Mixed
size: 12¹/₂"x18¹/₂"

3
artist: **Jacques Bredy**
art director: John Horowitz
client: Zao Press
title: Raven
medium: Oil
size: 18"x24"

4
artist: **O.B, Solinsky**
art director: Toby Schwartz
client: Doubleday Direct/Bookspan
title: Portal Twister
medium: Oil
size: 16"x24"

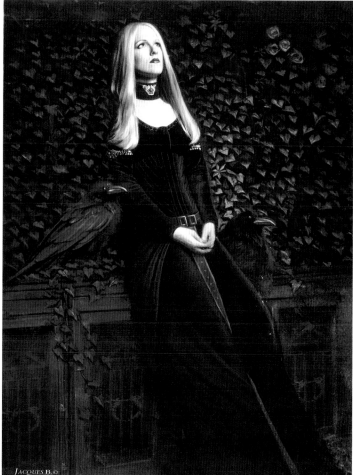

1
artist: **Jody A. Lee**
art director: Betsy Wollheim/Sheila Gilbert
designer: G-Force Designs
client: DAW Books
title: Gates of Sleep
medium: Acrylic
size: 23"x28"

2
artist: **Matt Wilson**
client: Privateer Press
title: Good Doggy
medium: Oil on paper on board
size: 40"x20"

3
artist: **José Emroca Flores**
art director: Amaranta
title: 2 Minute Hate
medium: Digital
size: 18"x12"

4
artist: **Scott M. Fischer**
art director: Lawrence Whalen
client: Monkey God Entertainment
title: Hero's Snare
medium: Mixed
size: 12"x18"

5
artist: **Ashley Wood**
client: Tripwire
title: Skull X
medium: Oil
size: 18"x24"

1

2

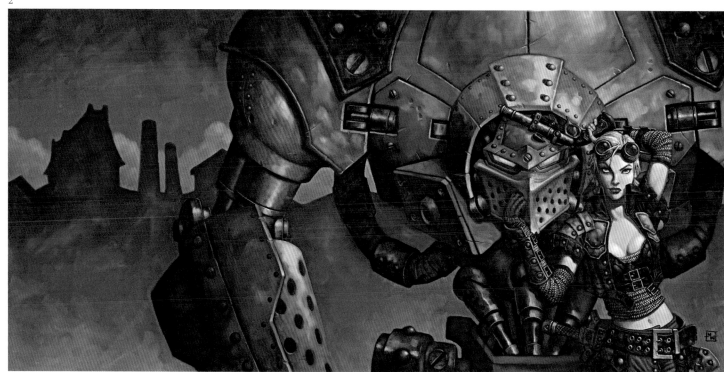

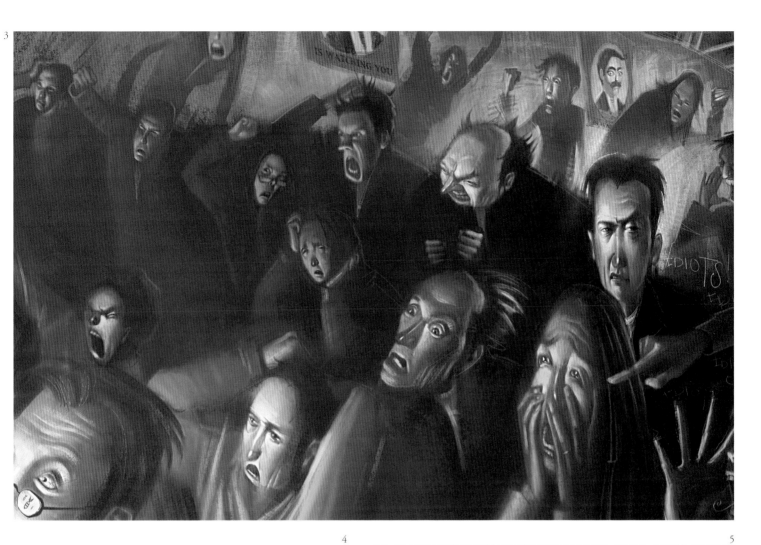

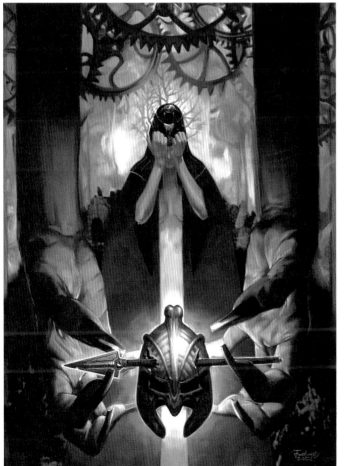

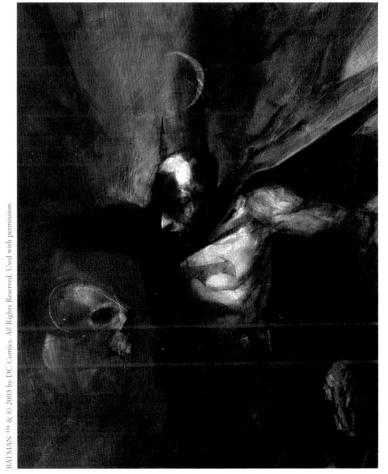

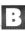

1
artist: **William Stout**
client: Terra Nova Press
title: Triple Monster Self Portrait
medium: Pen, brush & ink on board
size: 11¹/₂"x13¹/₂"

2
artist: **Peter de Sève**
art director: Vaughn Andrews
designer: Jeff Puda
client: Harcourt Trade Publishers
title: Dealing With Dragons
medium: Watercolor & ink
size: 10"x12"

3
artist: **William Stout**
client: ibooks/Terra Nova Press
title: Jobaria
medium: Ink & watercolor on board
size: 7¹/₄"x10⁵/₈"

4
artist: **Peter de Sève**
art director: Vaughn Andrews
designer: Jeff Puda
client: Harcourt Trade Publishers
title: Searching For Dragons
medium: Watercolor & ink
size: 10"x12"

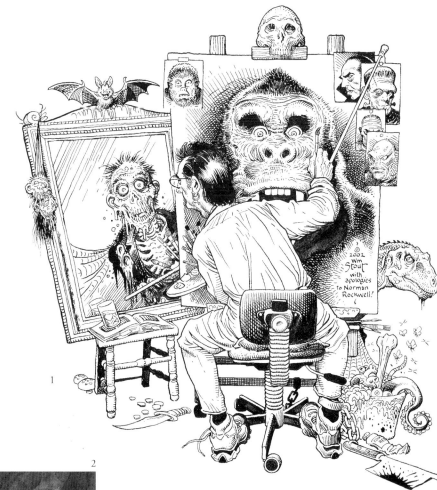

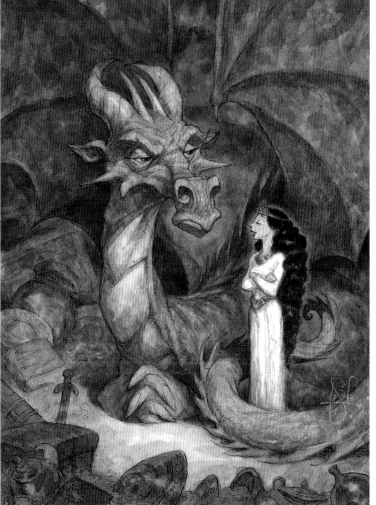

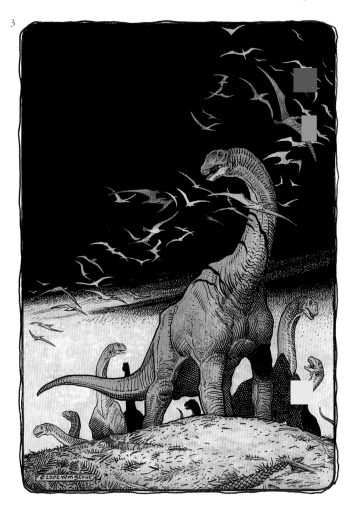

4

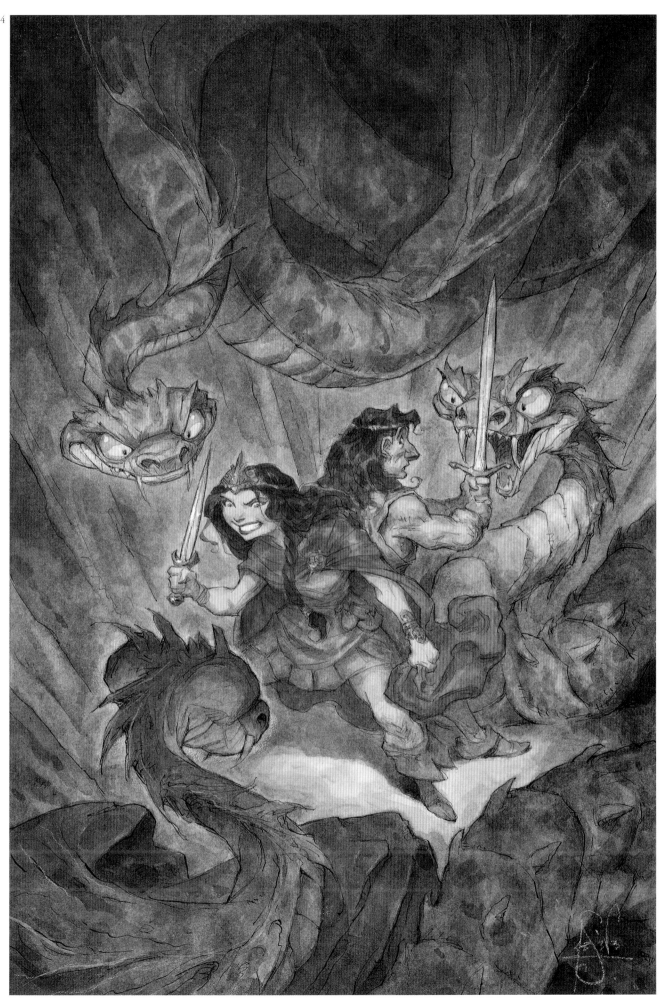

1
artist: **John Jude Palencar**
art director: Deborah Kaplan
designer: Nancy Brennan
client: Viking Books
title: Waifs and Strays
medium: Acrylic
size: 30"x27"

2
artist: **Charles Vess**
art director: Irene Gallo
client: Tor Books
title: Tapping the Dream Tree
medium: Colored inks
size: 12"x17"

3
artist: **John Jude Palencar**
art director: Irene Gallo
client: Tor Books
title: A Scattering of Jades
medium: Acrylic
size: 12"x14"

4
artist: **John Jude Palencar**
art director: Judith Murello
client: Ace Books
title: Angelica
medium: Acrylic
size: 27"x29¹/₂"

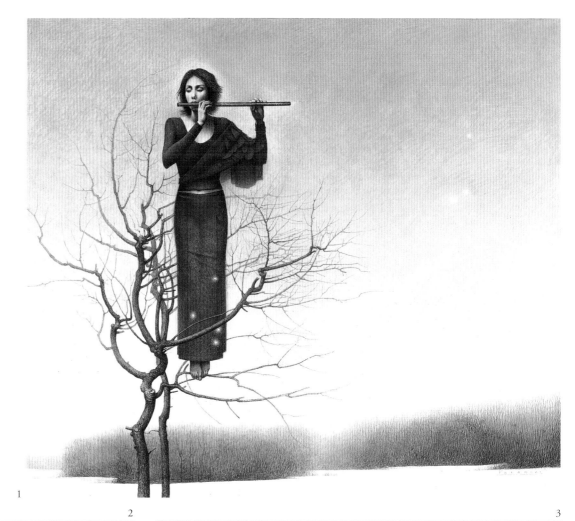

1

2

3

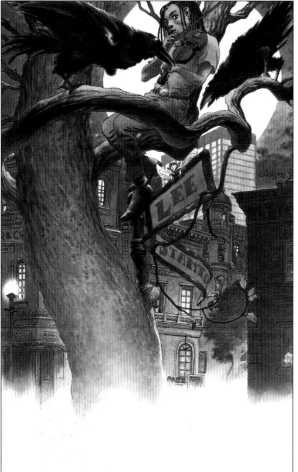

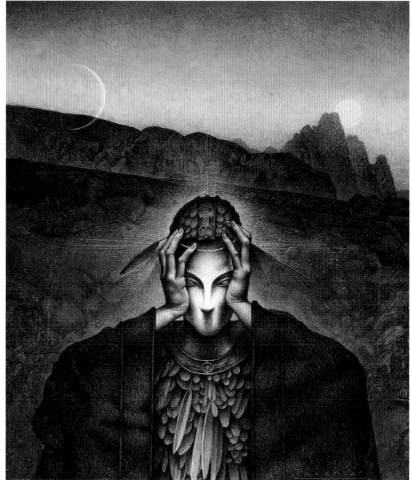

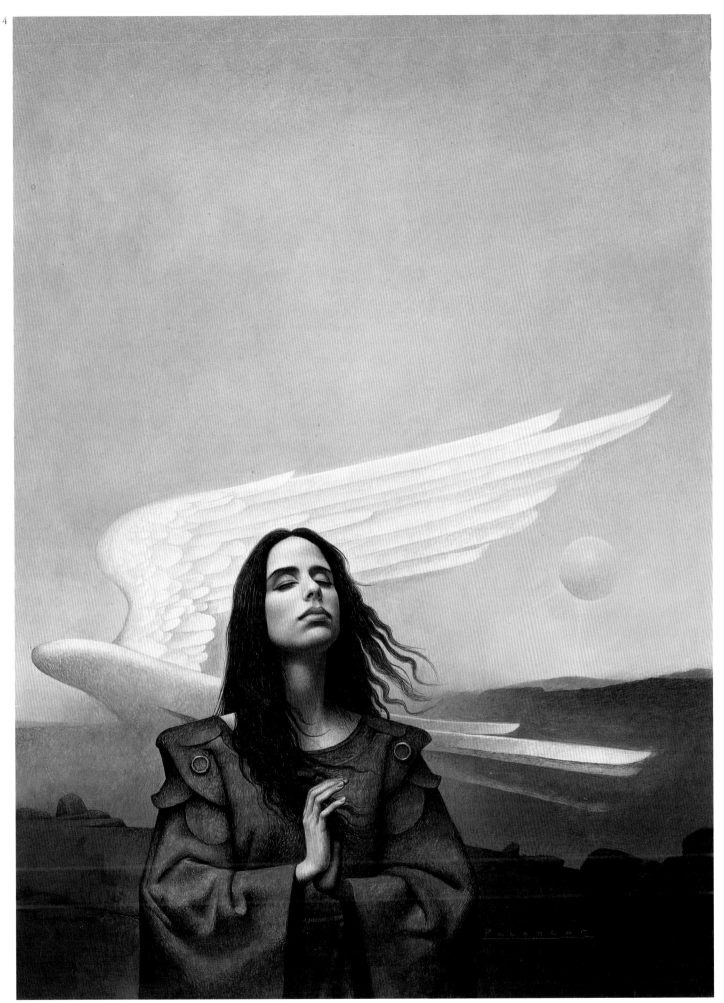

1
artist: **Jon Foster**
art director: David Stevenson
client: Del Rey Books
title: Remnant
medium: Digital

2
artist: **John Howe**
art director: Steven Pagel
designer: Kevin Murphy
client: Meisha Merlin Publishing
title: Crow
medium: Watercolor
size: 12"x18"

3
artist: **Dave Seeley**
art director: David Stevenson
client: Ballentine Books
title: Trading in Danger
medium: Photodigital

4
artist: **John Zeleznik**
client: Palladium Books
title: Rifts: Adventure Guide
medium: Acrylic
size: 14"x16"

5
artist: **Greg Swearingen**
art director: Irene Gallo
client: Tor Books
title: Hidden Talents
medium: Mixed
size: 10"x14"

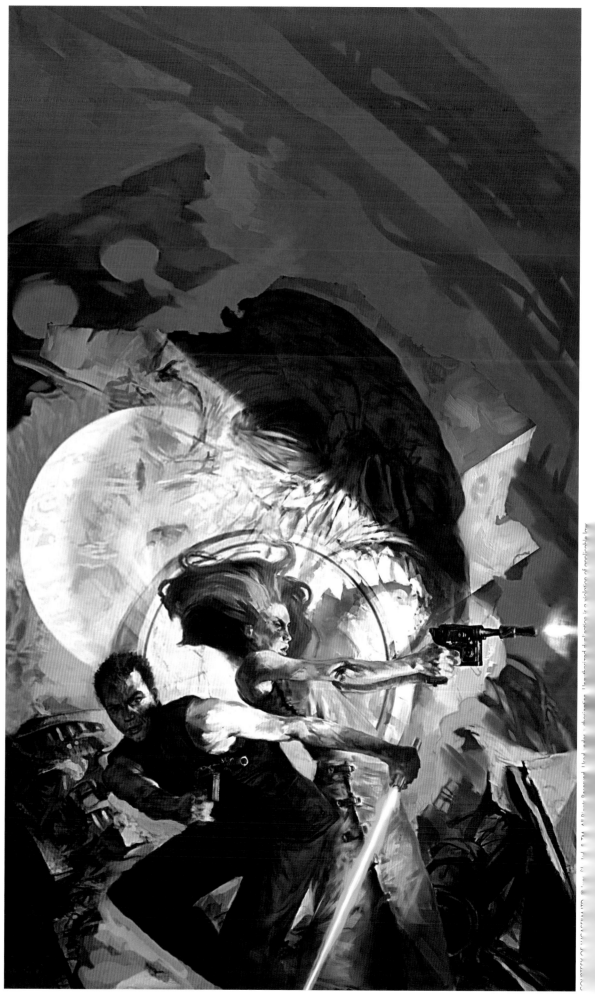

1

2

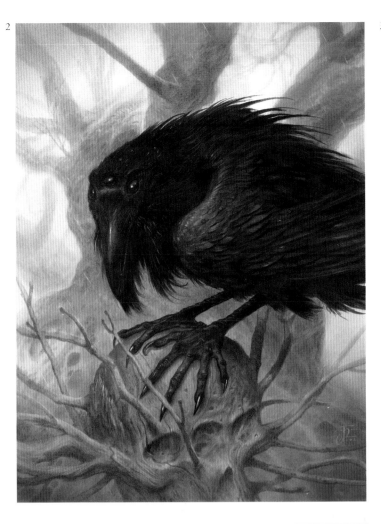

3

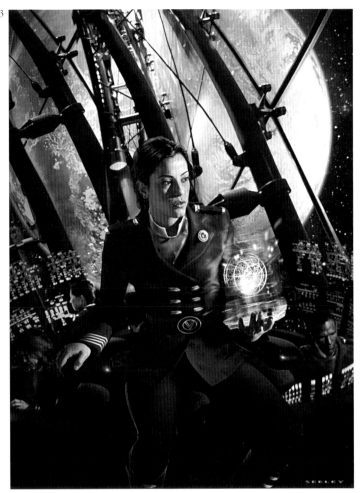

4

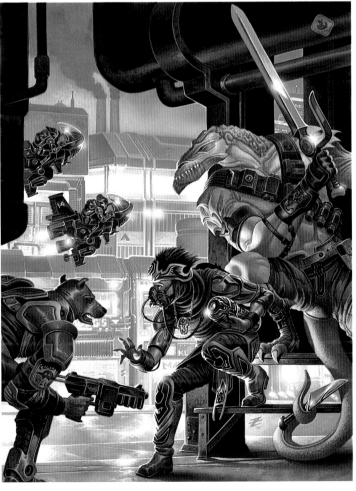

5

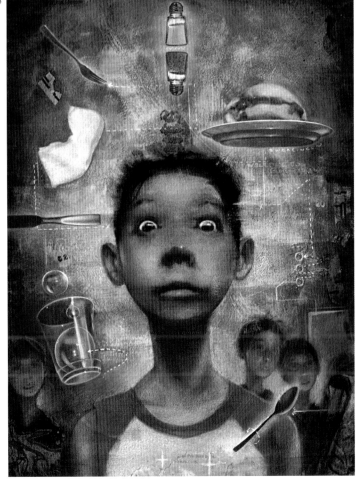

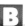

1
artist: **David Grove**
art director: Irene Gallo
client: Tor Books
title: Latro In the Mist
medium: Acrylic

2
artist: **Luis Royo**
client: Norma Editorial
title: Black Tinkerbell
medium: Acrylic
size: 14"x18"

3
artist: **Thomas Denmark**
art director: Greg Benage
client: Fantasy Flight Games
title: Midnight
medium: Digital
size: 8¹/₂"x11"

4
artist: **Justin Sweet**
art director: Theodore Berquiist
client: Riot Minds
title: Trudvang
medium: Oil/digital

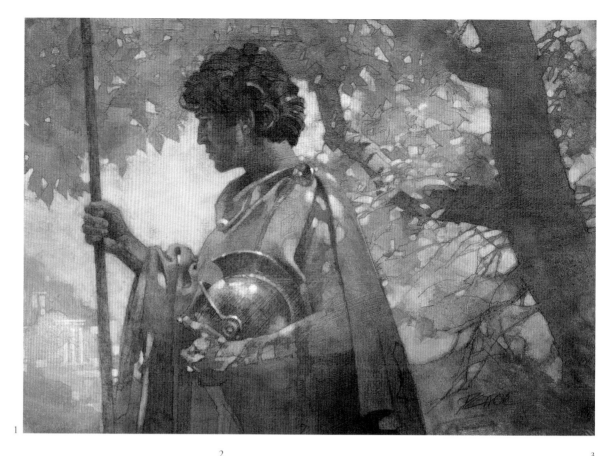

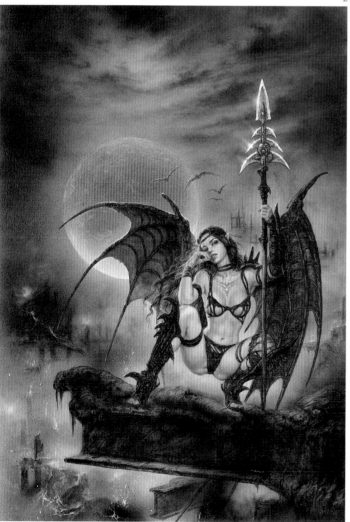

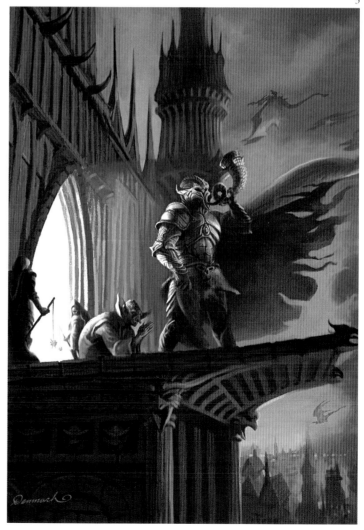

4

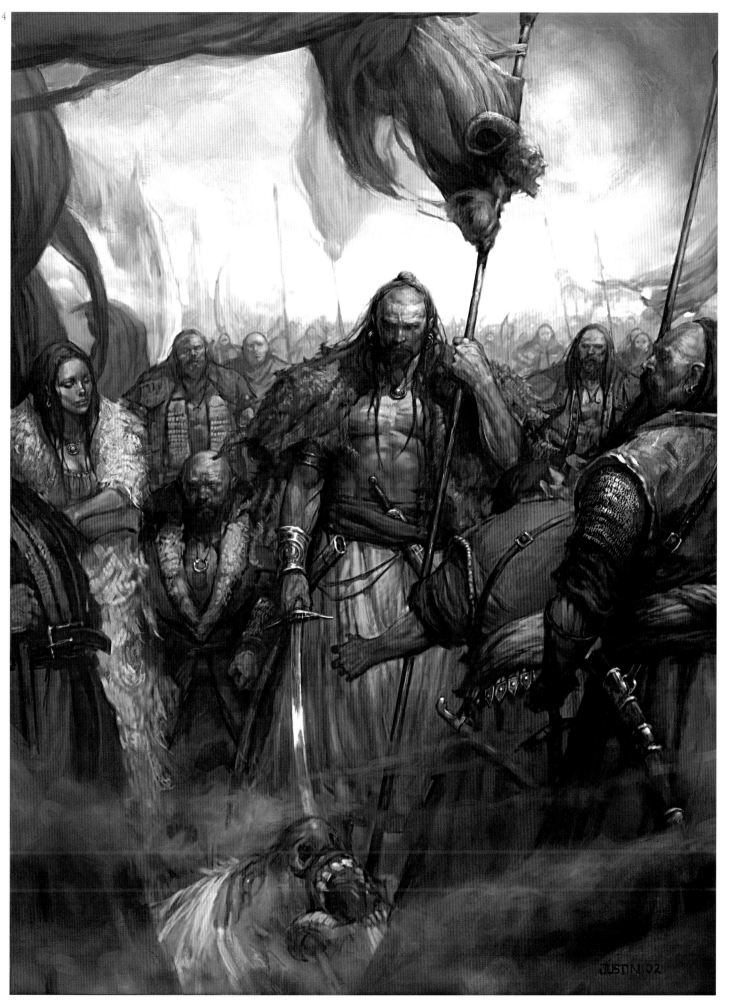

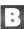

1
artist: **Bob Eggleton**
art director: Bob Eggleton
designer: Malcom Couch
client: Paper Tiger
title: Fine Dragons
medium: Acrylic
size: 36"x24"

2
artist: **Bob Eggleton**
art director: Bob Eggleton
designer: Desert Isle Design
client: Subterranean Press
title: From Weird and Distant Shores
medium: Oil
size: 40"x30"

3
artist: **William Stout**
client: ibooks/Terra Nova Press
title: The Title
medium: Ink & watercolor on board
size: 7^1/4"x10^5/8"

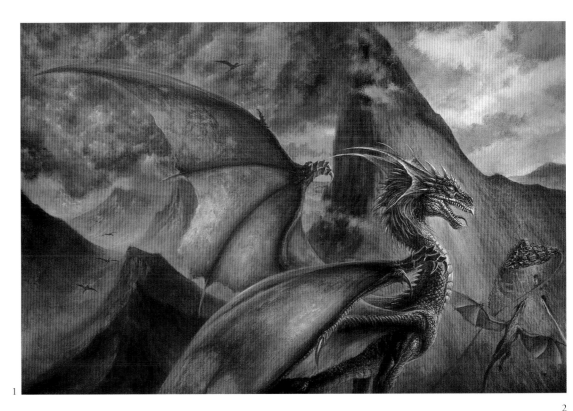

1

2

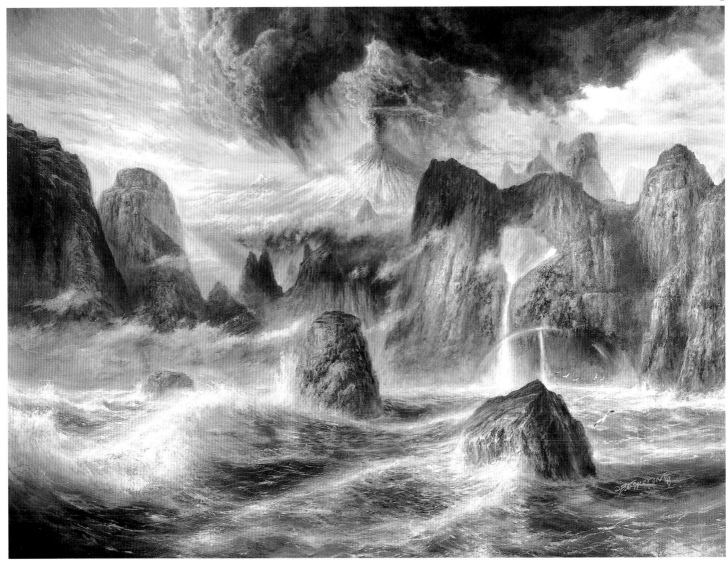

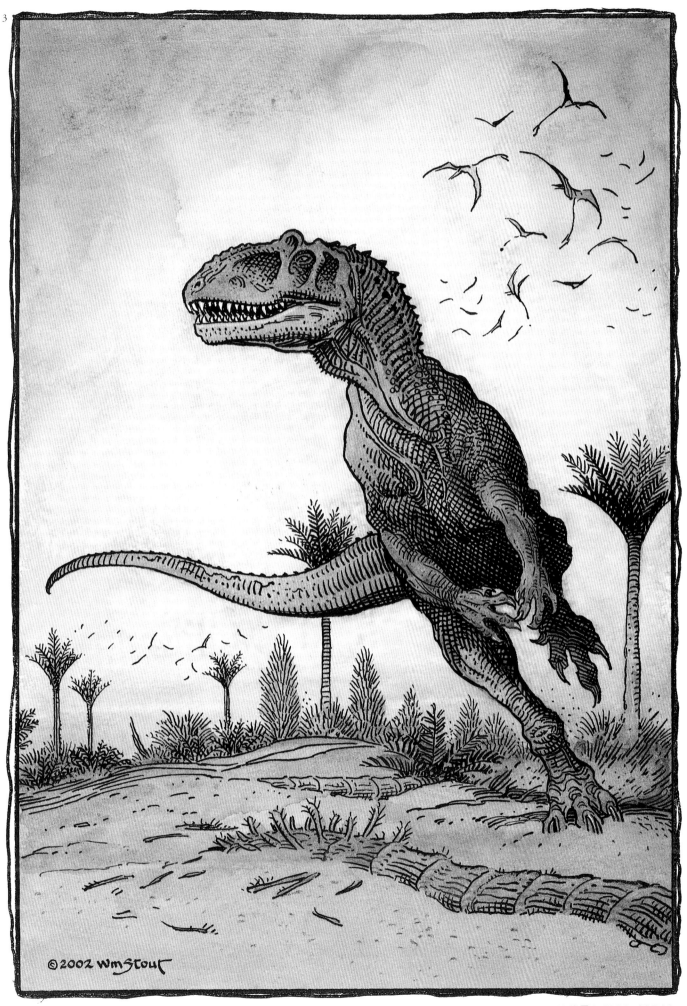

©2002 WmStout

1
artist: **Petar Meseldžija**
client: Grimm Press [Taiwan]
title: King Arthur and the Knights
 of the Round Table
medium: Acrylic
size: 17"x12"

2
artist: **Gregory Manchess**
art director: Irene Gallo
client: Tor Books
title: Finn Mac Cool
medium: Oil
size: 66"x28"

3
artist: **Kinuko Y. Craft**
art director: Ellen Friedman
designer: Mahlon F. Craft
client: Sea Star Books
title: Sleeping Beauty
medium: Oil
size: 23"x12"

1

2

3

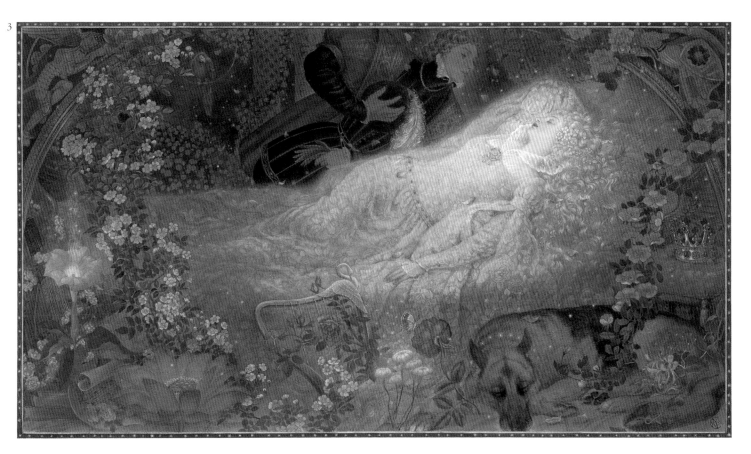

1
artist: **Bryan Ballinger**
client: Big Idea Books
title: The Great Cheese Squeeze
medium: Digital
size: 12¼"x9¼"

2
artist: **Ray-Mel Cornelius**
art director: Allyson Bradley
client: Half Price Books
title: Moon Watcher
medium: Acrylic

3
artist: **Z-ko Chuang**
title: The Sign
medium: Acrylic/digital
size: 15"x7"

4
artist: **Mark Zug**
art director: Rob Boyle
client: FanPro Games
title: Toxic Spirit
medium: Oil
size: 16"x21"

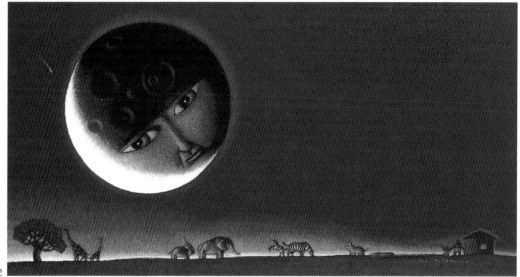

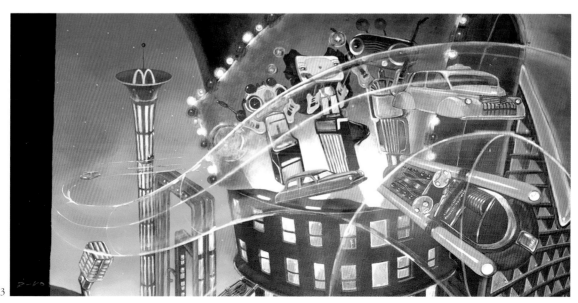

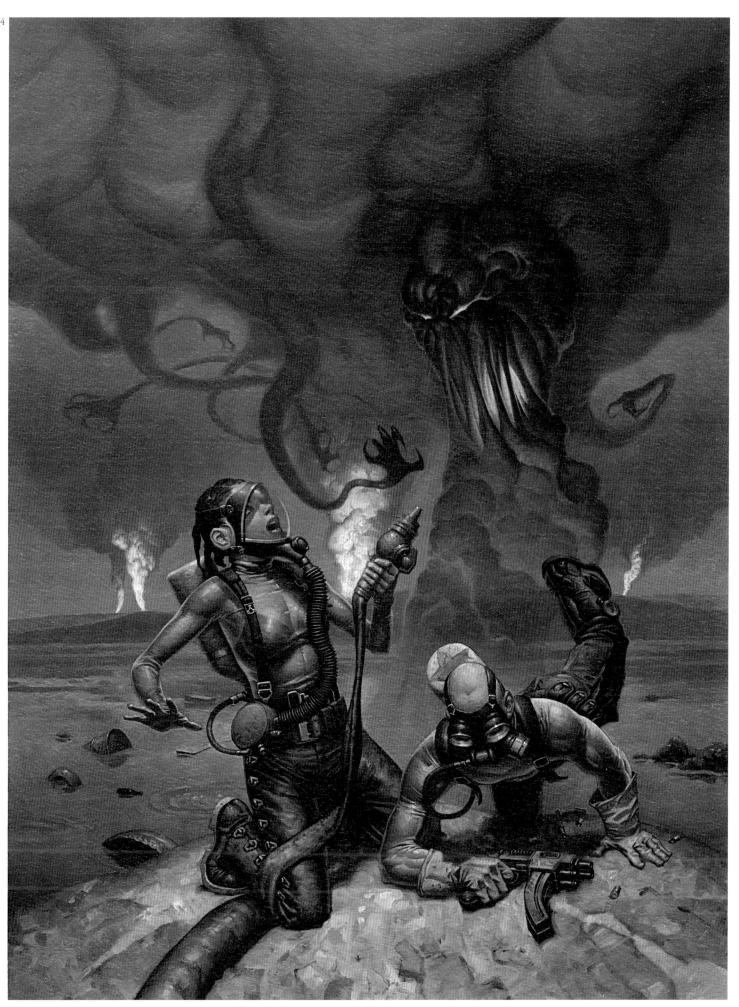

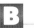

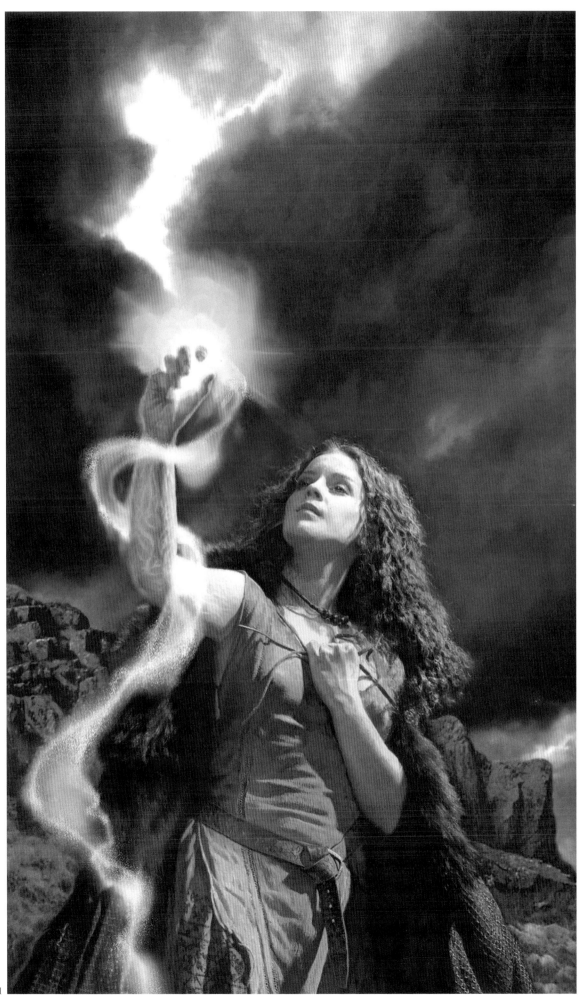

1

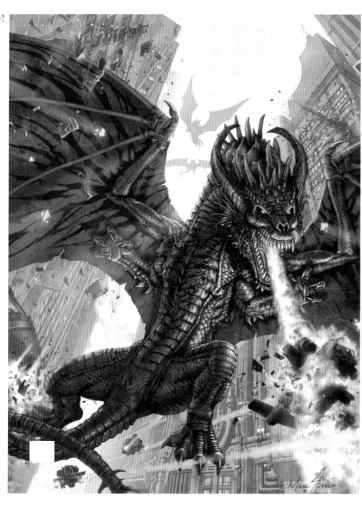

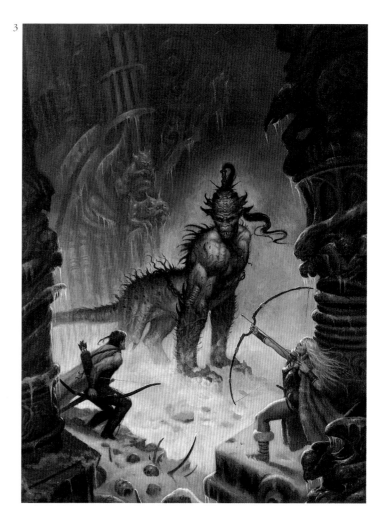

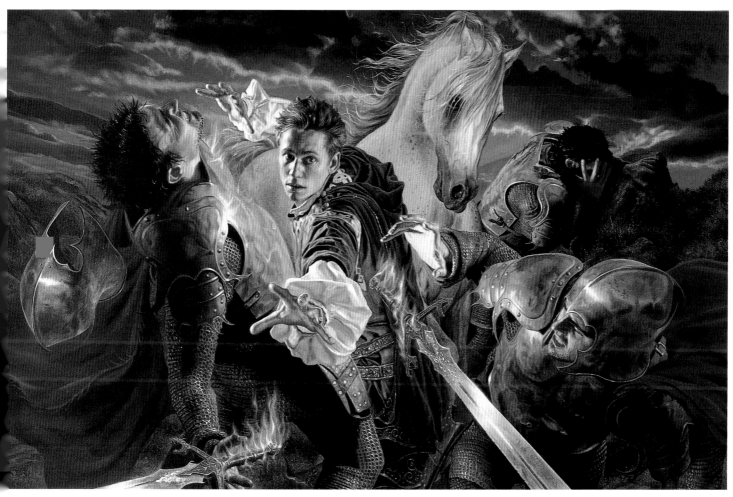

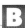

1
artist: **Roxana Villa**
art director: Mark Murphy
designer: Roxanna Villa
client: Murphy Design
title: Illuminated H^2/Heaven & Hell
medium: Acrylic/goldleaf/digital
size: 8^1/$_2$"x16"

2
artist: **Manchu**
client: Hachette—Livre de Poche
title: Le Sceptre du Hasard
medium: Acrylic
size: 50cmx65cm

3
artist: **Dave Seeley**
title: Pistol Whipped
medium: Photodigital

4
artist: **Janny Wurts**
client: HarperCollins/Eos
title: Peril's Gate
medium: Oil on masonite
size: 36"x23^1/$_2$"

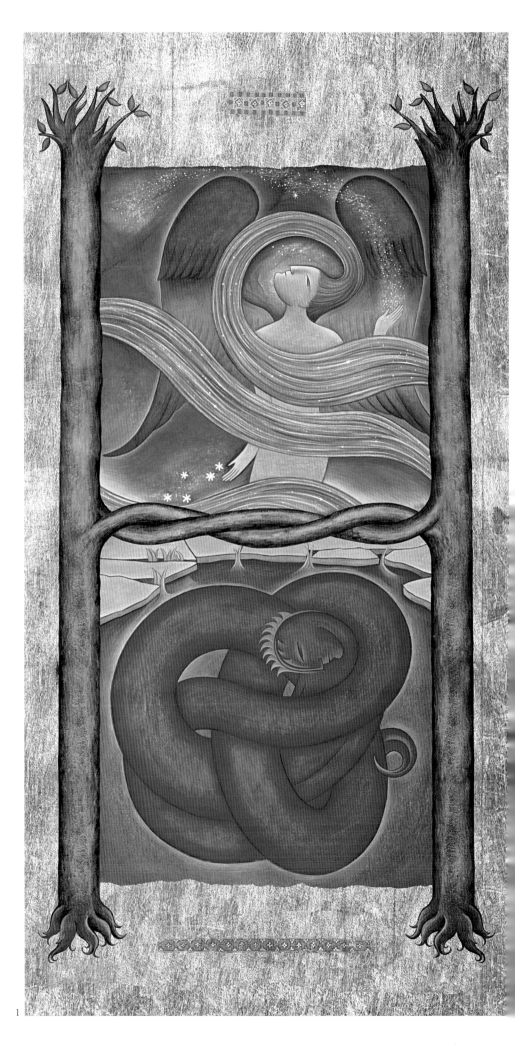

1

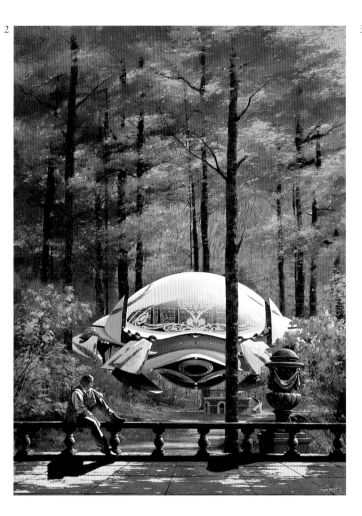

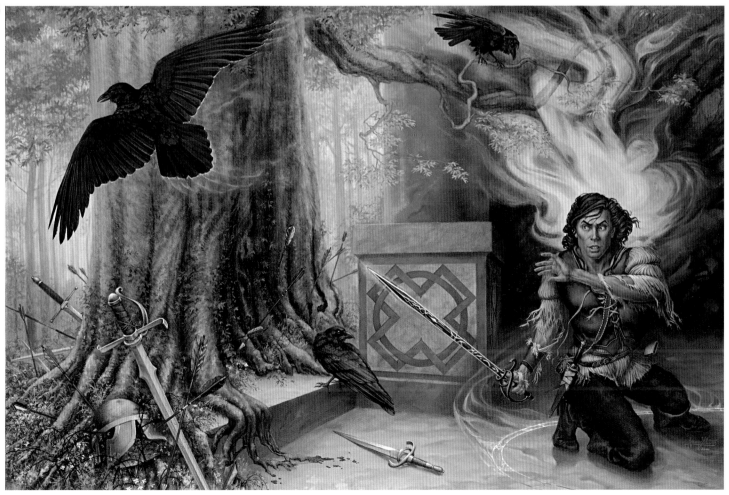

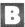

B *o o k*

1
artist: **H. Tom Hall**
art director: Irene Gallo
client: Tor Books
title: Hunters On the Dark Sea
medium: Oil

2
artist: **Tristan Elwell**
art director: Irene Gallo
client: Starscape Books
title: Ashling
medium: Oil

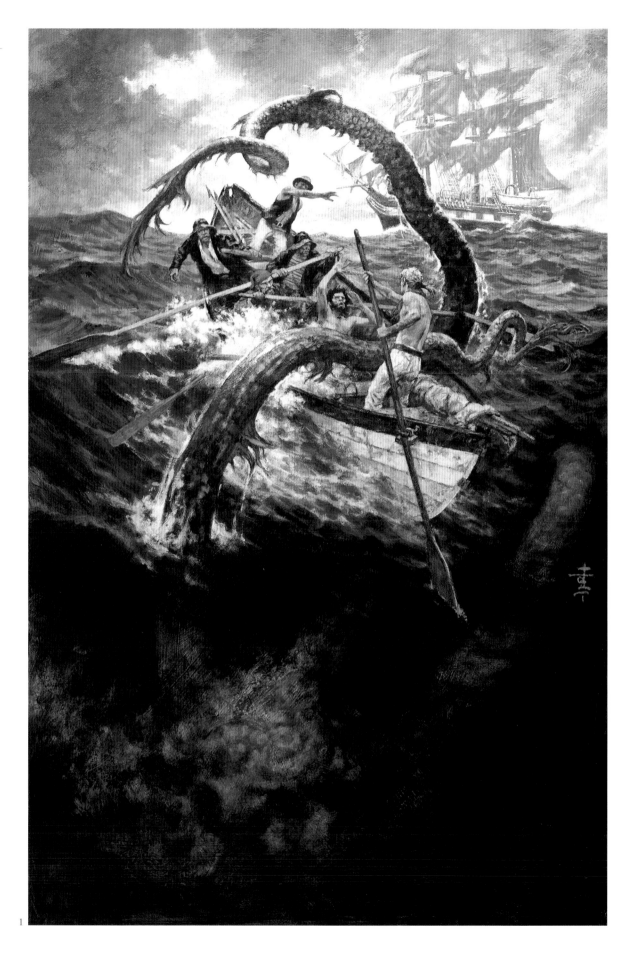

1

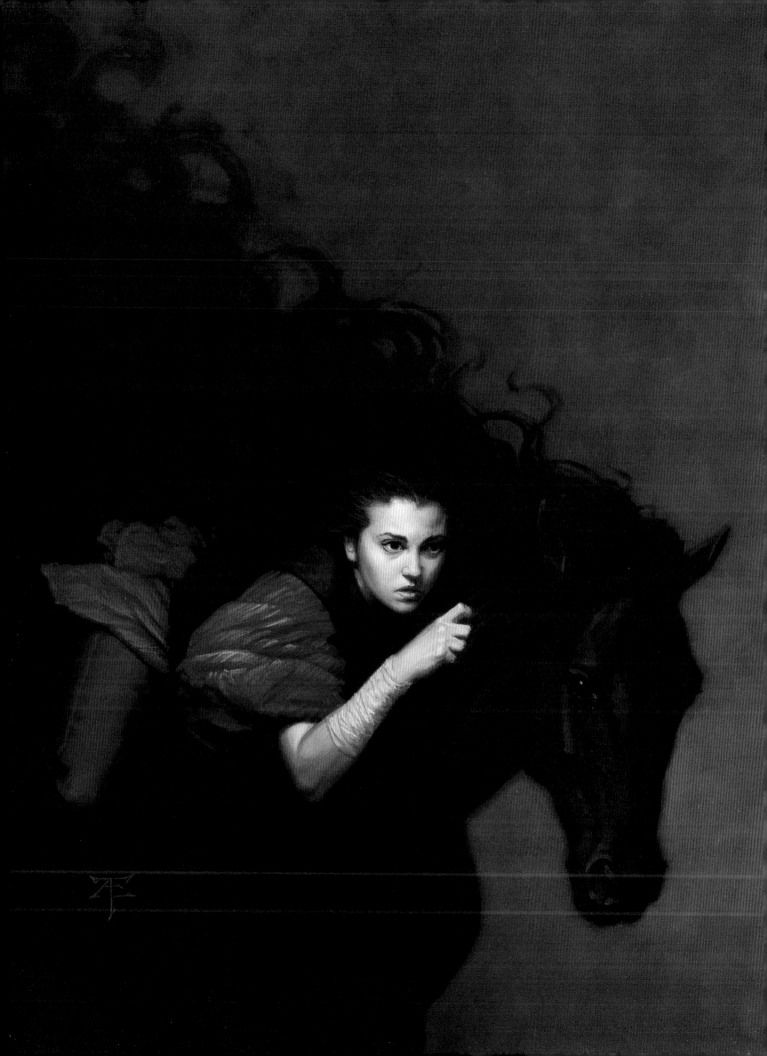

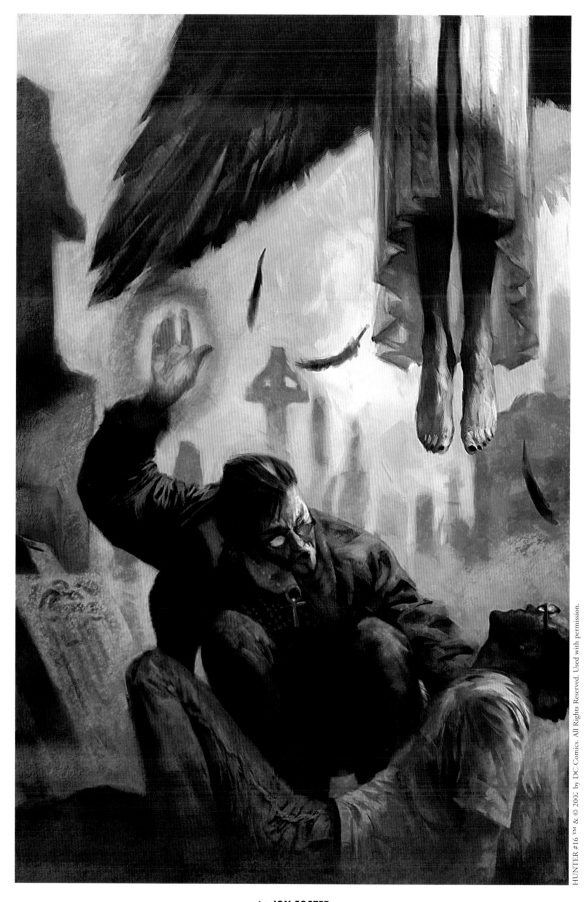

artist: **JON FOSTER**

art director: Steve Bunche client: DC Comics title: Hunter #16 medium: Digital

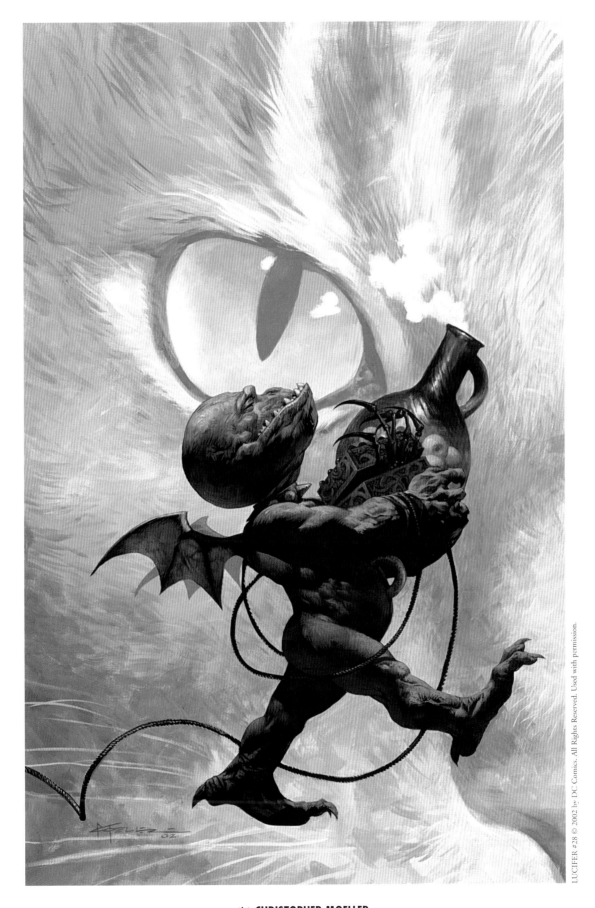

artist: **CHRISTOPHER MOELLER**

art director: Shelly Bond client: DC Comics title: Lucifer #28 size: 20"x30" medium: Acrylic on board

1
artist: **Jon J Muth**
art director: Shelly Bond
designer: Georg Brewer
client: DC/Vertigo Comics
title: Lucifer: Nirvana
medium: Mixed

2
artist: **Gary Gianni**
designer: Jim Keegan
client: Hieronymus Press
title: Corpus Monstrum Vol. 1
medium: Ink
size: 10"x15"

3
artist: **Christopher Moeller**
art director: Shelly Bond
client: DC Comics
title: Lucifer #27
medium: Acrylic on board
size: 20"x30"

4
artist: **Jason Alexander**
art director: Mark Bellis
designer: Kent Williams
client: Sirius Entertainment
title: Empty Zone
medium: Mixed
size: 18"x26"

1

2

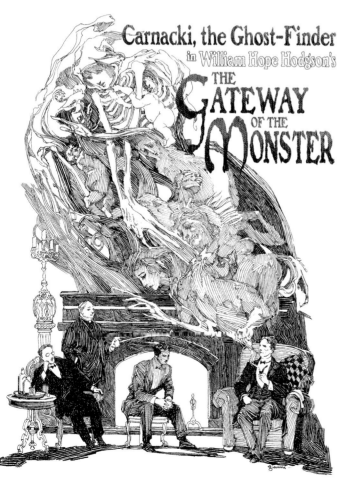

3

Comics

1
artist: **Christian Gossett**
colorist: Snakebit
title: Run, Makita, Run [The Red Star cover]

2
artist: **Raymond Swanland**
art director: Matt Alford
client: TokyoPop
title: Atonement
medium: Digital

3
artist: **Raymond Swanland**
art director: Matt Alford
client: TokyoPop
title: The Blessing
medium: Digital

4
artist: **Raymond Swanland**
art director: Matt Alford
client: TokyoPop
title: The Fall
medium: Digital

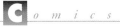
1
artist: **Glen Orbik**
art director: Shelly Bond
designer: Glen Orbik/Laurel Blechman
client: DC Comics
title: American Century #15
medium: Oil
size: 13"x16"

2
artist: **Joe Chiodo**
art director: Teal Marie K. Chimblo
designer: Shannon Rasberry
client: Penny-Farthing Press
title: Decoy: Storm of the Century #3
medium: Acrylic

3
artist: **Joe Chiodo**
art director: Teal Marie K. Chimblo
designer: Shannon Rasberry
client: Penny-Farthing Press
title: Decoy: Storm of the Century #1
medium: Acrylic

4
artist: **Ashley Wood**
client: Image Comics
title: The Real Fused
medium: Oil/digital
size: 17"x11"

5
artist: **Brian Horton/Paul Lee**
art director: Scott Allie
client: Dark Horse Comics
title: The Devil's Footprints #2
medium: Mixed
size: 6³/₄"x10"

6
artist: **Brian Horton/Paul Lee**
art director: Scott Allie
client: Dark Horse Comics
title: Buffy the Vampire Slayer #58
medium: Mixed
size: 6³/₄"x10"

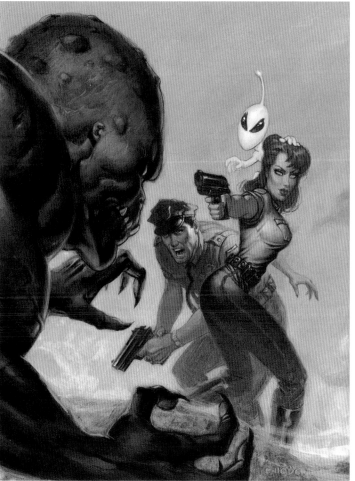

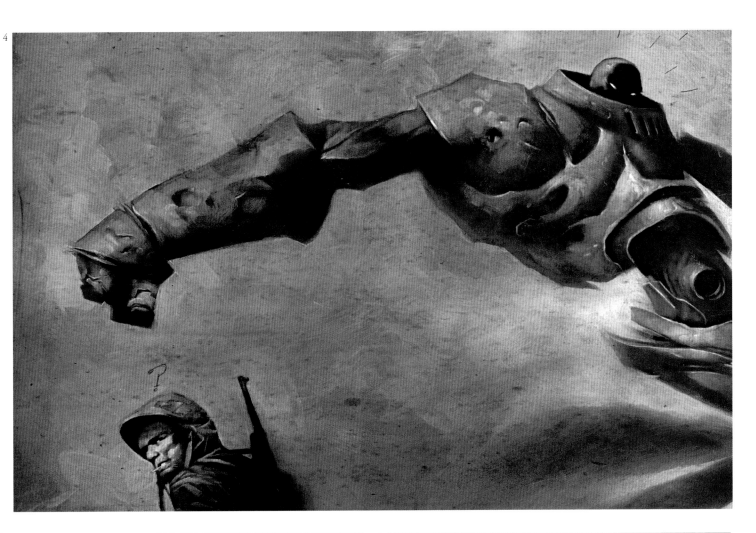

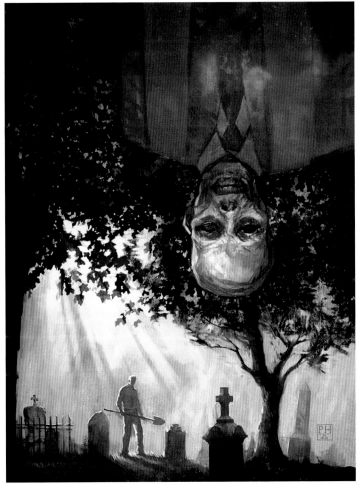

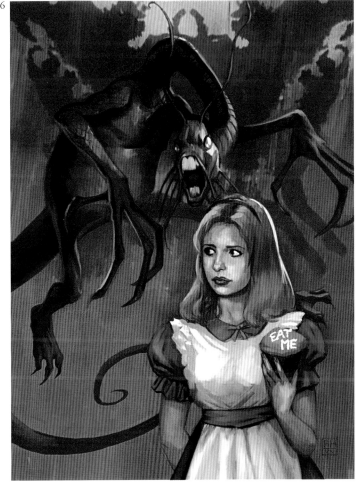

1
artist: **Jon Foster**
art director: Heidi MacDonald
client: DC Comics
title: Hunter #11
medium: Oil/digital
size: 28"x28"

2
artist: **Neal Adams**
art director: Teal Marie K. Chimblo
designer: Shannon Rasberry
client: Penny-Farthing Press
title: The Victorian #14
medium: Mixed

3
artist: **David Mack**
art director: Nanci Dakesian/Stuart Moore
designer: David Mack
client: Marvel Comics
title: Daredevil #25
medium: Mixed

4
artist: **Jon Foster**
art director: Heidi MacDonald
client: DC Comics
title: Hunter #12
medium: Oil/digital
size: 24"x36"

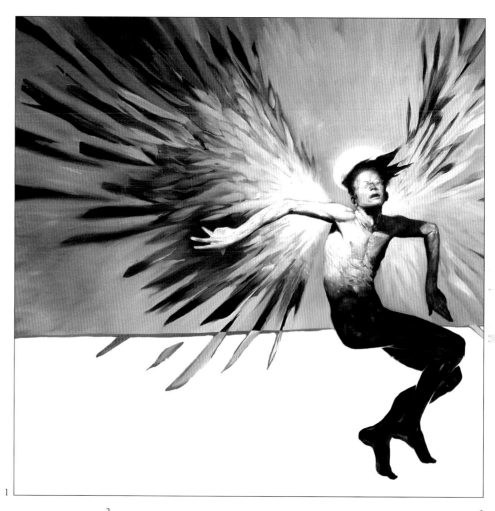

1

2

3

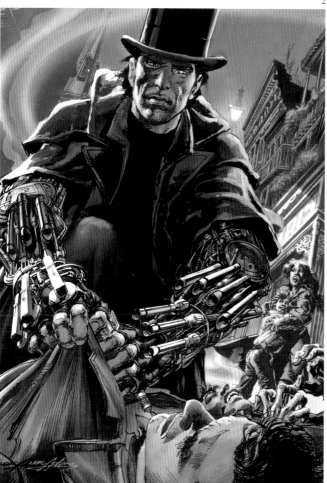

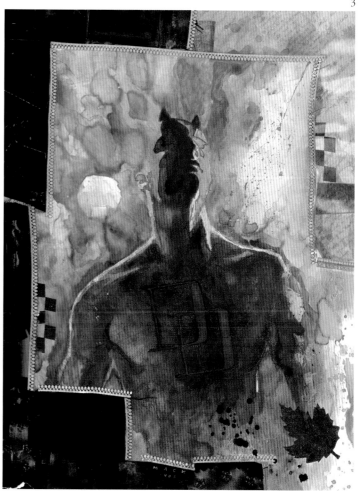

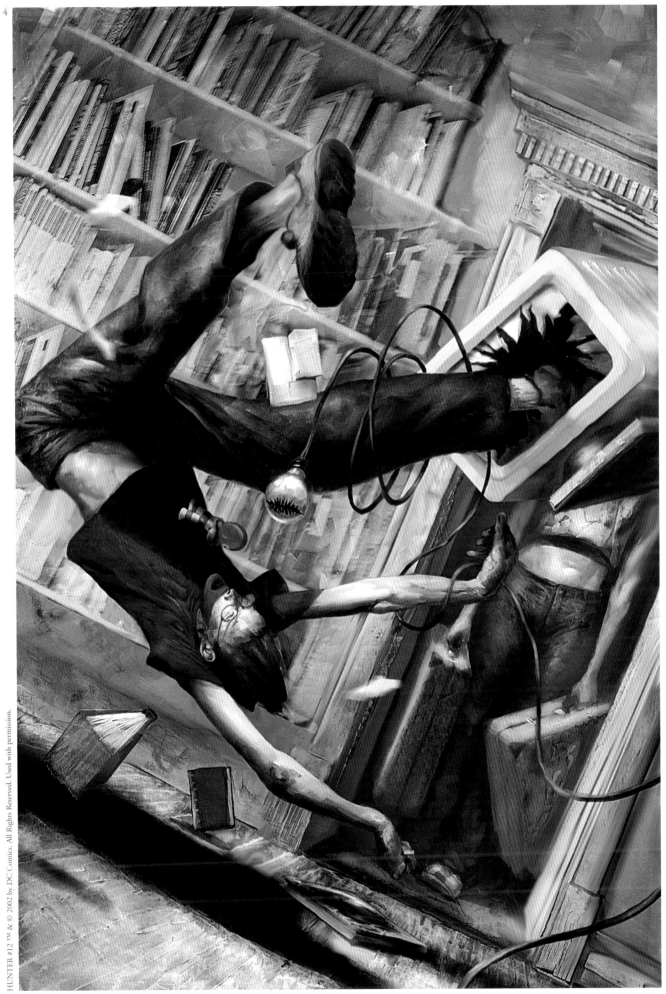

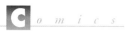

1
artist: **Steve Rude**
client: Marvel Comics
title: Cap Cover #1
medium: Cel-vinyl
size: 18"x28"

2
artist: **Lee Ballard**
client: Town O Crazies
title: Commercial Break
medium: Charcoal
size: 68"x42"

3
artist: **Joe Jusko**
art director: Tom Brevoort
client: Marvel Comics
title: Dr. Doom
medium: Acrylic
size: 16"x26"

4
artist: **Greg Horn**
art director: Tom Brevoort
client: Marvel Comics
title: Deadline #4
medium: Digital
size: 8"x10"

5
artist: **Paolo Rivera**
client: Marvel Comics
title: Iron Man
medium: Oil
size: 20"x30"

6
artist: **Scott Morse**
art director: Stuart Moore/Nanci Dakesian
client: Marvel Comics
title: Elektra: Glimpse & Echo #1
medium: Acrylic on board

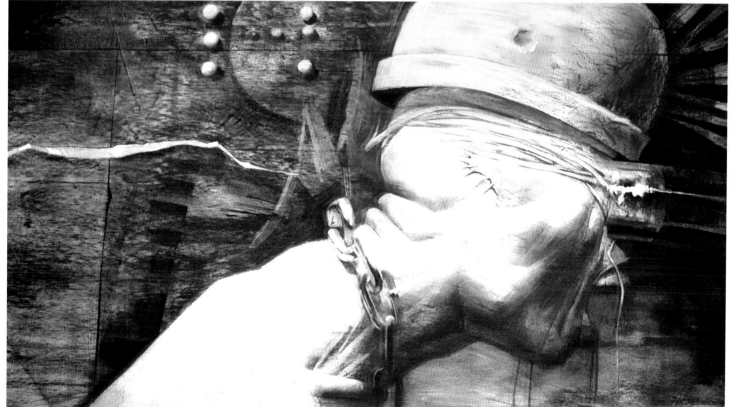

3

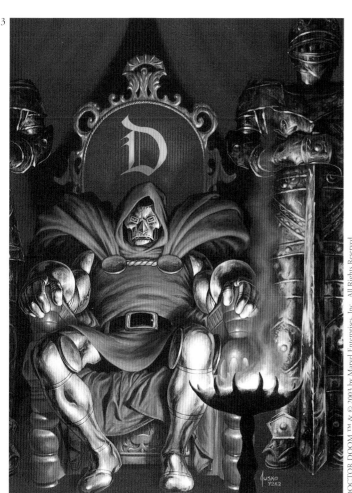

4

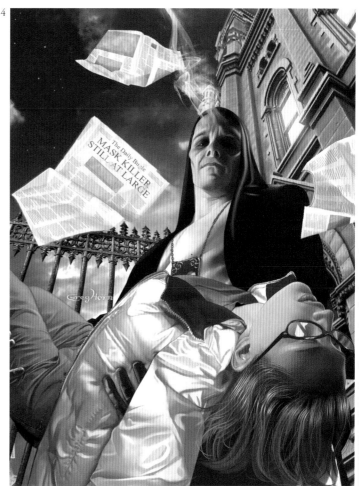

5

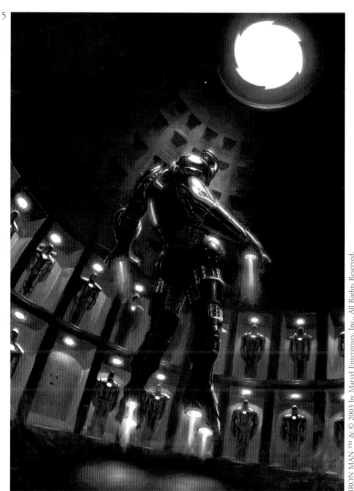

6

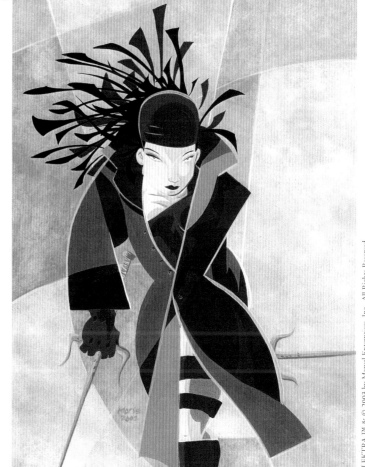

1
artist: **Vebjorn "Keel" Strommen**
art director: Wivi Eilertsen
client: Bladkompaniet As
title: Oriental Barbarian
medium: Digital

2
artist: **Paolo M. Rivera**
client: Jim Krueger
title: Children of the Left Hand
medium: Oil
size: 34"x22"

3
artist: **Greg Horn**
client: Marvel Comics
title: Elektra #16: Washing Away the Past
medium: Digital

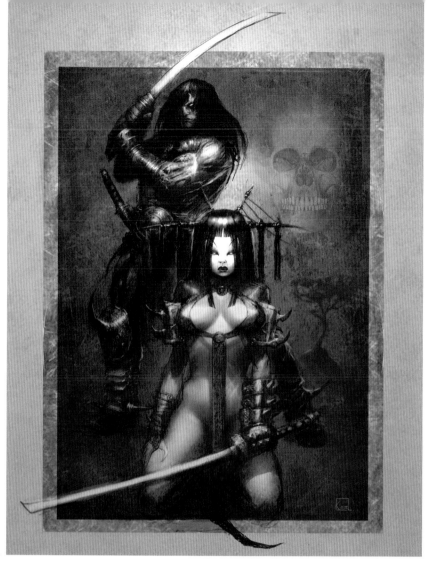

1

2

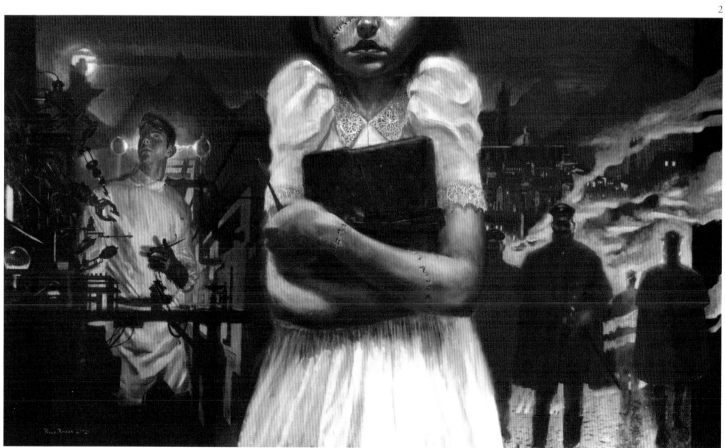

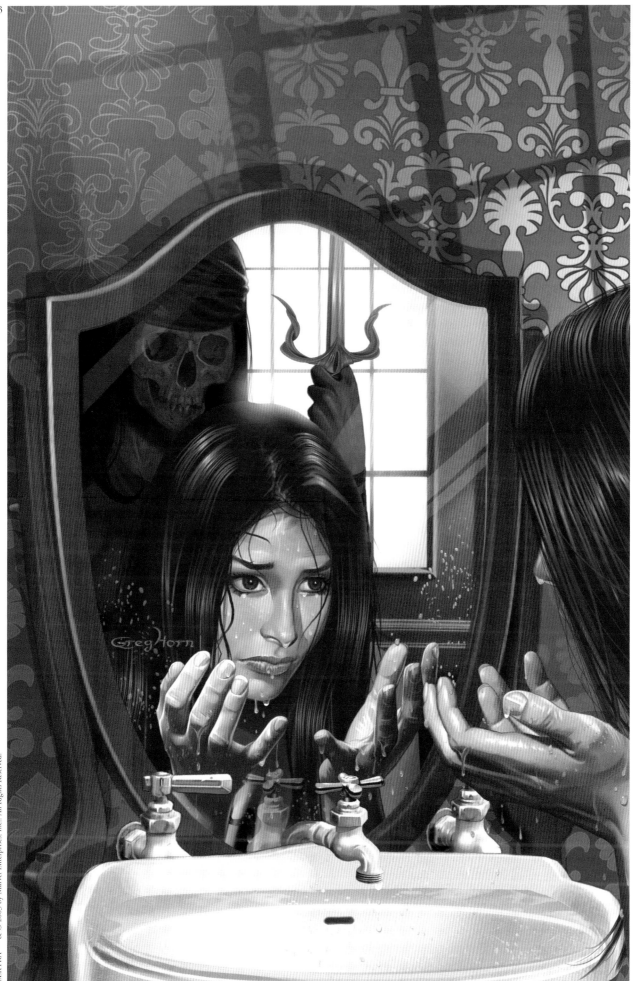

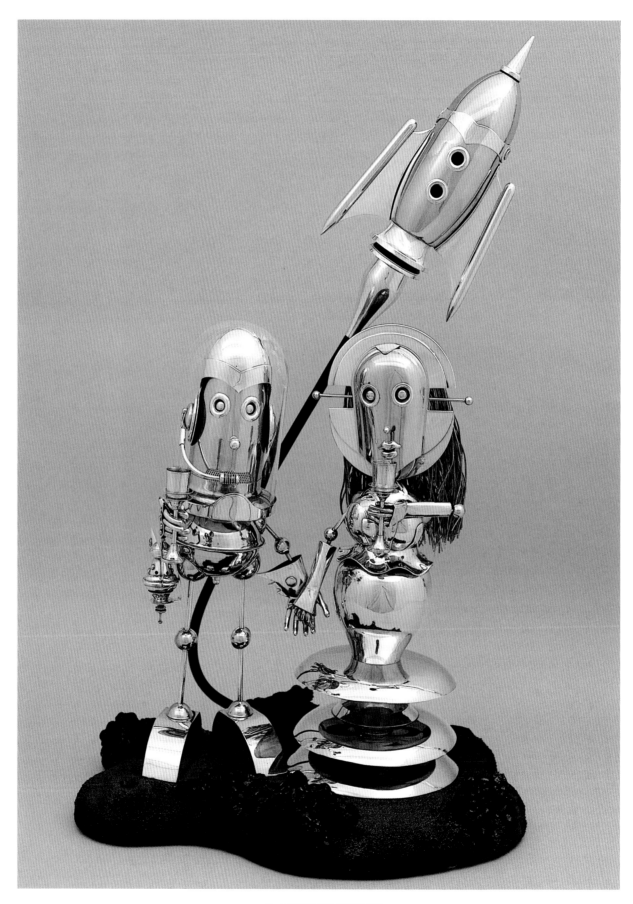

artist: **LAWRENCE NORTHEY**

designer: Lawrence Northey client: Randall & Kay Richmond title: Greetings and Salutations from the Planet Grape medium: Metal medium: 36"Hx26"W

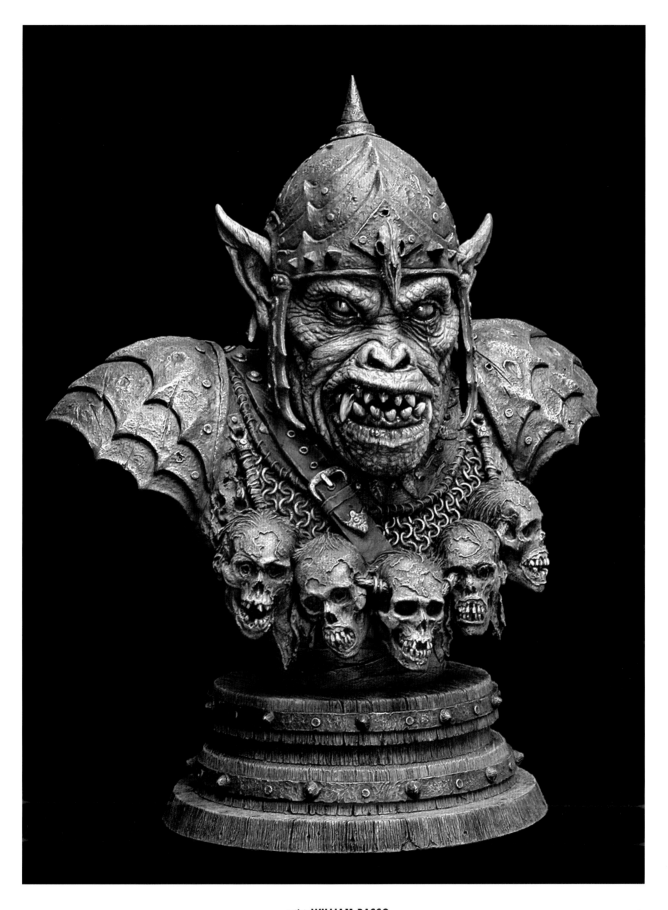

artist: **WILLIAM BASSO**

art director: William Basso *client:* Eldritch Design, Inc. *title:* The Warlord *size:* 11" tall *medium:* Painted resin

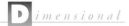
1
artist: **Tim Holter Bruckner**
art director: Georg Brewer
designer: Tim H. Bruckner/Georg Brewer
client: DC Direct
title: Batgirl
medium: Resin
size: 5¹/₂" tall

2
artist: **Tim Holter Bruckner**
art director: Georg Brewer
designer: Alex Ross
client: DC Direct
title: Wonder Woman: Kingdom Come
medium: Resin
size: 6¹/₂" tall

3
artist: **Tim Holter Bruckner**
art director: Georg Brewer
designer: Jim Lee
client: DC Direct
title: Batman
medium: Resin
size: 12" tall

4
artist: **Tim Holter Bruckner**
art director: Georg Brewer
designer: Alex Ross
client: DC Direct
title: Superman: Kingdom Come
medium: Resin
size: 6³/₄" tall

1

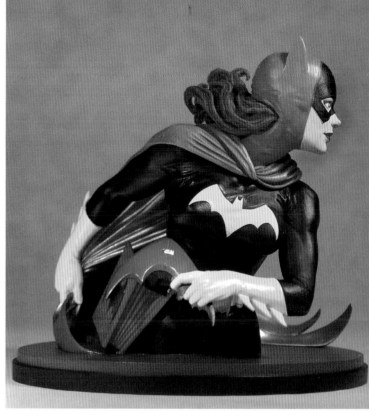

2

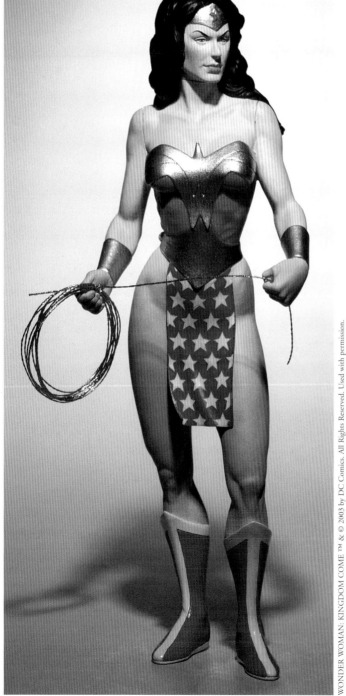

3

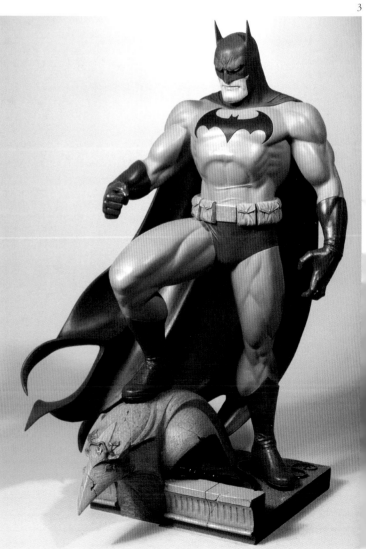

4

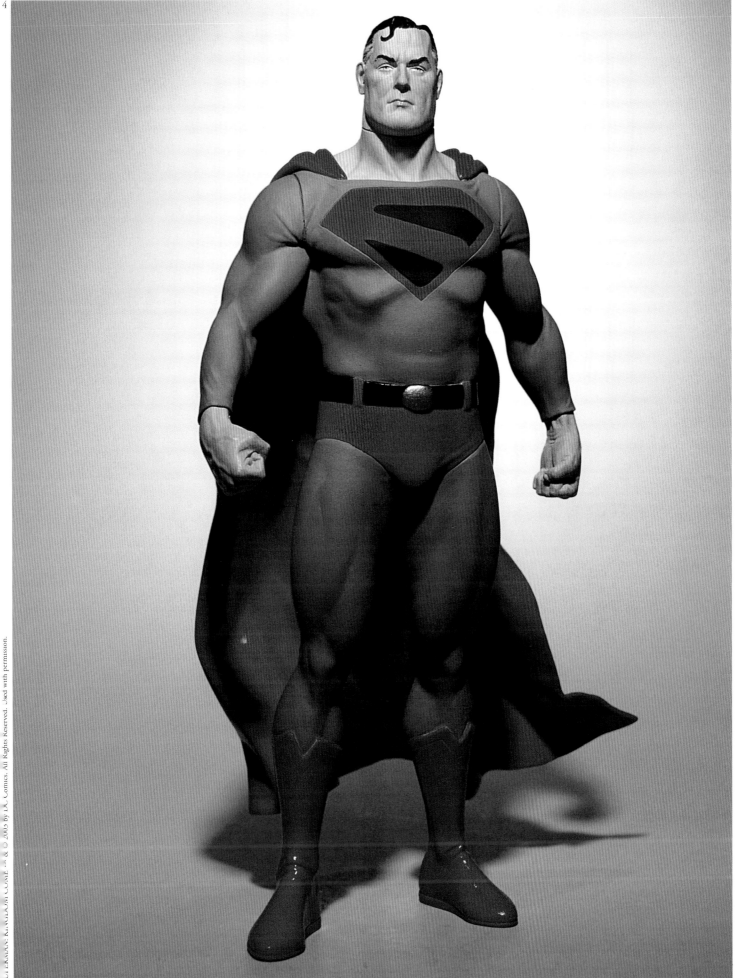

1
artist: **Steven W. West**
designer: Boris Vallejo
photographer: Michael Edenfield
client: Enchanted Arts
title: Tattoo
medium: Bonded bronze
size: 8³/4"x11³/4"

2
artist: **Mick Wood**
art director: Michael F. Heintzelman
designer: Michael F. Heintzelman
photographer: Graeme Weeks
client: The Pelennor Fields
title: The Cyclops
medium: Resin
size: 9¹/2"Hx9¹/2"W
Inspired by the work of Ray Harryhausen

3
artist: **Michael Dooney**
title: White Elf King
medium: Super sculpey
size: 4" tall

4
artist: **Pablo Viggiano**
art director: Gore Group
designer: Pablo Viggiano/Juan Bobillo
colorist: Alejandra Jorquera
client: Dynamic Forces
title: Hulk
medium: Resin
size: 9¹/2"

5
artist: **Clayburn Moore**
designer: Clayburn Moore
client: David Mack
title: Snapdragon Bust
medium: Cold cast porcelain
size: 5" tall

6
artist: **Dene Mason**
art director: Aaron Ethridge
designer: Dene Mason
client: Top Cow Comics
title: Magdalena
medium: Cold cast porcelain
size: 7¹/2"x6"x7"

7
artist: **Ryan Kenneth Peterson**
title: Hellboy Interpretation
medium: Chevant clay
size: 12"x22"
Inspired by the work of Mike Mignola

1

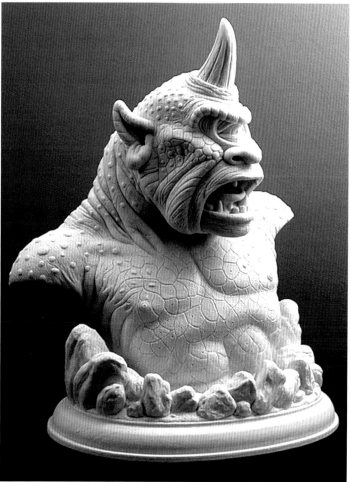

2

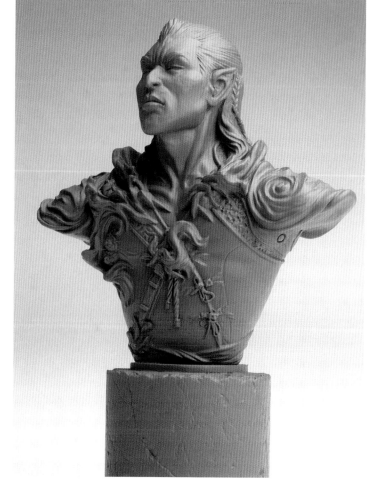

3

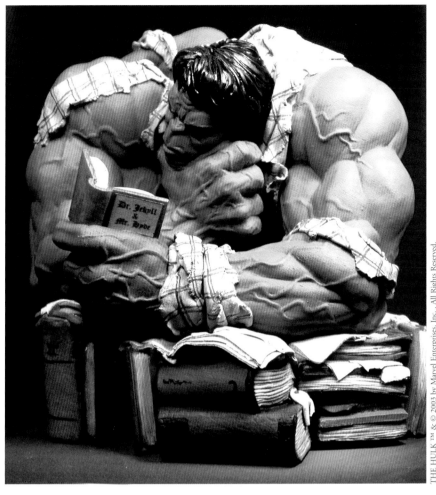

5

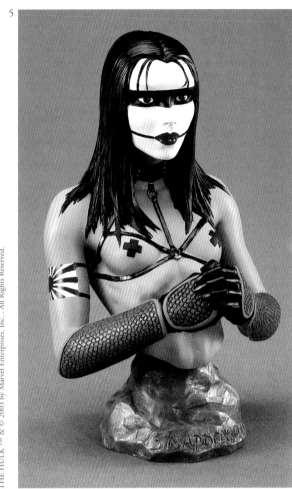

7

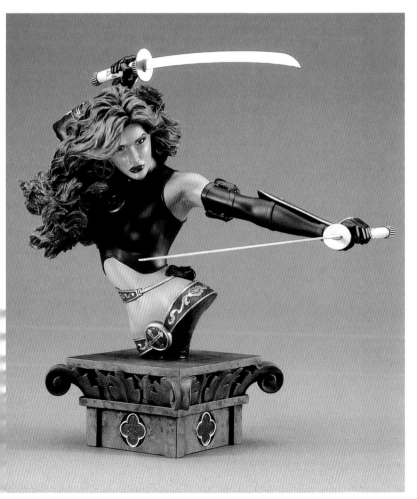

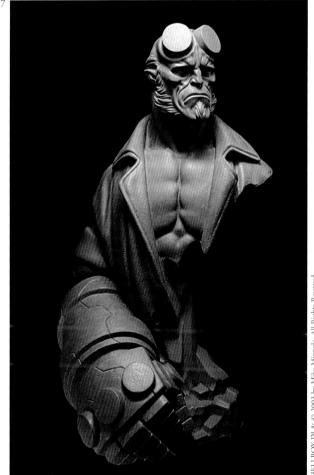

1
artist: **Lisa Snellings Clark**
title: Winter Guardians
medium: Papier-maché
size: 26" tall

2
artist: **Brett Klisch**
art director: Burt Sun
photographer: Andre Constantini
client: www.helendetroit.com
title: Helen the Destroyer
medium: Mixed
size: 16"Hx18"L

3
artist: **Zook**
title: The Moon Maid [after Frazetta]
medium: Oil-based clay
size: 18"Hx24"L

4
artist: **David Cheng Lu**
art director: Monte Moore
designer: Monte Moore
client: Tradox (Germany)
title: Sunsatiable
medium: Clay/cast resin
size: 8"

5
artist: **Andrew Burr**
client: Bonewerks
title: Venus
medium: Epoxy/metal/glass
size: 15"H

6
artist: **Spencer Davis**
client: Imij POP
title: Booty Babe Art—"Heavy Metal"
medium: Resin
size: 11¹/₂"H

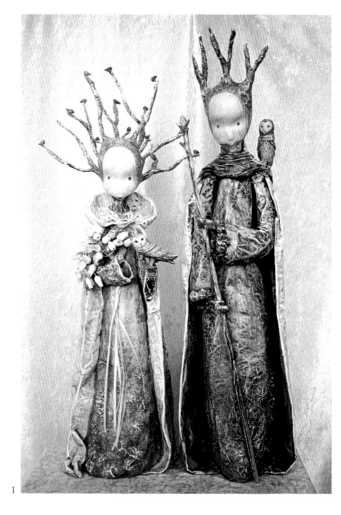

1

2

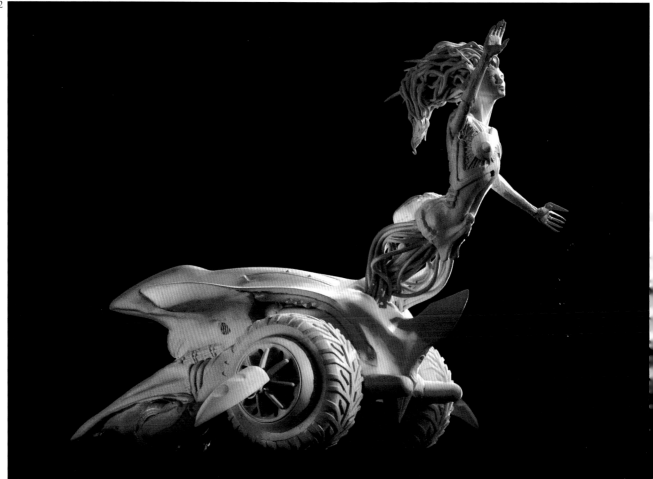

43

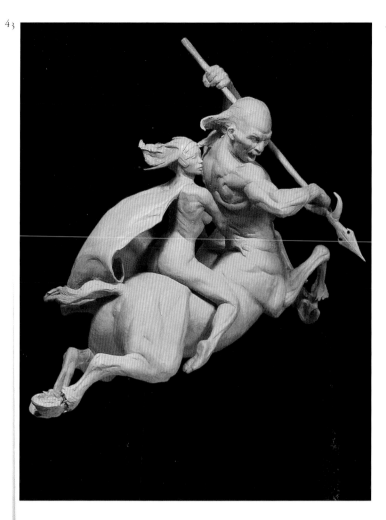

4

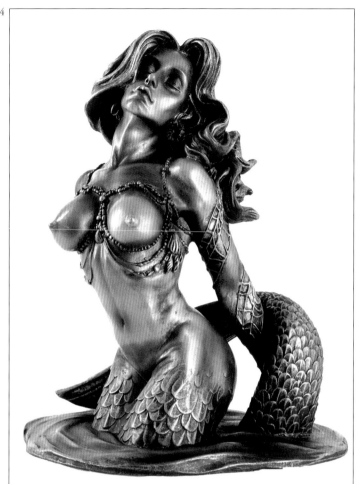

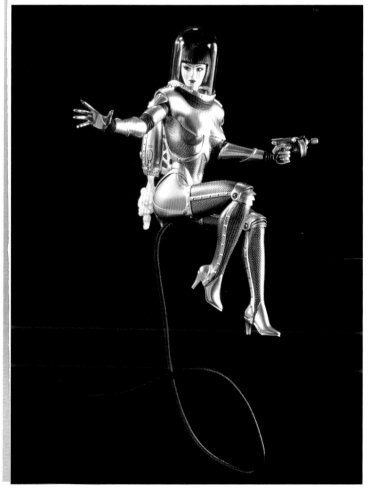

6

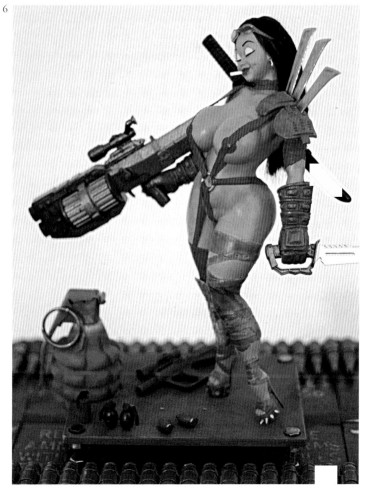

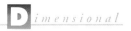

Dimensional

1
artist: **Karl Deen Sanders**
photographer: Tisha Lyons
painter: Rick Cantu
molding/casting: Mike Evans
graphic artist: David Fisher
client: Dragonfire Studios
title: Keeper of Time
medium: Cold cast resin
size: 14"H

2
artist: **Dave Pressler**
title: Robot Gangster Mouse
medium: Polyresin
size: 6¹/₂"Hx4"W

3
artist: **Bill Toma**
photographer: David Kern
title: Battle Cry
medium: Bronze
size: 32"Hx16"Dx14"W

4
artist: **Daniel Hawkins**
title: 99 Heads Installation Section A
medium: Mixed
size: Various

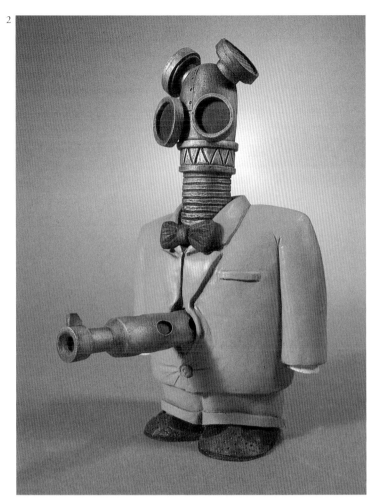

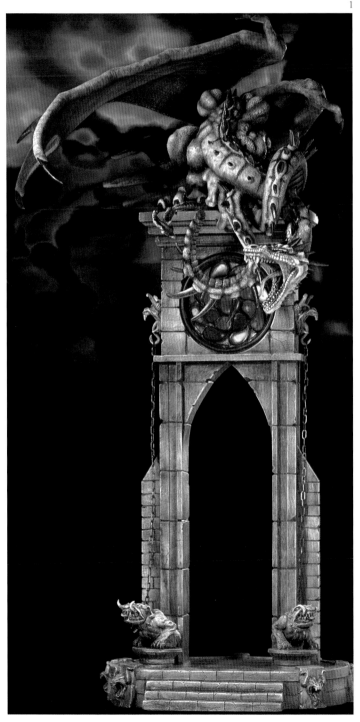

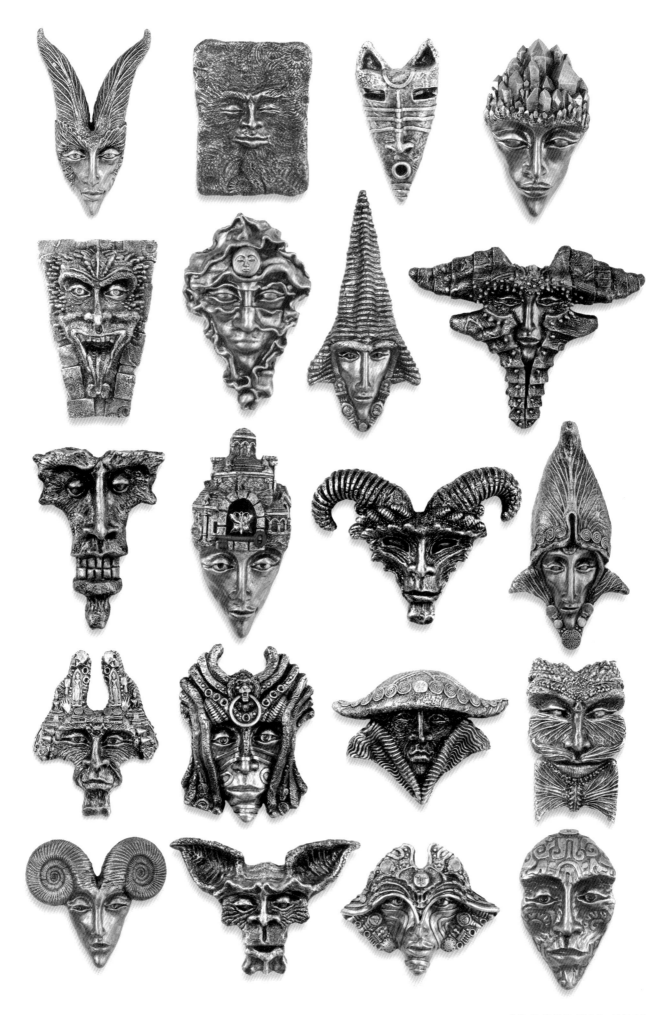

4

artist: **JAMES GURNEY**
art director: Mike Mrak client: Discover Magazine title: T. Rex Drinking medium: Oil size: 30"x14"

artist: **OMAR RAYYAN**

art director: Tony Jacobson client: Spider Magazine title: Turtle Race medium: Watercolor size: 11"x13"

Editorial

1
artist: **Anthony S. Waters**
art director: Kyle Hunter
client: Paizo Publishing
title: Bolette
medium: Digital
size: 16"x8"

2
artist: **Yoko Mill**
client: Gensou Bungaku
title: Getsi-Un-Kan
 (*The Moon Halo Palace*)
medium: Digital

3
artist: **Puddnhead**
art director: Kyle Hunter
client: Wizards of the Coast
title: Polyhedron Cover
medium: Digital
size: 12"x18"

4
artist: **Marc Sasso**
art director: Lisa Chido
client: Paizo Publishing
title: The Drow
medium: Mixed/digital

1

2

3

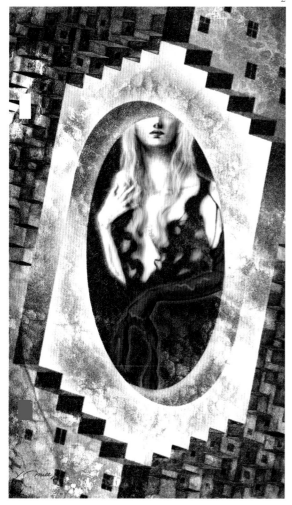

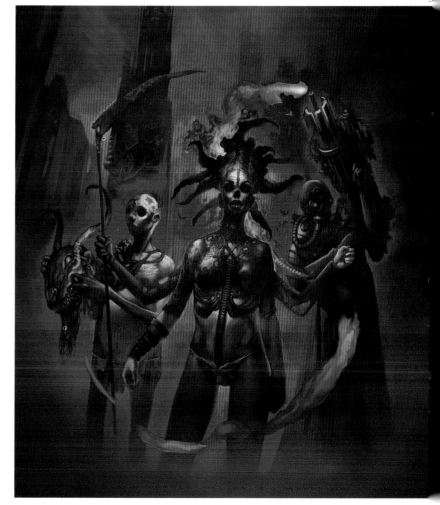

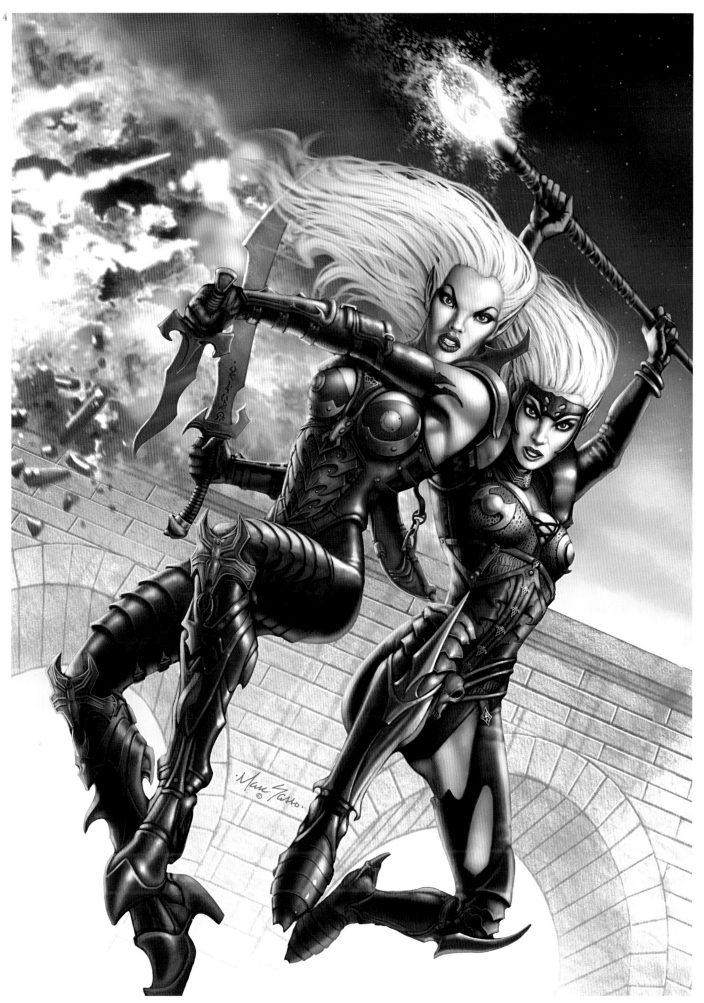

4

1
artist: **Anita Kunz**
art director: Andy Cowles
client: Rolling Stone
title: Alicia Keys
medium: Mixed
size: 8"x12"

2
artist: **Cheryl Griesbach/
Stanley Martucci**
art director: Nick Torello
client: Penthouse
title: The Martyr of Hollywood Hills
medium: Oil on gessoed masonite
size: 12"x16"

3
artist: **Lori Koefoed**
art director: Laura Cleveland
client: Realms of Fantasy
title: Fable From a Cage
medium: Oil/digital
size: 8¹/₂"x11"

4
artist: **Randy Pollak**
art director: Jamie Elsis
designer: Randy Pollak
client: BusinessWeek
title: Money Laundering
medium: Digital

5
artist: **John Picacio**
art director: Laura Cleveland
client: Realms of Fantasy
title: Vida
medium: Mixed/digital
size: 8¹/₄"x11¹/₄"

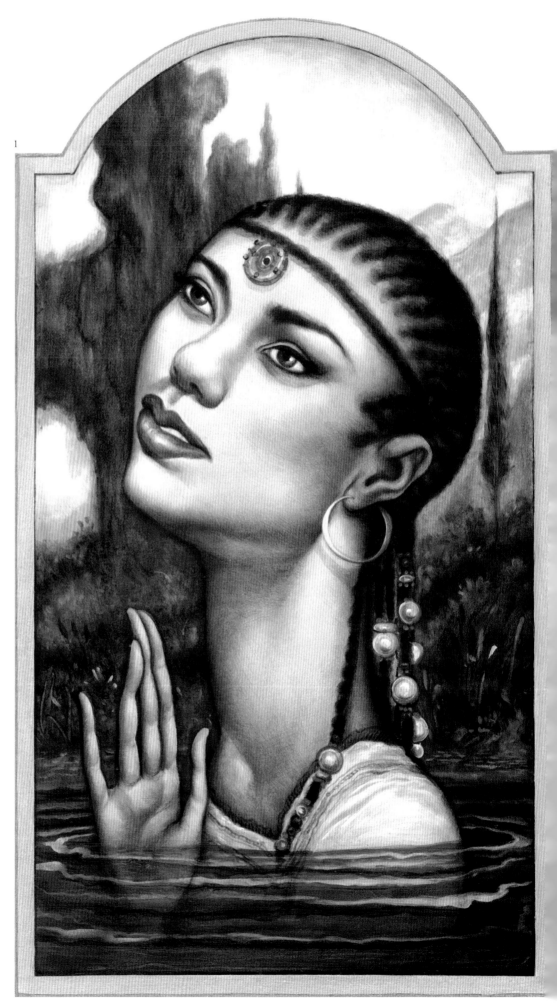

1

2

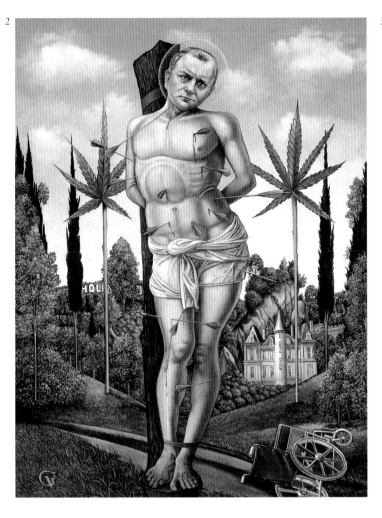

3

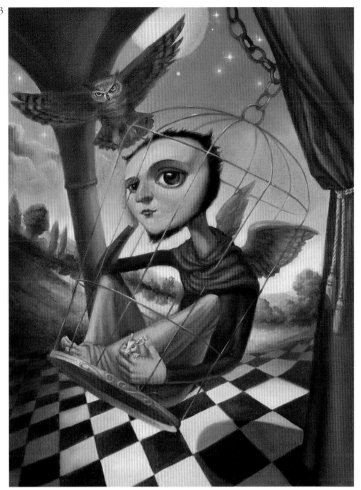

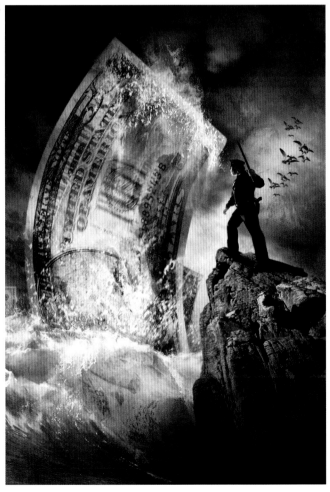

5

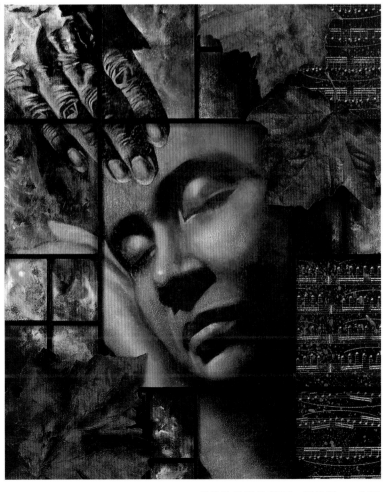

1
artist: **Rodney J. Brunet**
client: Giant Studios/Candice Alger
title: The Crib
medium: Mixed/digital

2
artist: **Greg Horn**
client: Wizard Magazine
title: Hulk Eye
medium: Digital
size: 16"x10"

3
artist: **Mark Zug**
art director: Peter Whitley
client: Dragon Magazine
title: Garden of Souls
medium: Oil
size: 20"x8"

4
artist: **Jum-ichi Fujikawa**
client: IDG Japan
title: 666
medium: Digital
size: 9"x13"

5
artist: **Scott Easley**
client: Heavy Metal
title: Prom
medium: Digital
size: 8¹/₂"x12³/₄"

6
artist: **Greg Horn**
client: PSM2 Magazine
title: Tomb Raider Bikini
medium: Digital
size: 16"x10"

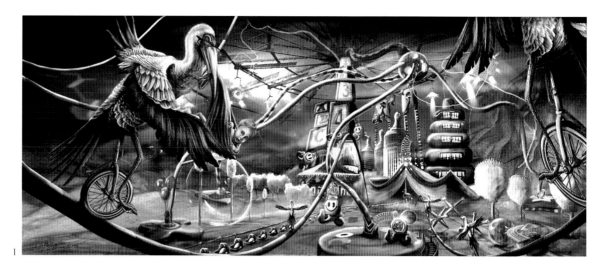

1

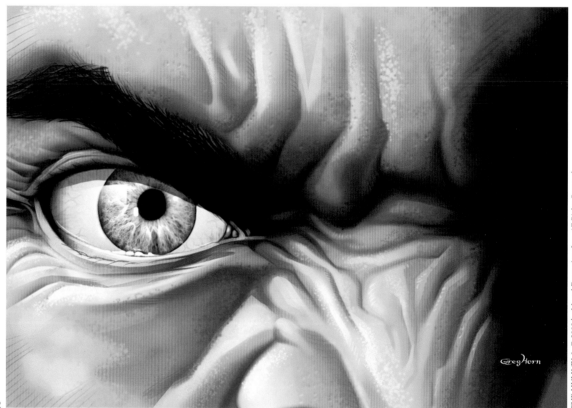

2

3

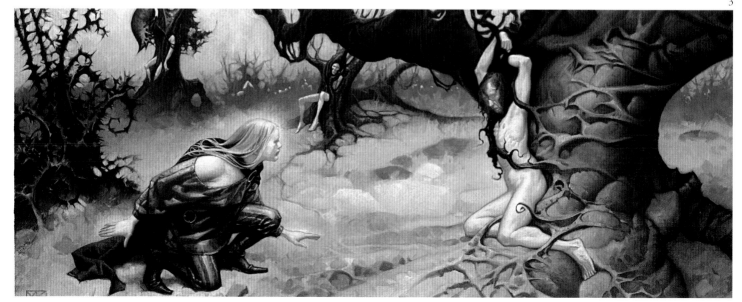

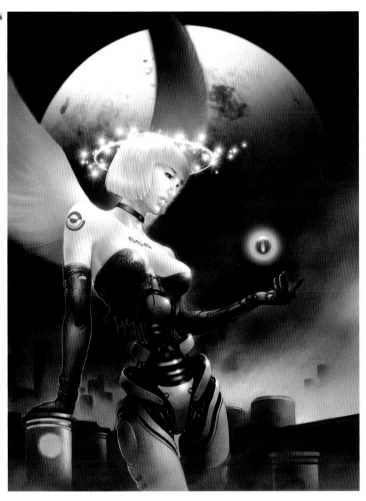

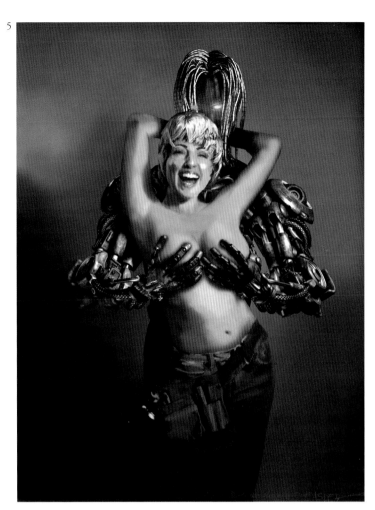

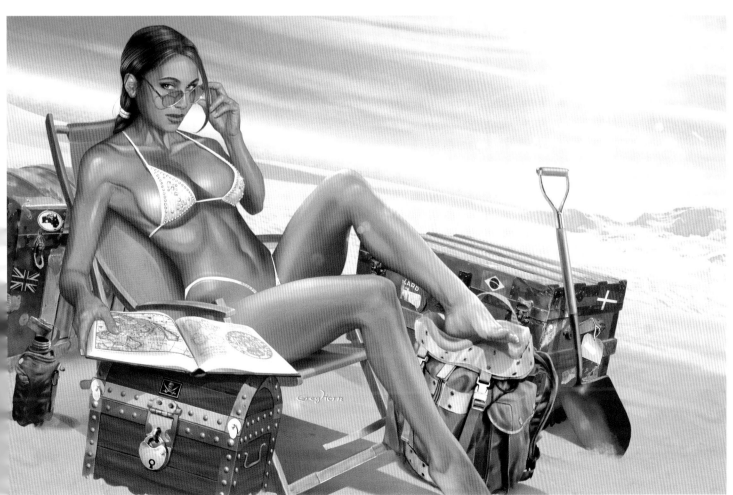

1
artist: **Scott E. Anderson**
art director: Christine Morrison
client: Stocks & Commodities Magazine
title: Cruel Bear Market
medium: Mixed
size: 7"x10"

2
artist: **Bruce Jensen**
art director: Bruce Jensen
client: 60 Minutes II
title: The 6th Sense
medium: Digital
size: 9"x6"

3
artist: **Omar Rayyan**
art director: Suzanne Beck
client: Ladybug Magazine
title: The More, The Merrier
medium: Watercolor
size: 8¹/₂"x10¹/₂"

4
artist: **Omar Rayyan**
art director: Suzanne Beck
client: Ladybug Magazine
title: The More, The Merrier [cover]
medium: Watercolor
size: 11"x14"

artist: **Justin Sweet**
art director: Lisa Chido
client: Dragon Magazine
title: Crows Eye
medium: Oil/digital

1

2

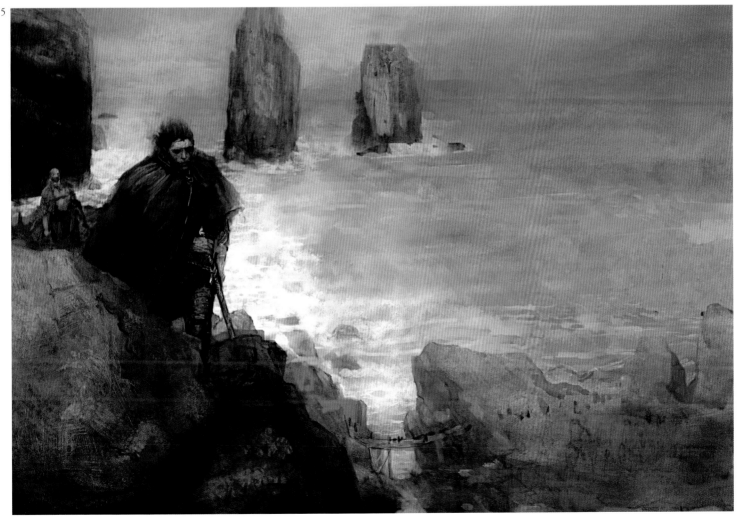

1
artist: **Greg Spalenka**
art director: Chiara Caballero
client: Ornithopter
title: Queen
medium: Mixed
size: 10"x13"

2
artist: **David Bowers**
art director: Marti Golin
client: Time
title: Factory Head
medium: Oil
size: 7"x14"

3
artist: **David Bowers**
art director: Dwayne Cogdill
client: Christian Research Journal
title: Demon Face
medium: Oil
size: 8"x10"

4
artist: **Stephen Hickman**
client: Weird Tales
title: Norhala of the Lightnings
medium: Oil
size: 30"x40"

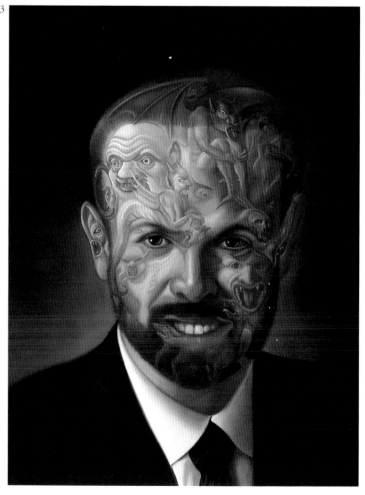

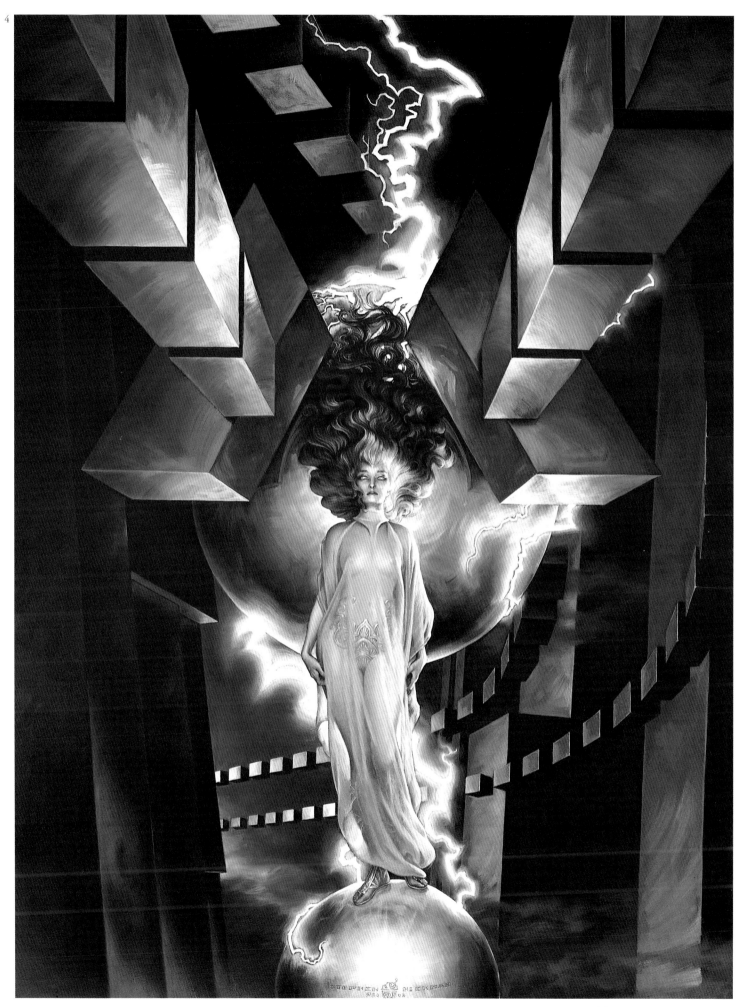

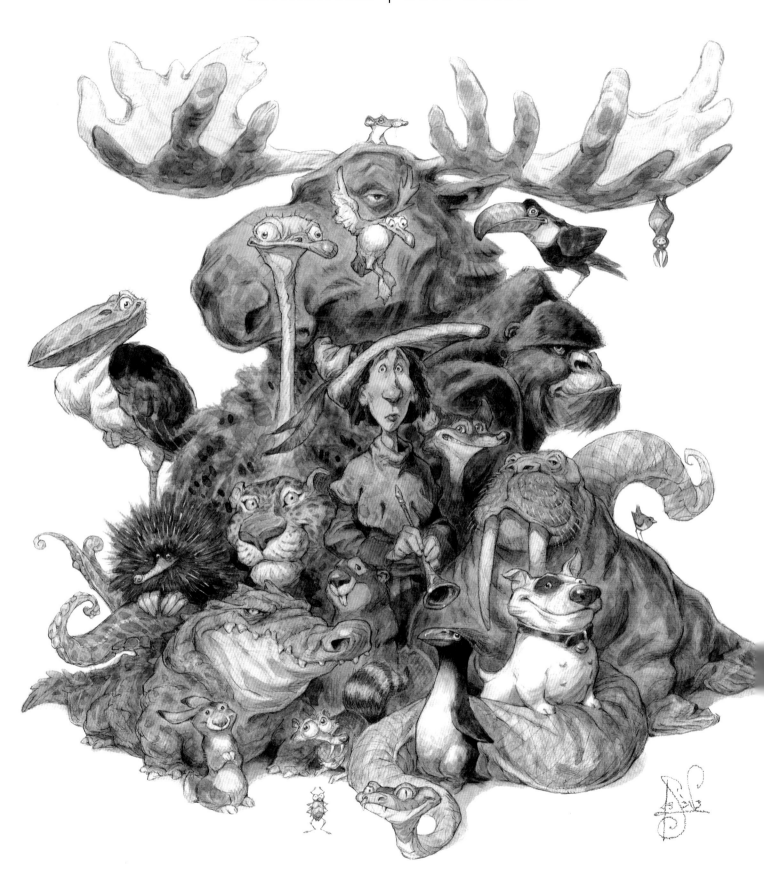

artist: **PETER de SÈVE**

art director: Chris Curry client: Society of Illustrators title: Call For Entries medium: Watercolor and ink size: 12"x16"

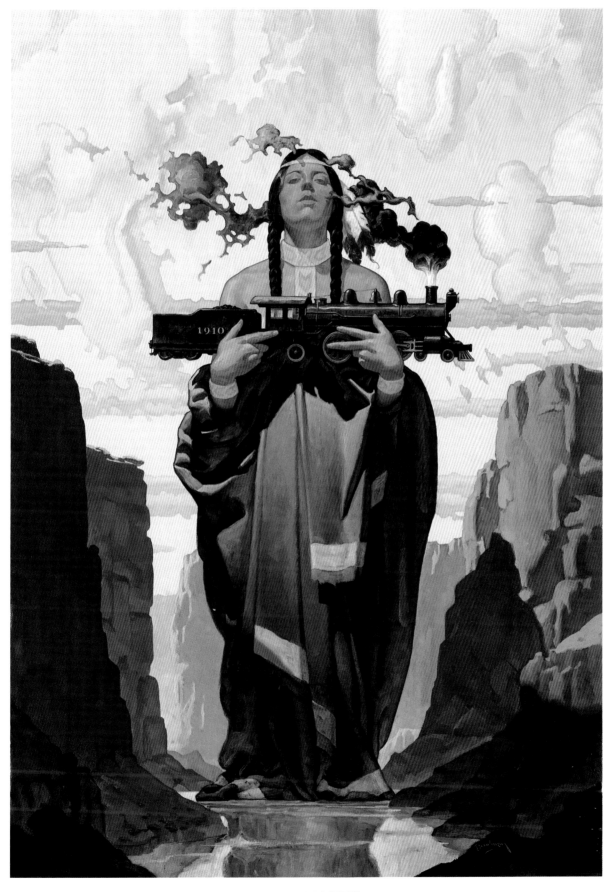

artist: **ERIC BOWMAN**
title: Iron Maiden *medium:* Oil *size:* 13"x18"

1
artist: **Tony DiTerlizzi**
client: DiTerlizzi Gals Portfolio
title: Succubus
medium: Gouache
size: 18"x24"

2
artist: **Paul Bonner**
client: Rackham
title: Orks
medium: Watercolor
size: 11¹/₂"x15¹/₄"

3
artist: **Paul Bonner**
client: Rackham
title: Tigre de Dirz
medium: Watercolor
size: 11"x15¹/₂"

4
artist: **Paul Bonner**
client: Rackham
title: Minotaur D'Avagddu
medium: Watercolor
size: 12"x16¹/₂"

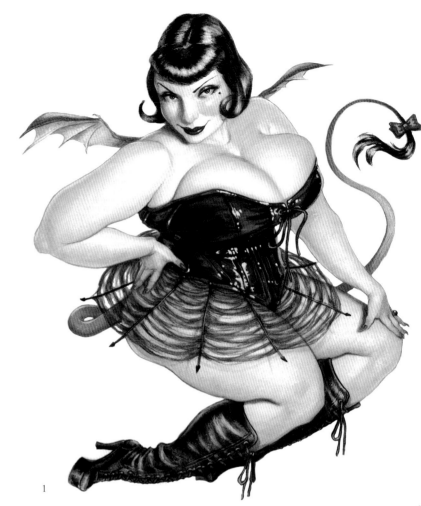

1

2

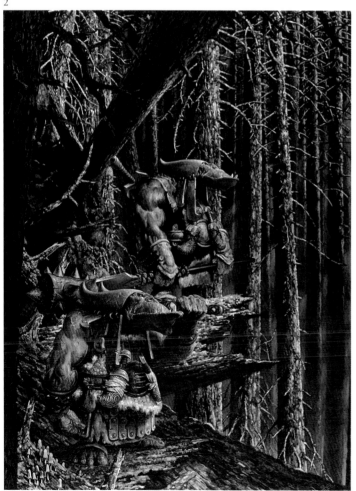

3

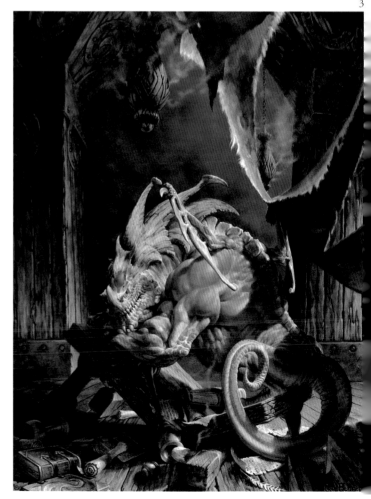

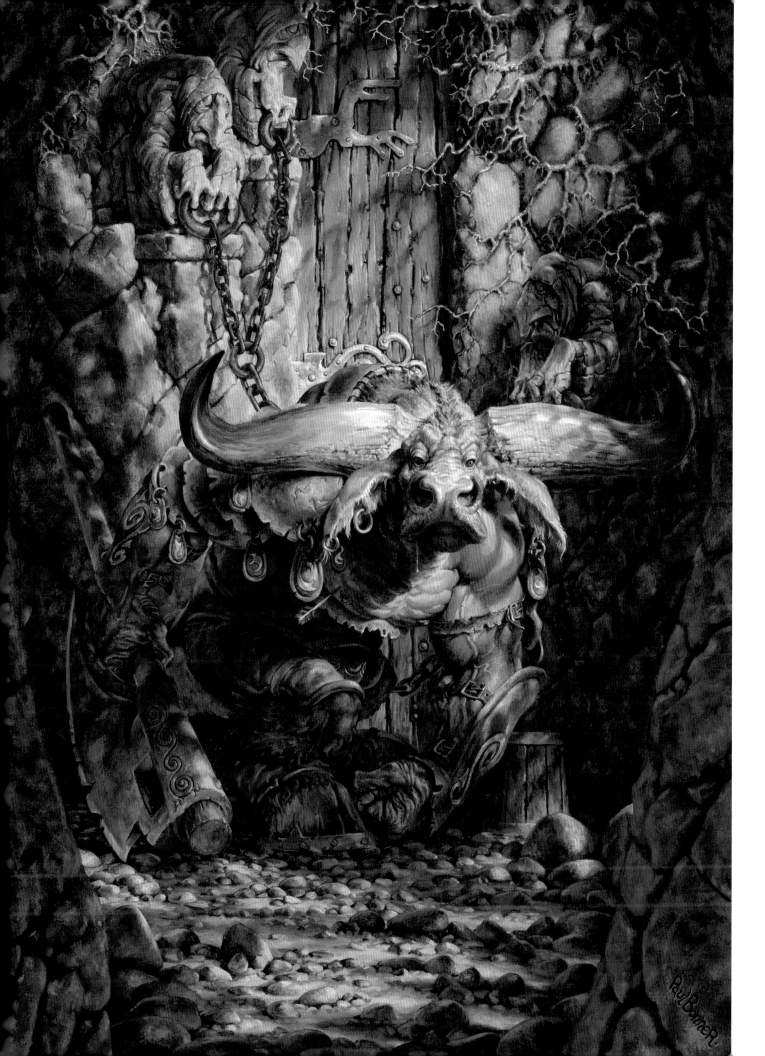

1
artist: **Gary A. Lippincott**
client: G.L. Limited Editions
title: Elfin Aja
medium: Watercolor
size: 11"x14¹/₂"

2
artist: **Mark A. Nelson**
client: Grazing Dinosaur Press
title: Veraskull
medium: Ink
size: 10"x15"

3
artist: **Mark A. Nelson**
client: Grazing Dinosaur Press
title: Broken Angel
medium: Colored pencil
size: 10"x13"

4
artist: **Greg Spalenka**
art director: Allen Spiegel
client: Allen Spiegel Fine Arts
title: Spirit of the Season
medium: Mixed/digital
size: 5"x8"

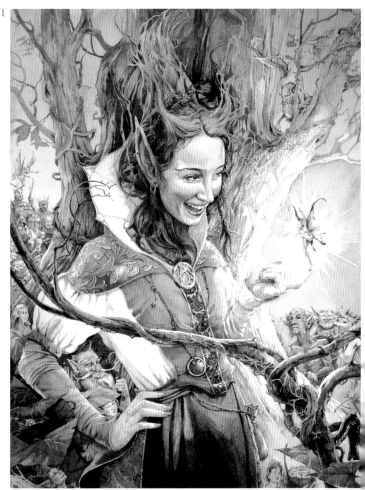

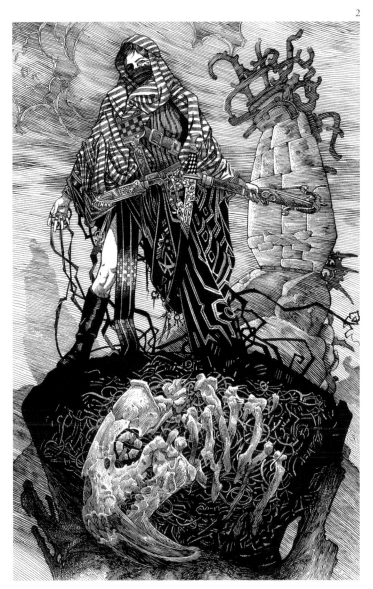

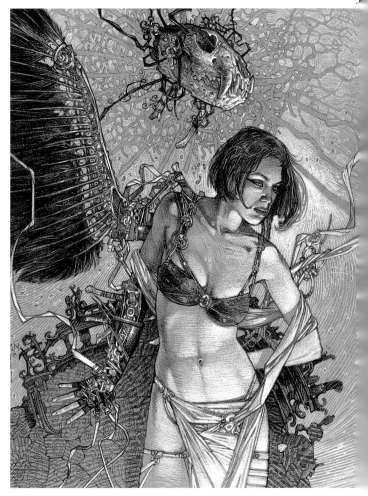

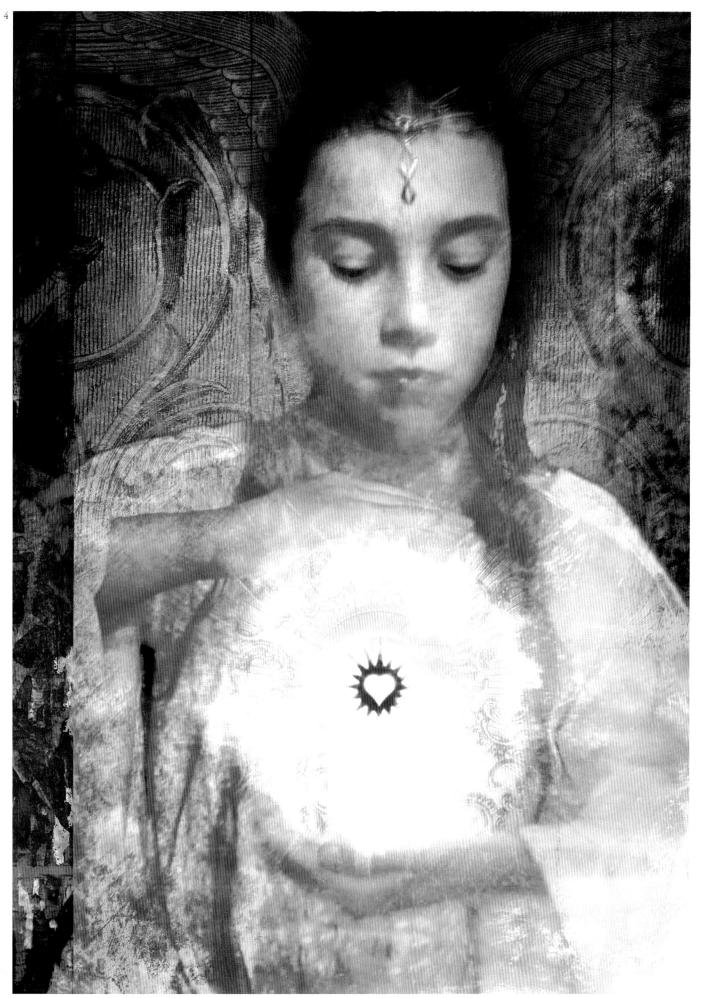

1
artist: **Gregory Manchess**
art director: Jim Burke
client: Dellas Graphics
title: Frogoyle
medium: Oil
size: 17"x21"

2
artist: **Dave DeVries**
title: Skinny Skull
medium: Mixed
size: 4"x16¹/₄"

3
artist: **Wes Benscoter**
client: Zoku Shobo, Japan
title: Weirdscape
medium: Acrylic on paper
size: 24"x18"

4
artist: **Larry MacDougall**
art director: Patricia Lewis
client: Underhill Studio
title: The Soloist
medium: Gouache
size: 12"x9"

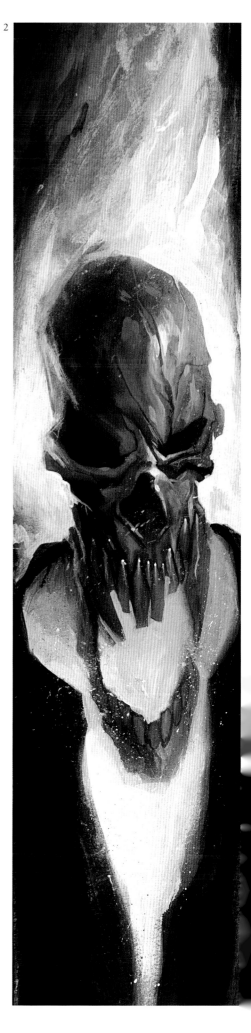

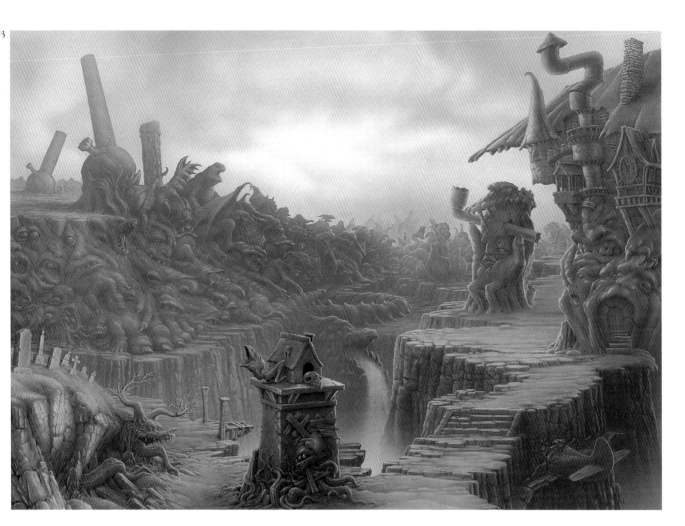

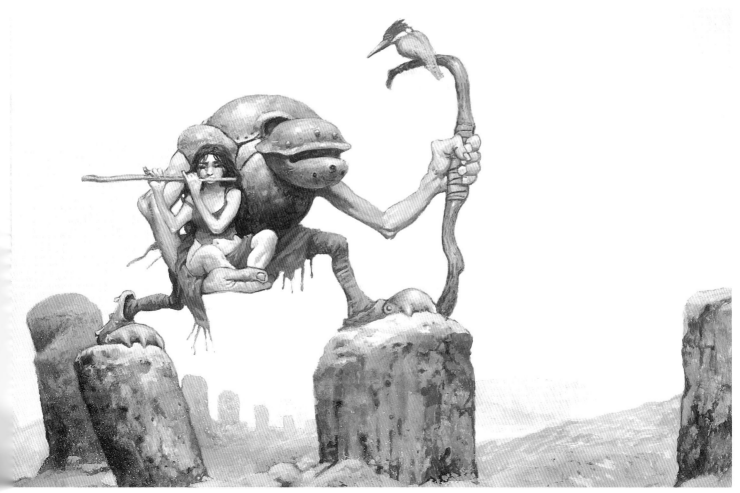

1 & 2
artist: **Peter de Sève**
art director: Ron Clements and John Musker
client: Walt Disney Studios
title: Treasure Planet Character Study
medium: Pencil
size: 14"x17"

3
artist: **Peter de Sève**
art director: Joanna Dean
client: St. Ann's School
title: Pan
medium: Watercolor and ink
size: 11"x14"

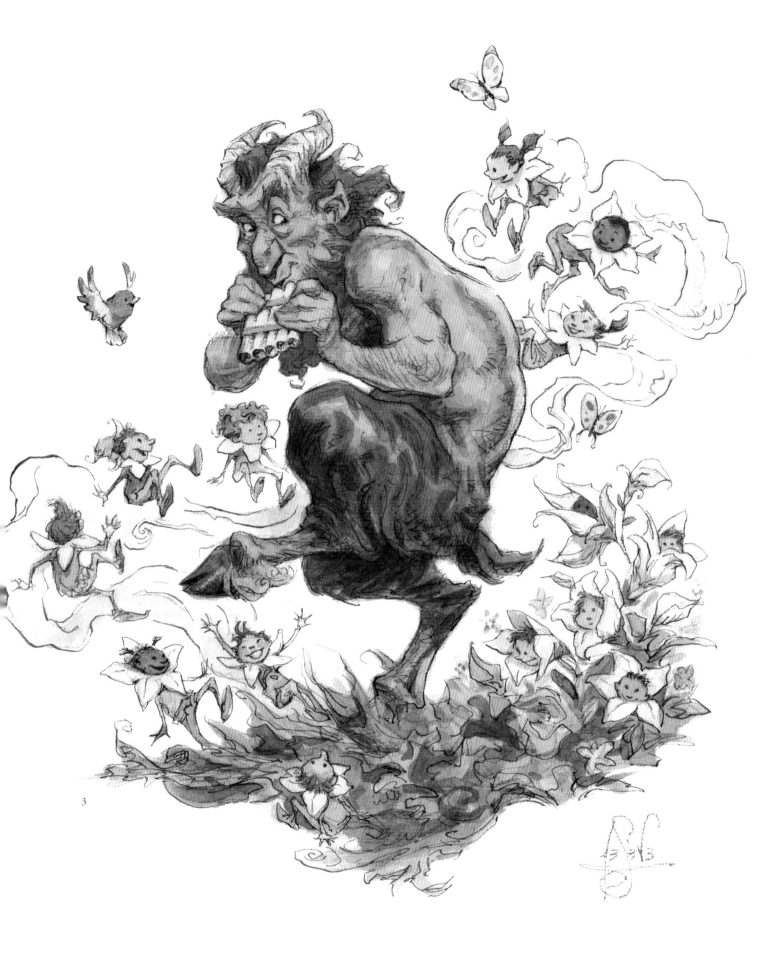

3

1
artist: **Rafal Olbinski**
designer: Leah Majeriski
client: Herbapol
title: Primavera
medium: Acrylic
size: 20"x30"

2
artist: **Richard Laurent**
art director: Cheryl Jefferson
designer: Richard Laurent
client: Laurent Design
title: The Muse
medium: Oil
size: 14"x18"

3
artist: **Daniel R. Horne**
art director: Rachael Robbins
client: Blondezilla, Inc.
title: Blondezilla
medium: Oil
size: 24"x36"

4
artist: **Tony DiTerlizzi**
client: Diterlizzi Gals Portfolio
title: Medusa
medium: Gouache
size: 18"x24"

5
artist: **Ed Org**
client: Ed Org Fine Prints
title: The Lilly Maid of Astolat
medium: Pencil
size: 10"x14"

6
artist: **Daren Bader**
client: Viscurreal Entertainment
title: Hookah
medium: Oil
size: 18"x24"

1
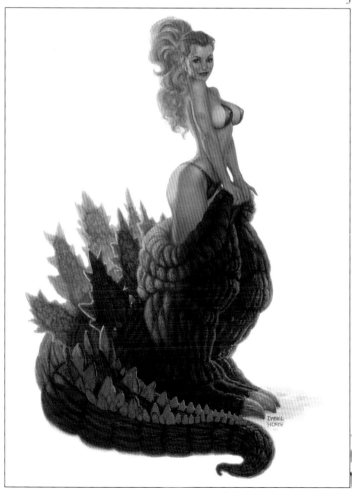

2
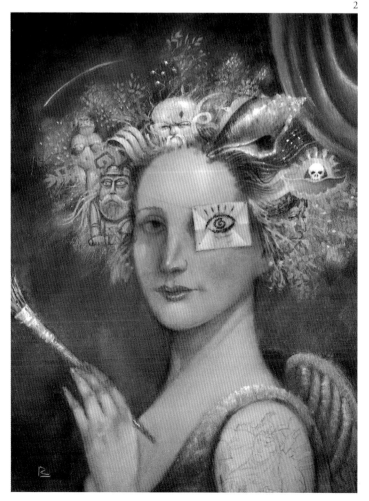

3
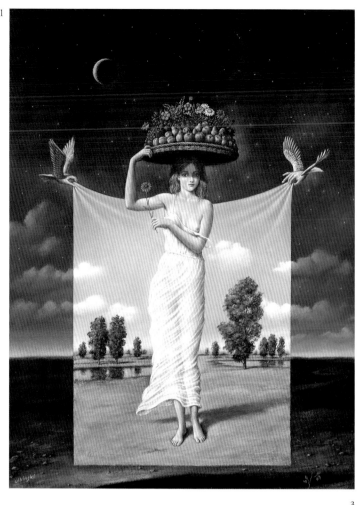

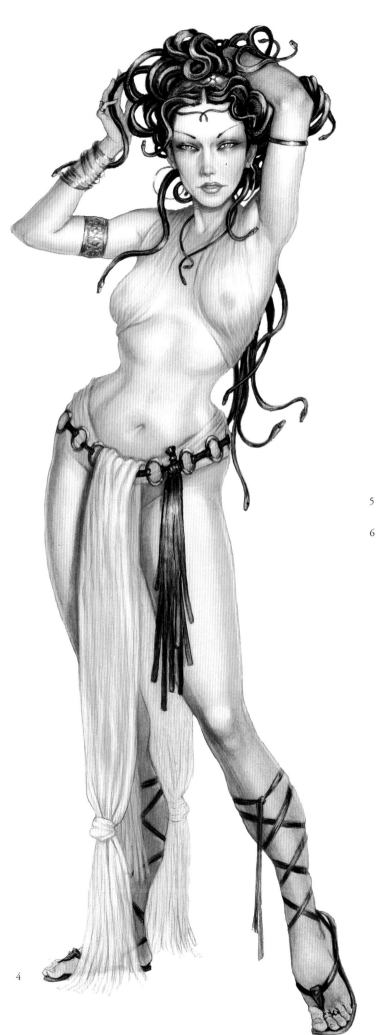

4

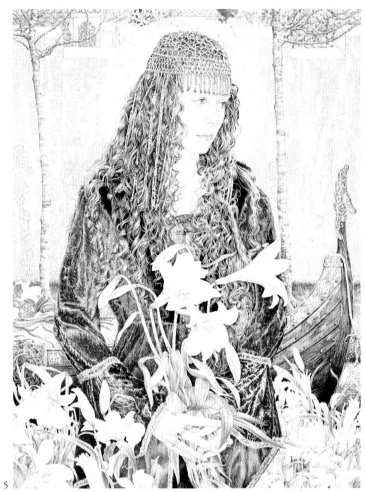

5

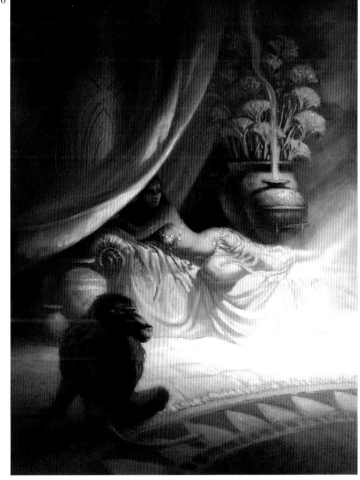

6

1
artist: **Scott M Fischer**
art director: Dana Knudsen
client: Wizards of the Coast
title: Blue Morph
medium: Oil on paper

2
artist: **Brian Despain**
title: Blendboy 2000
medium: Digital
size: 6"x8"

3
artist: **Jon Foster**
title: Self Portrait #5
medium: Gouache
size: 8"x10"

4
artist: **Jon Foster**
title: Catbot
medium: Oil/digital
size: 30"x40"

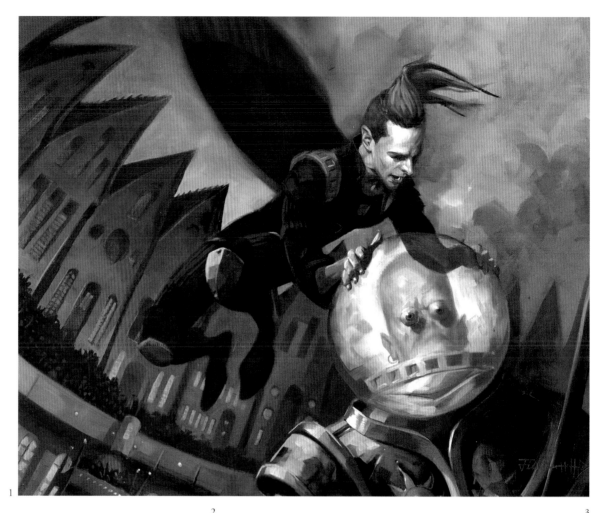

1

2

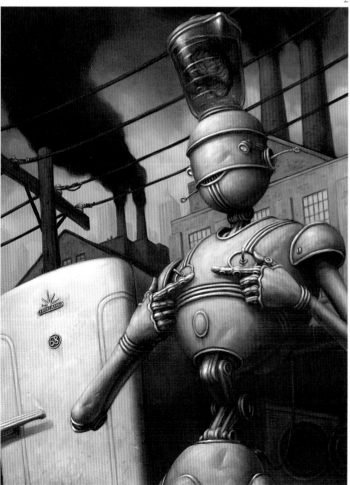

3

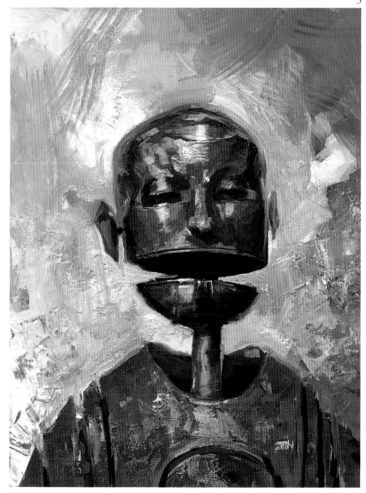

4

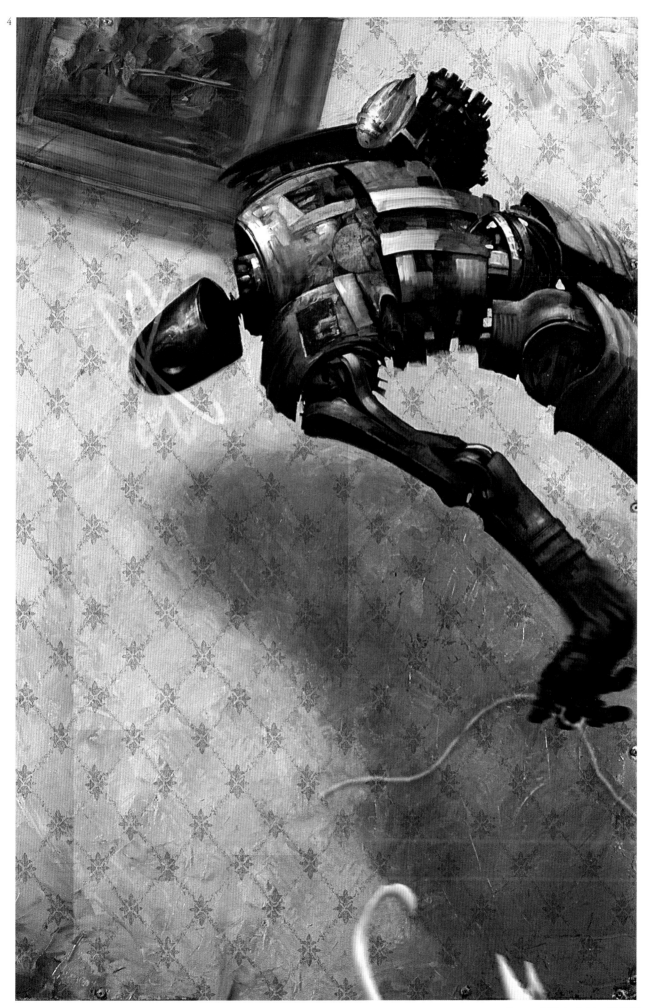

1
artist: **Young Chun**
title: The Search
medium: Oil
size: 22"x22"

2
artist: **Ezra Tucker**
title: A Child Will Lead Them
medium: Acrylic
size: 30"x20"

3
artist: **Jason Felix**
client: www.jasonfelix.com
title: Halo
medium: Mixed
size: 8 1/2"x11"

4
artist: **Matt Dicke**
title: Divorce
medium: Mixed
size: 18"x24"

5
artist: **Mike Weaver**
client: Idée Fixe
title: Danger Bob
medium: Oil
size: 24"x36"

6
artist: **Stu Suchit**
art director: Heidi Younger
designer: Stu Suchit
client: Vision Theater
title: A Christmas Carol
medium: Mixed
size: 9"x12"

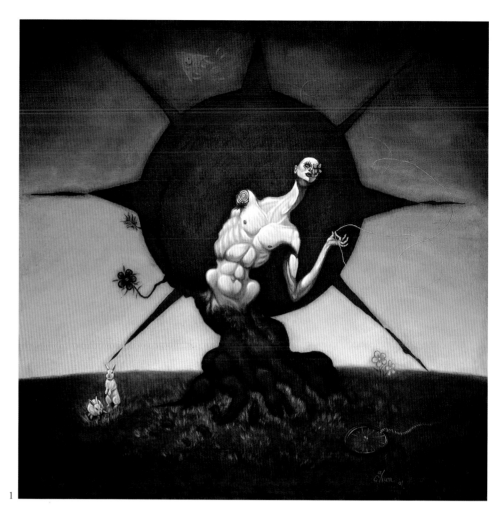

1

2

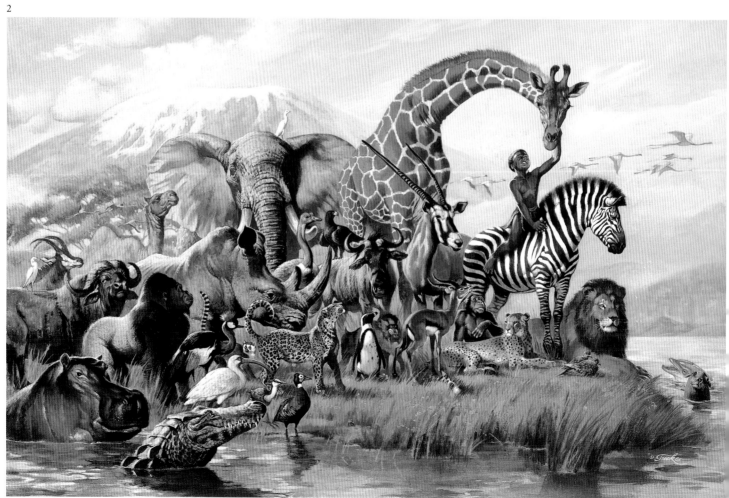

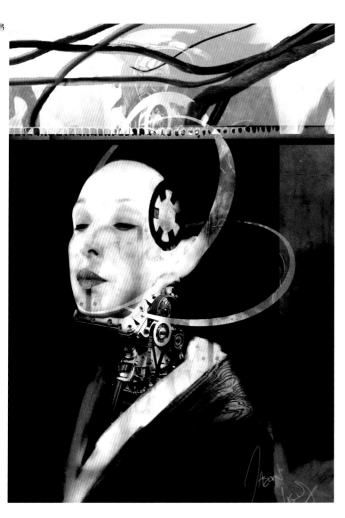

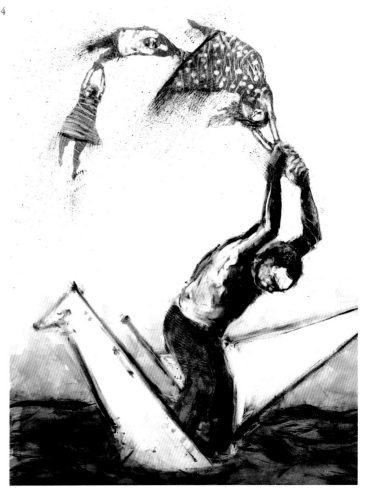

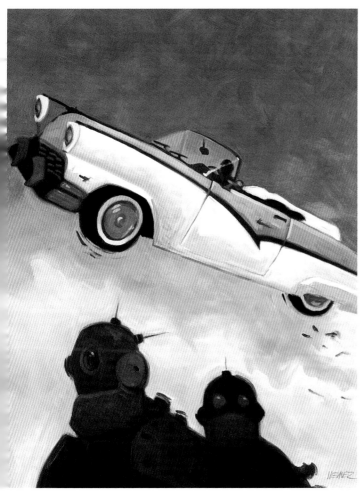

1
artist: **Meats Meier**
client: sketchovision.com
title: Etcher
medium: Digital

2
artist: **Darrel Anderson**
client: GroBoto
title: The Vortex Reed
medium: Digital
size: 3"x6¹/₂"

3
artist: **Larry Price**
client: larrypriceart.com
title: Future 1
medium: Digital
size: 8¹/₂"x11"

4
artist: **Meats Meier**
client: sketchovision.com
title: Devil
medium: Digital

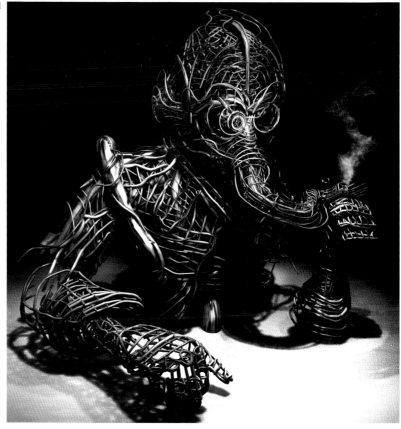

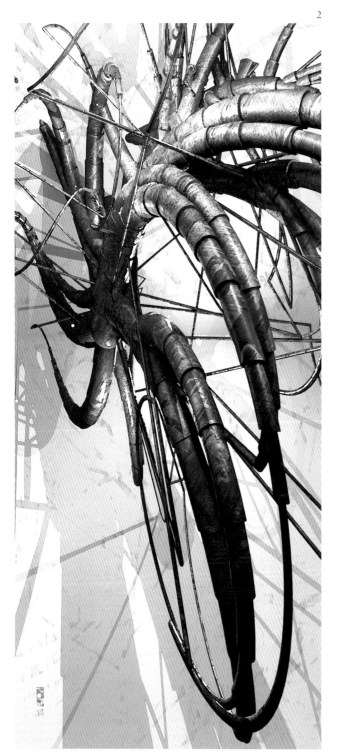

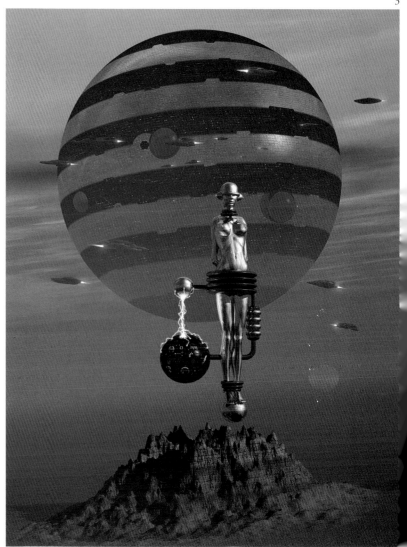

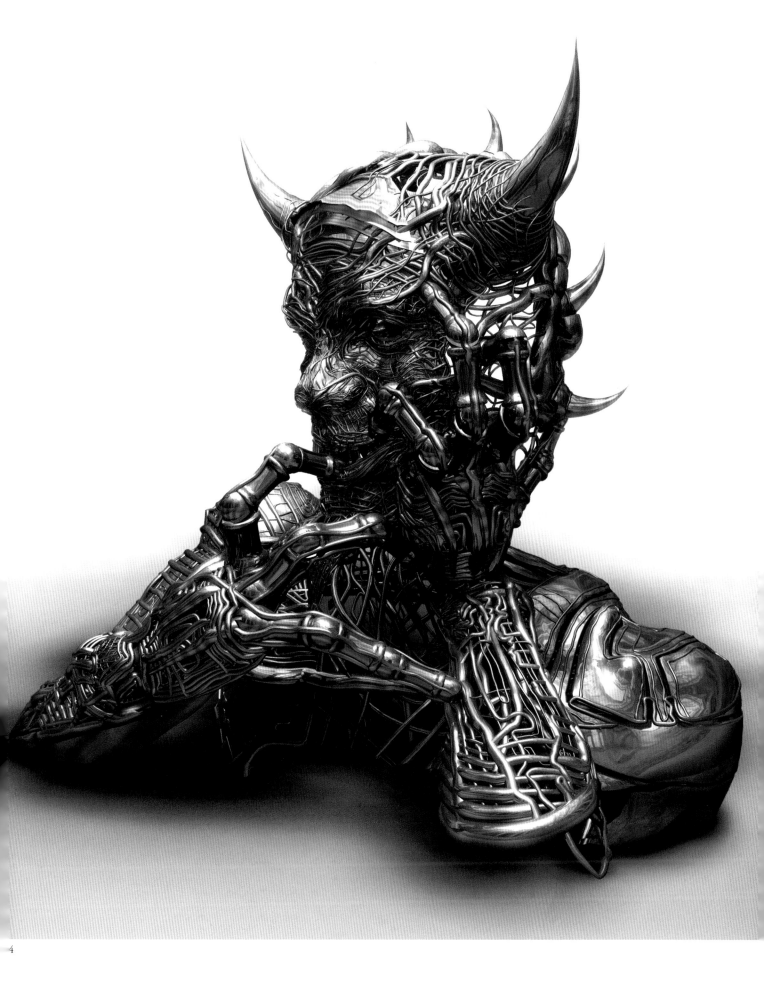

1
artist: **Douglas Klauba**
art director: Hans Lushina
designer: Pagliuco Design Company
client: Chicago Fantastic Film Festival
title: Stella-7
medium: Acrylic
size: 16"x24"

2
artist: **rk post**
art director: Dana Knutson
client: Wizards of the Coast
title: Jeska, Warrior Adept
medium: Oil
size: 24"x20"

3
artist: **Drew Posada**
client: Brian Haberlin/The Wicked
title: Dawn
medium: Mixed/digital
size: 15 1/2"x30"

4
artist: **Ratal Olbinski**
designer: MM Studio
client: Patinae, Inc.
title: Primavera 2000
medium: Acrylic
size: 30"x40"

5
artist: **Anita Kunz**
title: March
medium: Mixed
size: 10"x5"

1

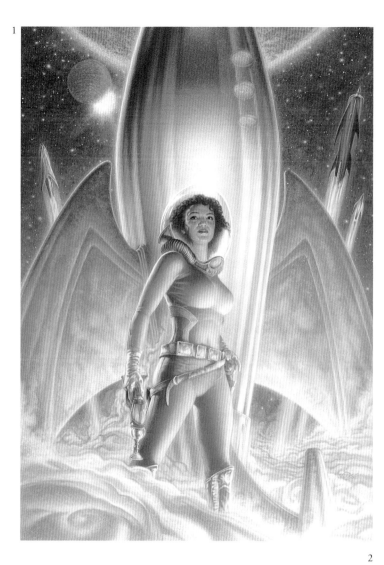

2

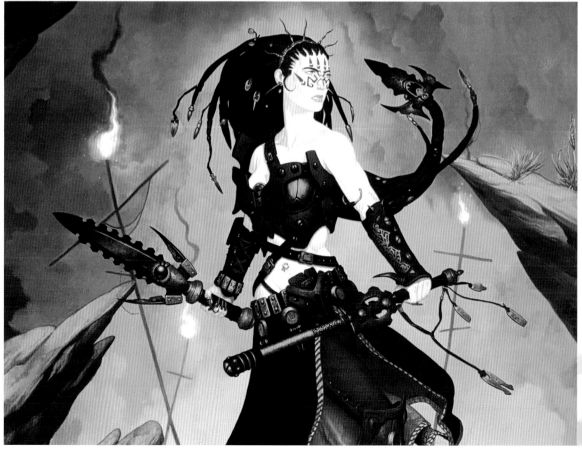

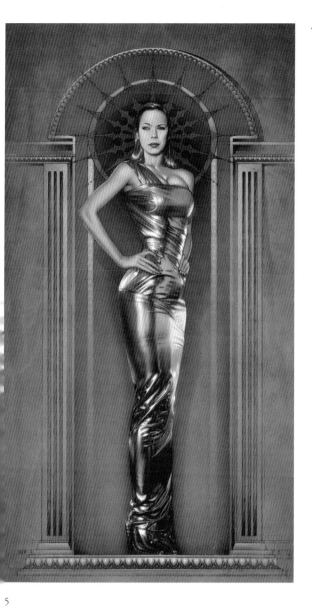

4

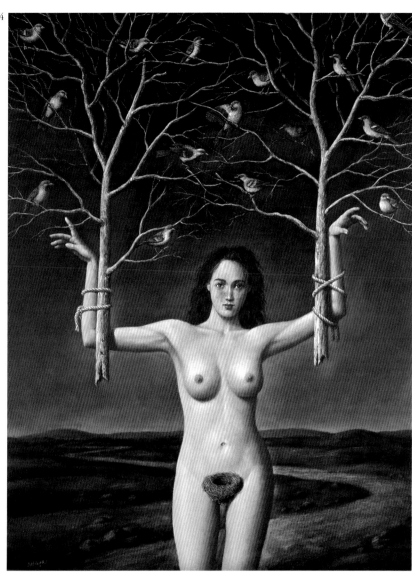

5

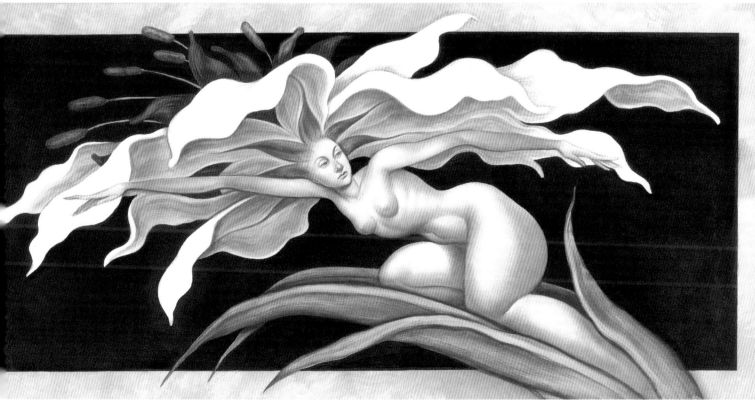

1
artist: **Brom**
art director: Brom
client: Tidemark
title: Soulforge
medium: Oil

2
artist: **Raymond Swanland**
art director: Raymond Swanland
client: Oddworld Inhabitants
title: The Hunt
medium: Digital

3
artist: **Silvio Aebischer**
art director: Silvio Aebischer
client: Oddworld Inhabitants
title: GlockStat and Slig Valet
medium: Digital

4
artist: **Cam de Leon**
client: happypencil.com
title: Dream.01
medium: Mixed

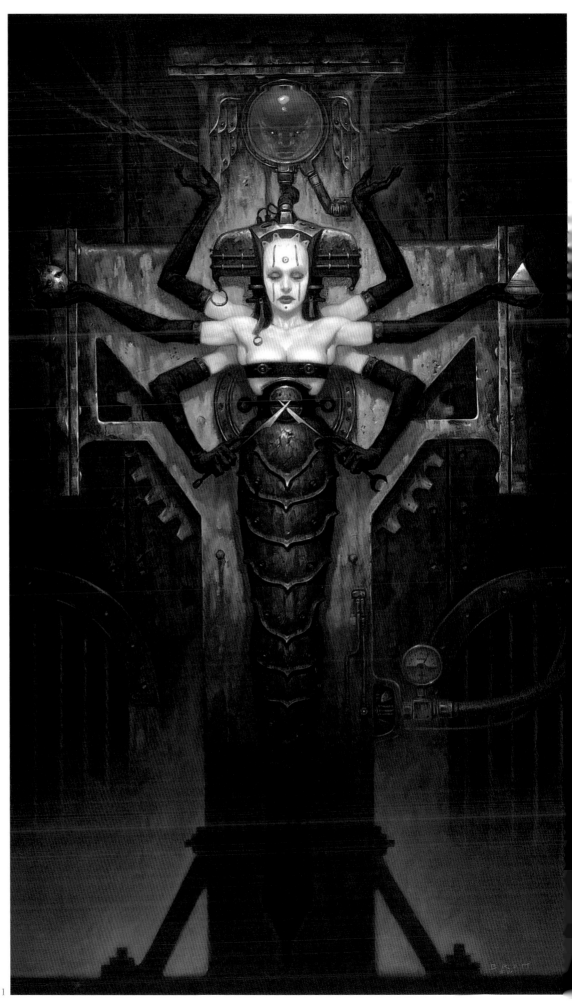

1

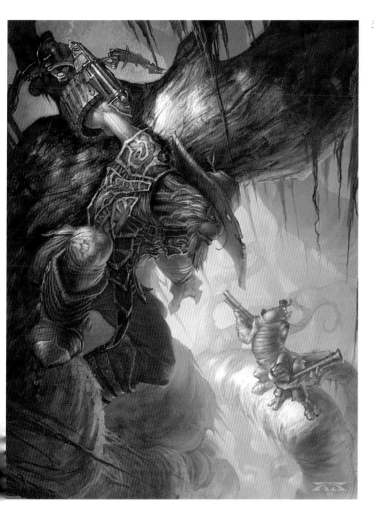

3

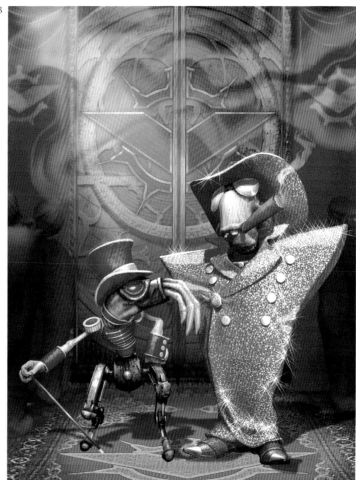

4

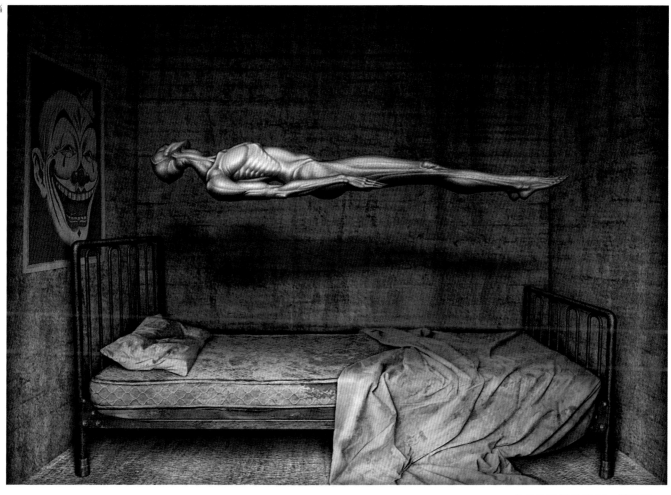

1
artist: **Scott Everett Burton**
client: Scott Burton's Universe: Ltd Ed Prints
title: Batya's Journey with Aviram the Sentinel
medium: Acrylic/pencil
size: 20"x20"

2
artist: **Lee Ballard**
art director: Lee Ballard
designer: Doug Cunningham
client: Figment
title: Morgan
medium: Oil
size: 52"x20"

3
artist: **Daniel R. Horne**
art director: Daniel R. Horne
client: Arcadia Press
title: A Gilded Cage
medium: Oil
size: 24"x36"

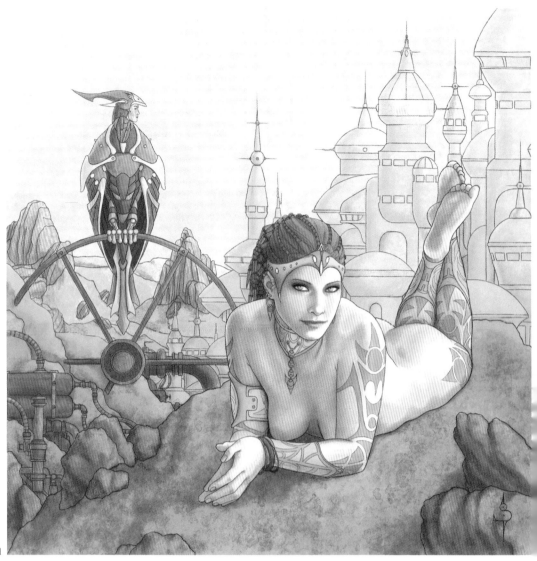

1

2

3

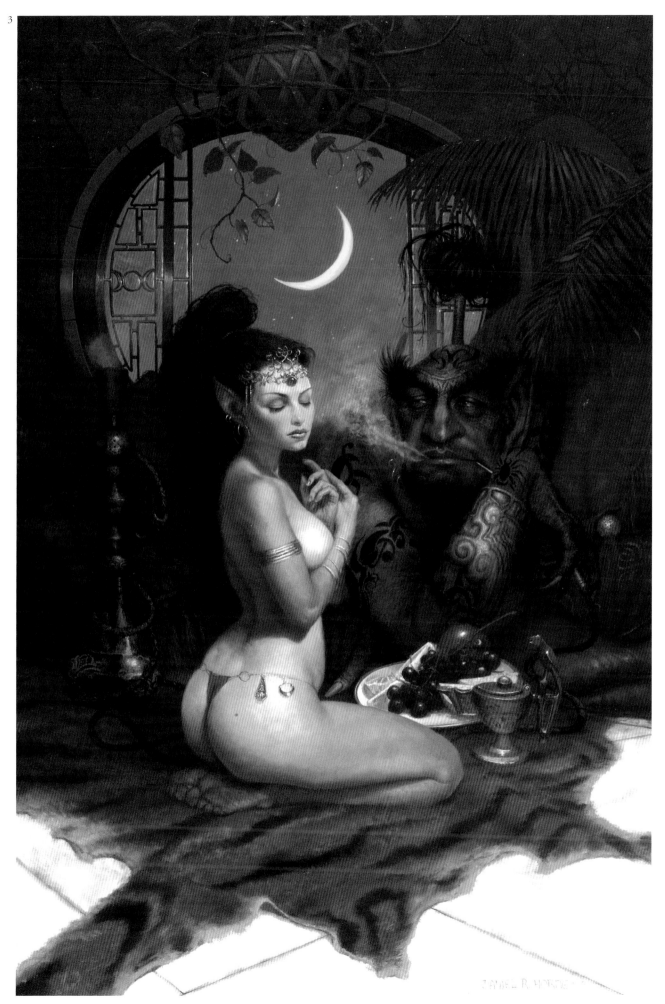

1
artist: **Michael Kerr**
art director: Michael Kerr
title: Progress
medium: Oil on canvas
size: 38"x32"

2
artist: **Jon Sullivan**
art director: Lucie Stericker
client: Victor Gollancz Ltd.
title: Terry Pratchett's Discworld Calendar
medium: Oil
size: 16"x13"

3
artist: **Jerry Lofaro**
art director: Duy Nguyen
client: Hallmark Entertainment
title: Dinotopia Style Guide: T-Rex 1
medium: Digital
size: 8"x10"

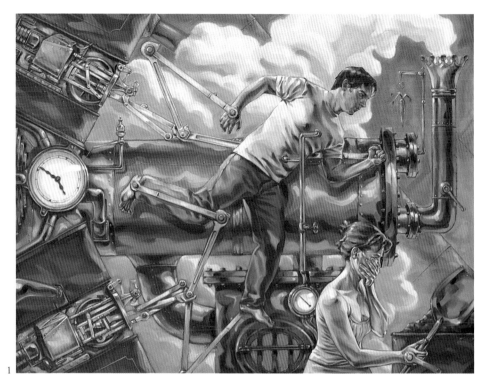

1

2

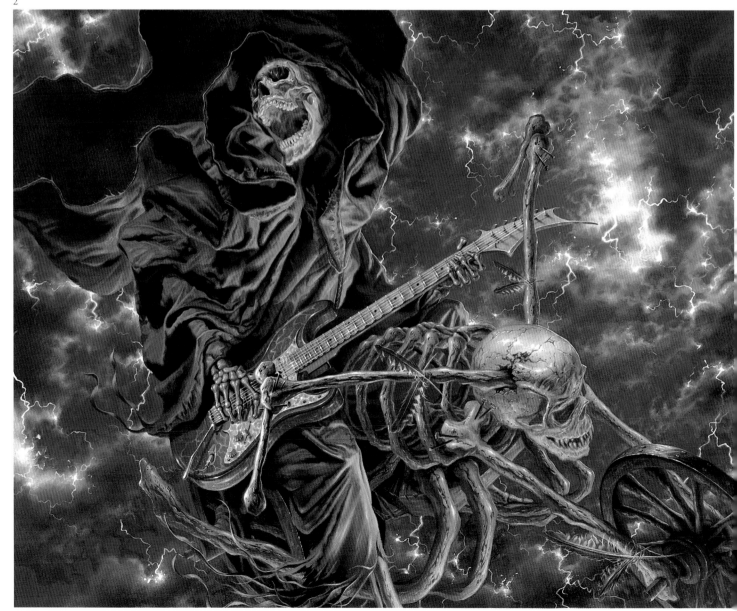

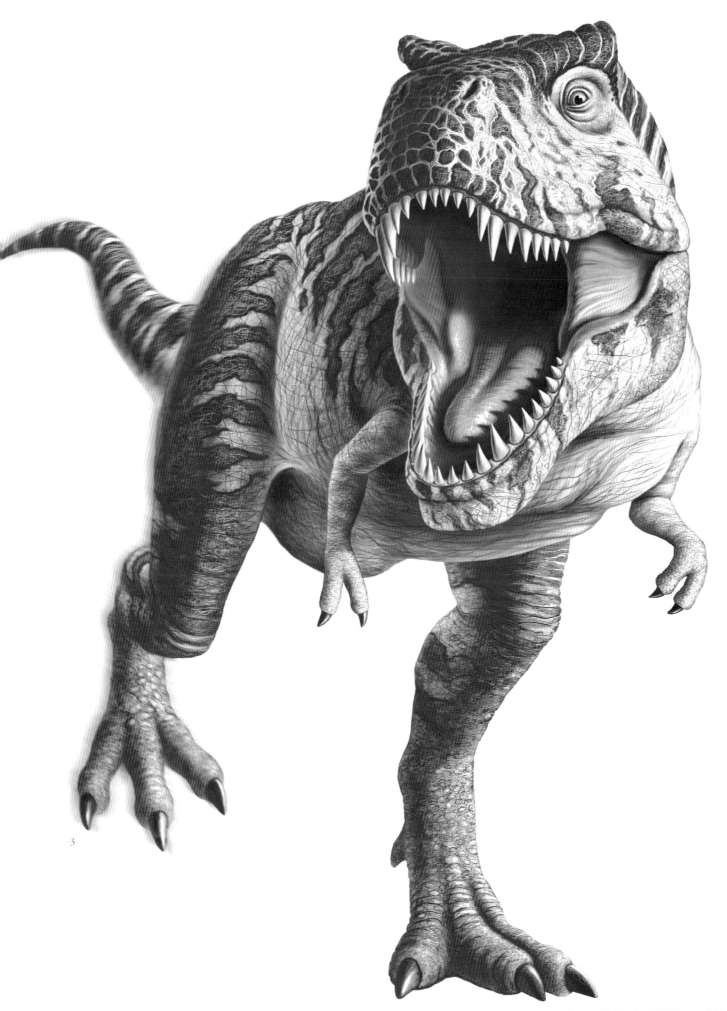

3

1
artist: **Sally Wern Comport**
art director: Matt Marsh
client: National Labor Federation
title: Deferred Income=No Income
medium: Mixed
size: 20"x11"

2
artist: **Kirk Reinert**
art director: Kirk Reinert
title: Feathered Friends
medium: Acrylic
size: 48"x36"

3
artist: **Daniel Dos Santos**
client: Greenwich Workshop Gallery
title: Shiva's Crown
medium: Oil
size: 36"x24"

4
artist: **Simon Thorpe**
client: The Sci Fi Picture Co.
title: Flight of the Fenri
medium: Digital
size: 81.5cmx50cm

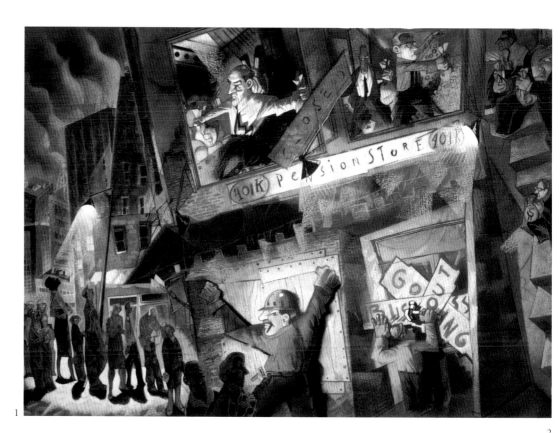

1

2

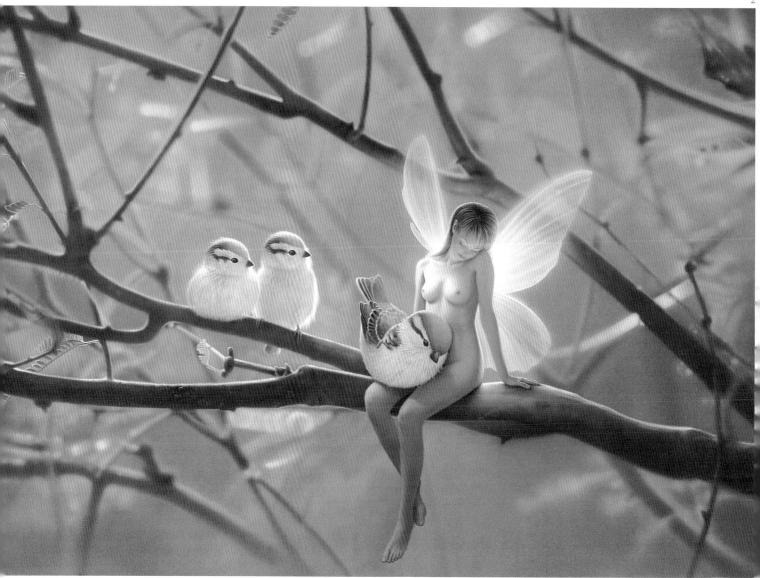

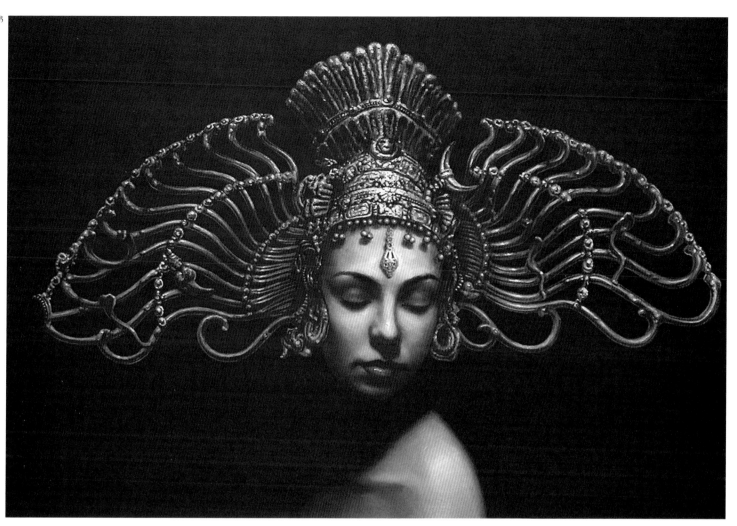

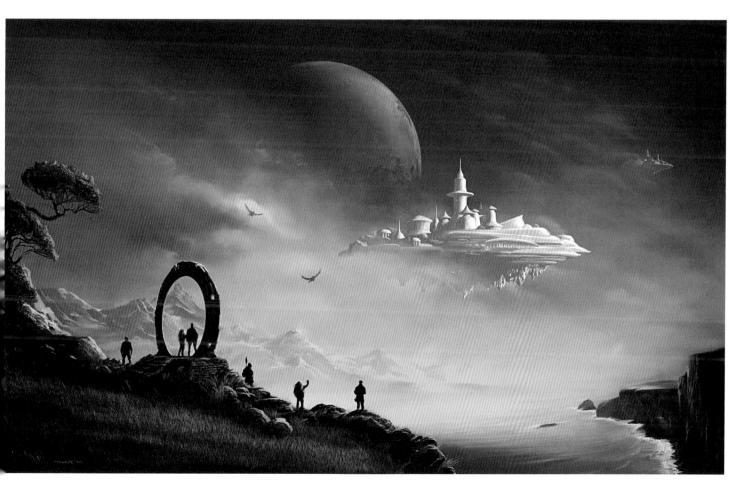

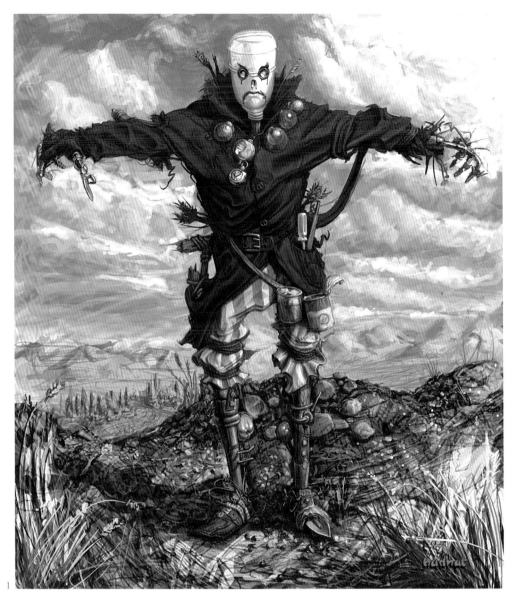

1

artist: **David Hudnut**
art director: David Hudnut
client: Dorian Martin
medium: Digital
size: 7"x8"

2

artist: **Scott Gustafson**
art director: Scott Usher/Wendy Wentworth
designer: Scott Gustafson
client: The Greenwich Workshop
title: Happily Ever After
medium: Oil
size: 60"x28"

3

artist: **Brian Despain**
title: Mr. Bubble's Birthday
medium: Digital
size: 6"x8"

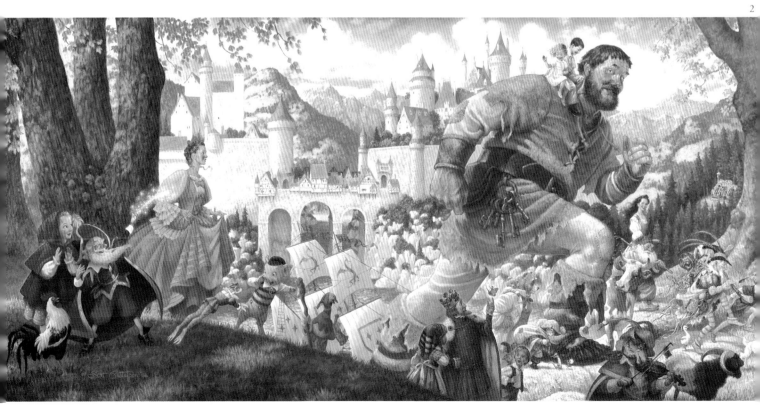

3

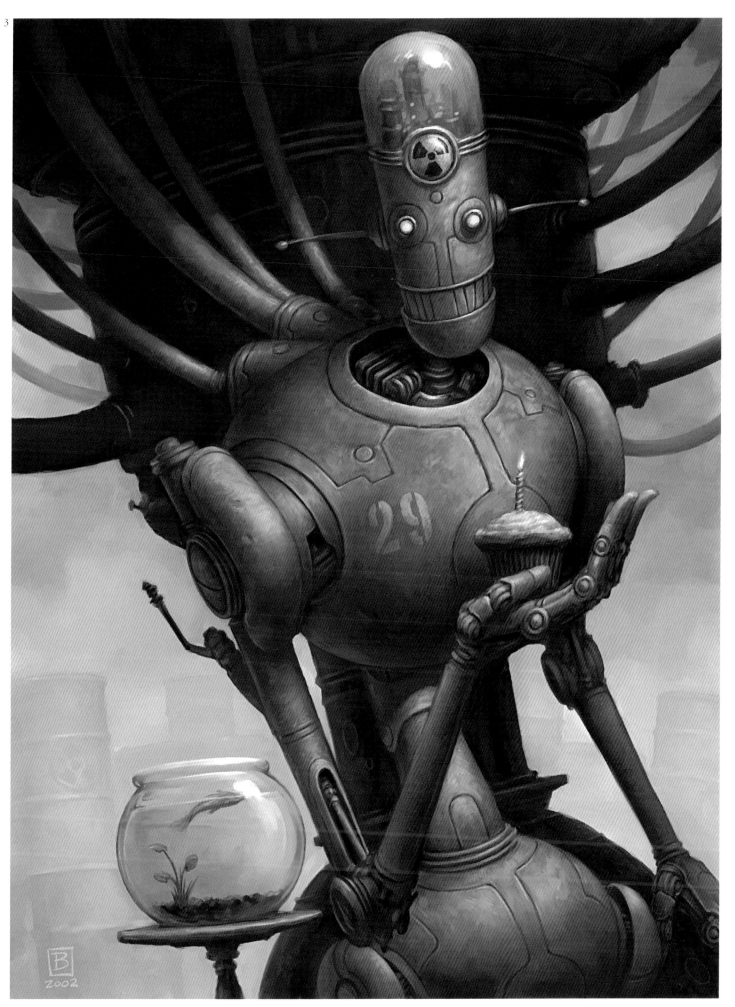

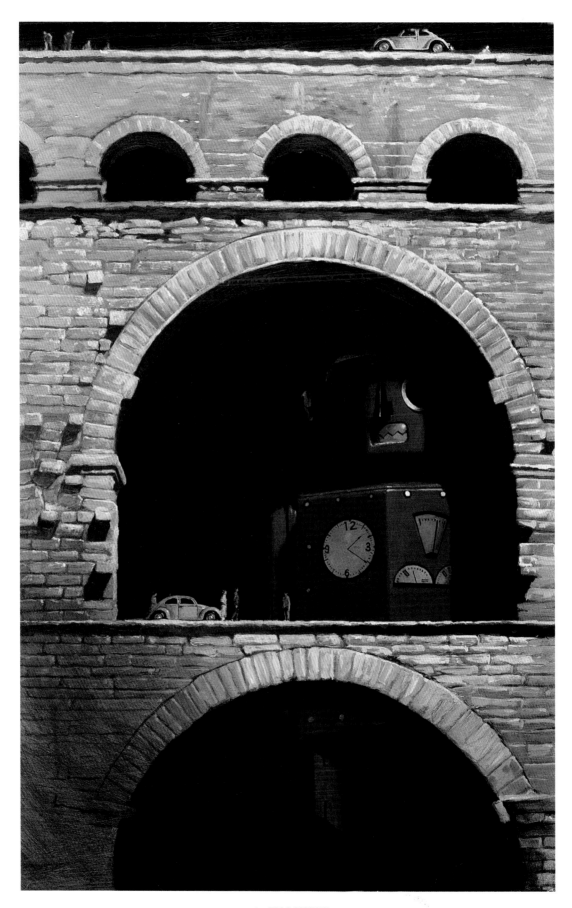

artist: **ERIC JOYNER**

title: The Last Tinman medium: Oil

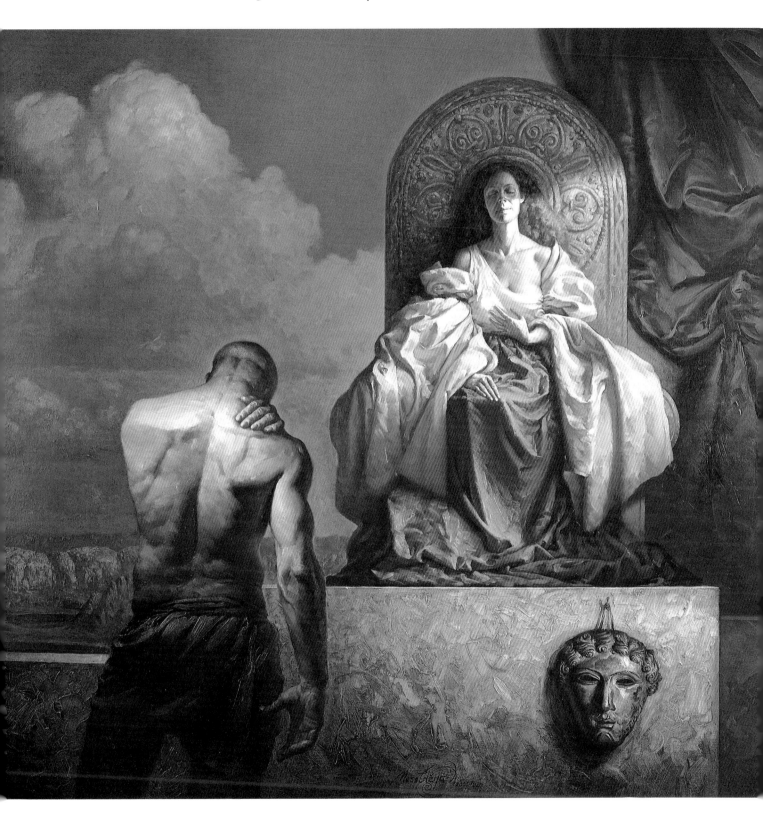

artist: **PETAR MESELDŽIJA**
title: The Dawn of the Day *size:* 36¹/₂″x35¹/₂″ *medium:* Oil

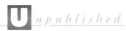

1
artist: **Puddnhead**
art director: Puddnhead
medium: Digital
size: 14"x18"

2
artist: **Puddnhead**
art director: Puddnhead
title: The Queen of Spades
medium: Digital
size: 11"x17"

3
artist: **Dave Dorman**
art director: Stephen D. Smith
client: Atomic Vision Entertainment
title: Dementia
medium: Oil/acrylic
size: 12"x18"

4
artist: **Viktor Koen**
title: Damsel No. 6
medium: Digital
size: 24"x35"

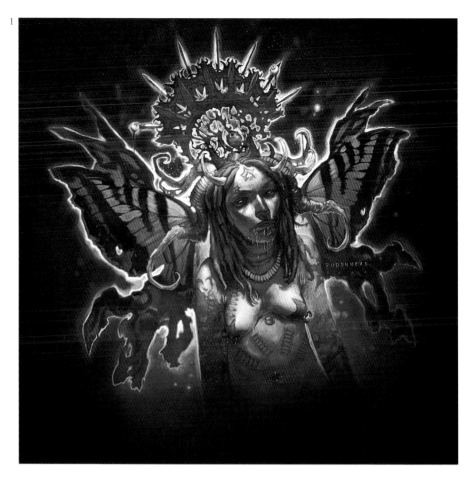

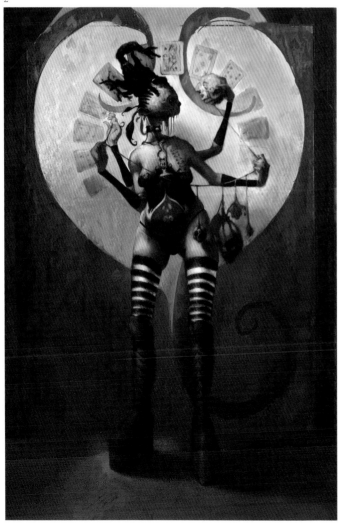

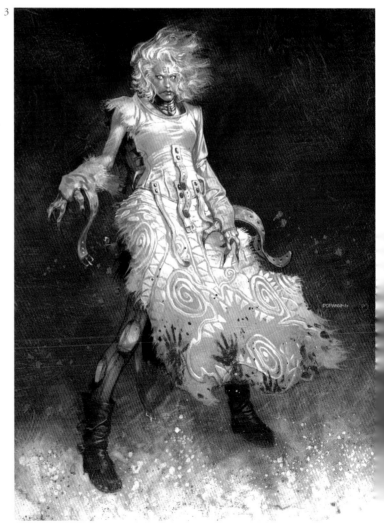

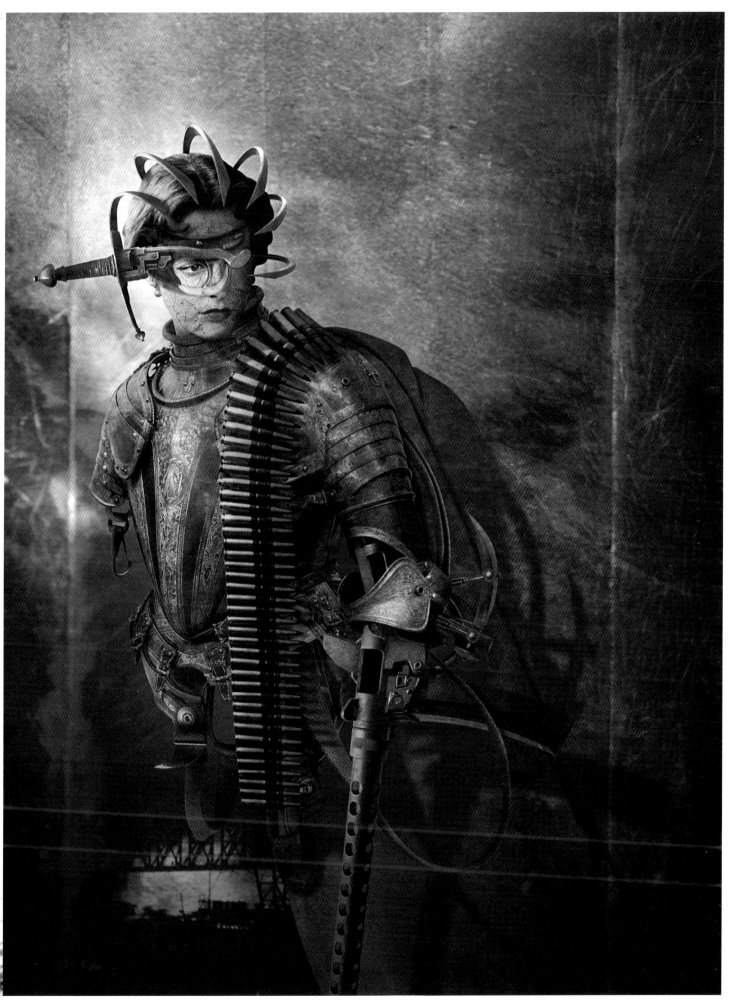

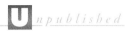

1
artist: **David Ho**
art director: David Ho
title: Something to Believe In
medium: Digital
size: 11"x11"

2
artist: **Carlos Huante**
art director: Carlos Huante
title: Vocations
medium: Mixed/digital

3
artist: **Mark Covell**
title: Growth
medium: Digital
size: 8"x12"

4
artist: **Briclot Aleksi**
title: Stimponkz
medium: Mixed
size: 8¹/₂"x12¹/₂"

5
artist: **Tanner Goldbeck**
title: Isaac's House
medium: Oil/digital
size: 28"x46"

6
artist: **David Ho**
art director: David Ho
client: Renderosity Magazine
title: The Dreamer
medium: Digital
size: 8¹/₂"x11"

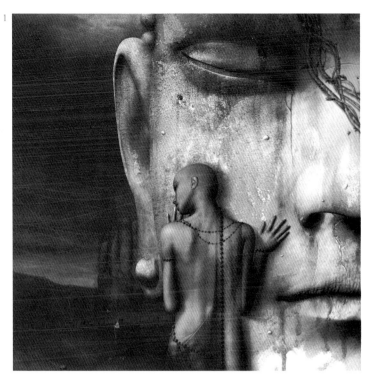

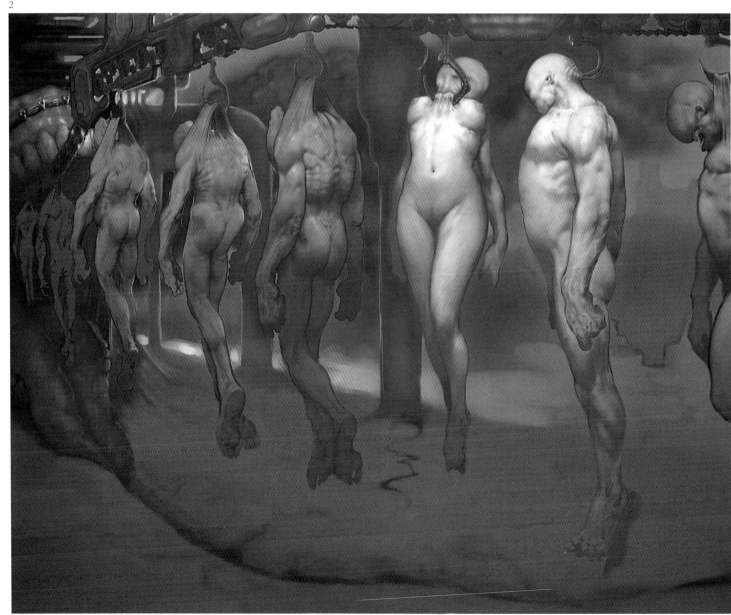

4

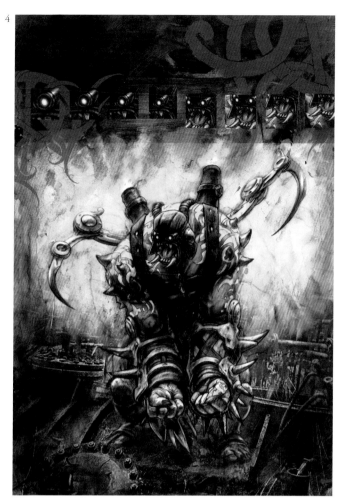

6

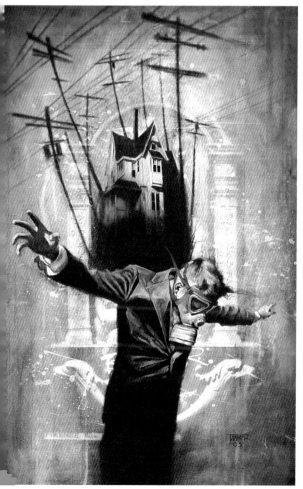

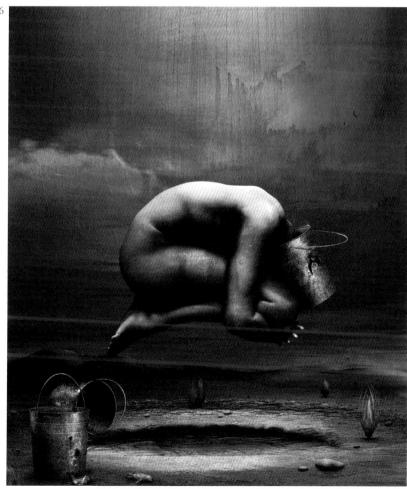

1
artist: **Cam de Leon & Chet Zar**
art director: Adam Jones
designer: Cam de Leon & Chet Zar
client: Tool
title: Salival Figure
medium: Digital

2
artist: **John C. Berkey**
title: The Other Women
medium: Casein acrylic
size: 16¹/2"x26"

3
artist: **Mark Hendrickson**
title: Burning Church
medium: Oil/digital
size: 5"x7¹/2"

4
artist: **John C. Berkey**
title: Relics, Both
medium: Casein acrylic
size: 22"x17"

4
artist: **John C. Berkey**
title: Margret—There Back
medium: Casein acrylic
size: 26"x22"

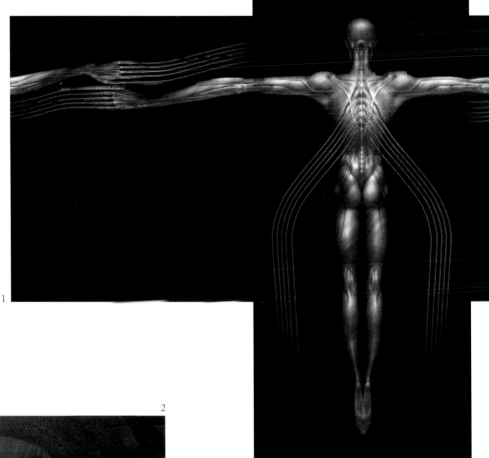

1

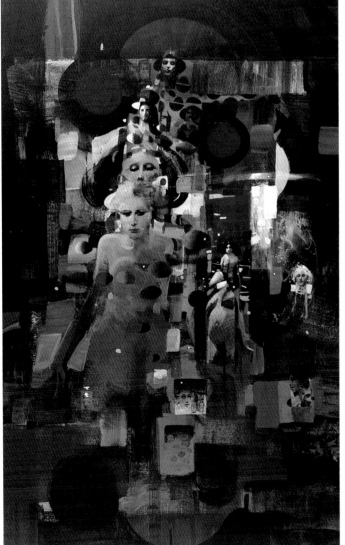

2

3

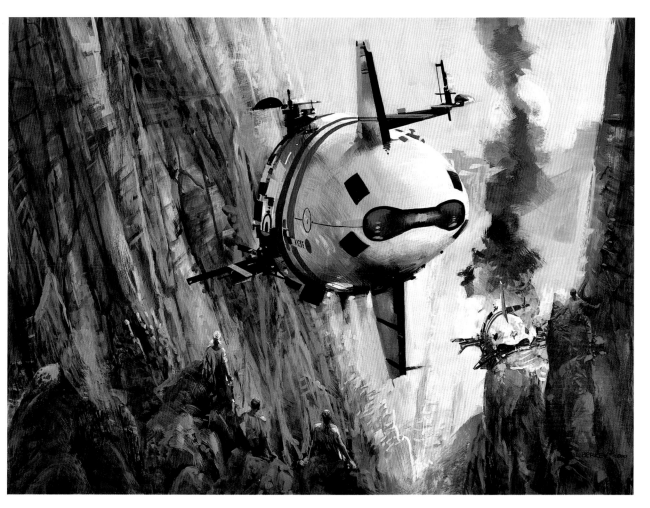

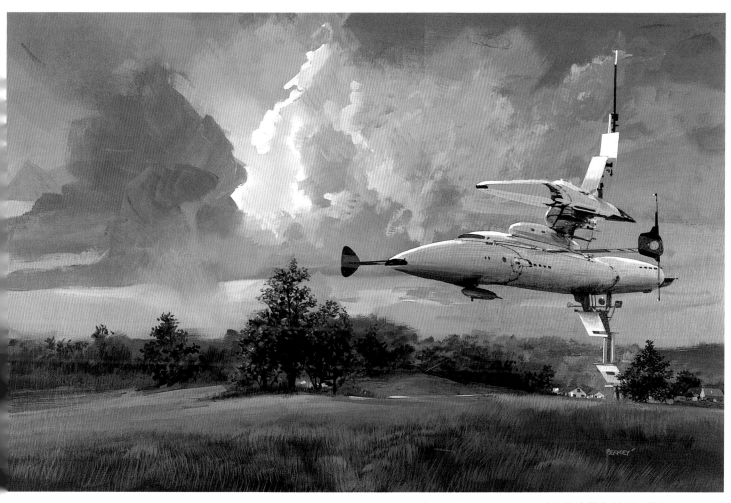

1
artist: **Steven Kenny**
title: Birch Bark Dress
medium: Oil on canvas
size: 30"x36"

2
artist: **Michael Whelan**
client: Tree's Place Gallery
title: Asylum
medium: Mixed
size: 30"x22"

3
artist: **Michael Whelan**
client: Tree's Place Gallery
title: Edgedancer
medium: Mixed
size: 28"x35"

1

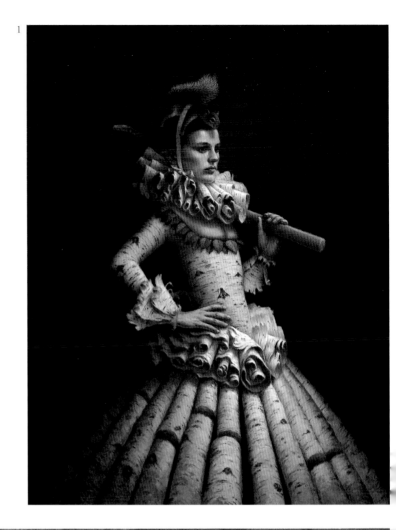

2

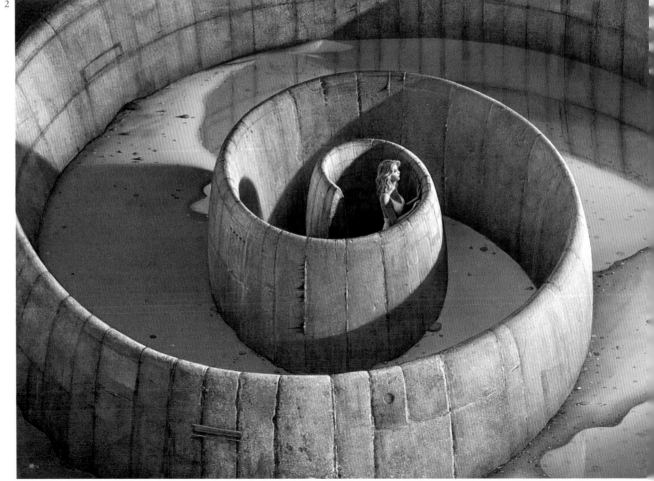

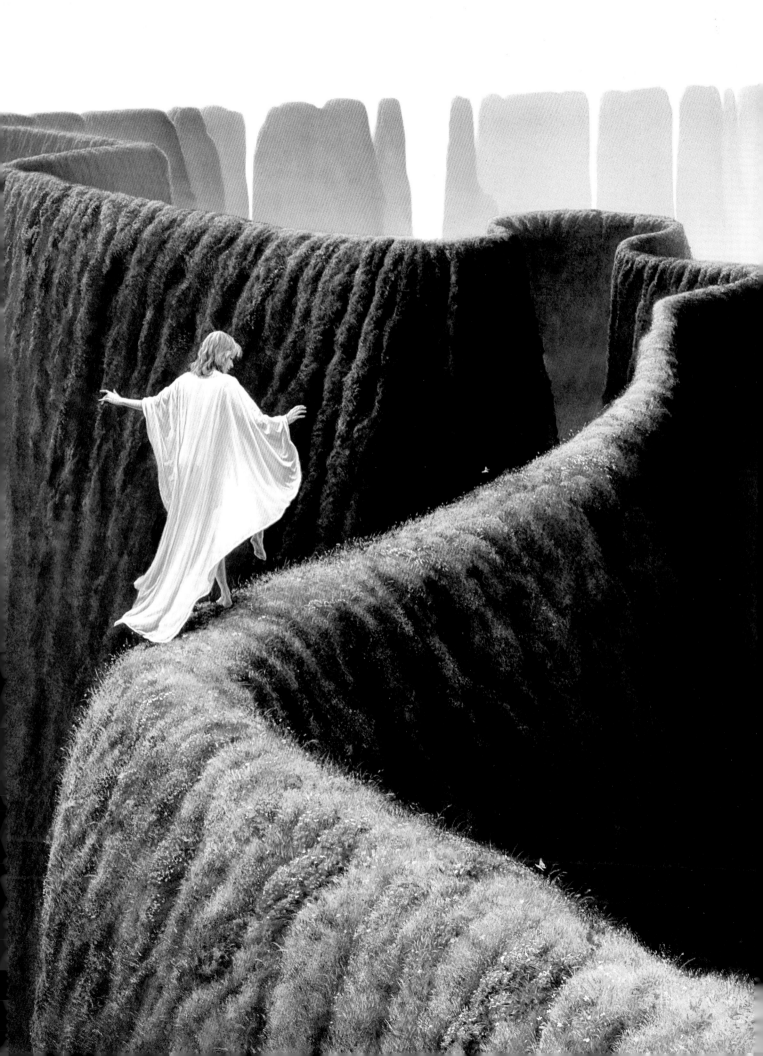

1
artist: **Peter Clarke**
title: Seeder
medium: Acrylic
size: 18"x18"

2
artist: **Peter Clarke**
title: Bartered
medium: Acrylic
size: 18"x24"

3
artist: **Frank Grau, Jr.**
title: Goblins
medium: Oil
size: 16"x20"

4
artist: **Craig Elliott**
designer: Craig Elliott
title: Winter Declines/Judith II
medium: Oil and acrylic
size: 11"x22"

5
artist: **Jhoneil M. Centeno**
art director: Jhoneil M. Centeno
title: Maternal Instinct
medium: Digital
size: 4¹/2"x7"

2
artist: **Peter Clarke**
title: Defender
medium: Acrylic
size: 34"x11"

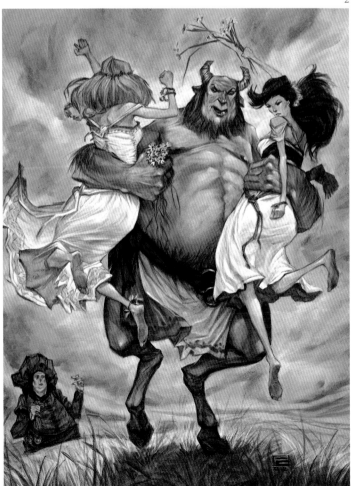

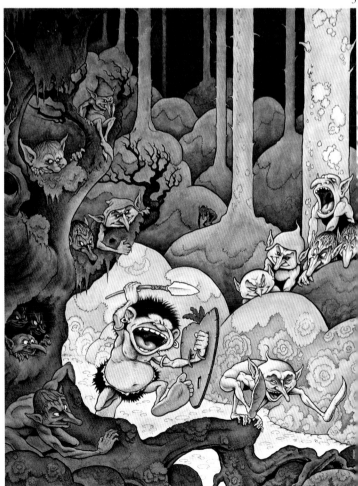

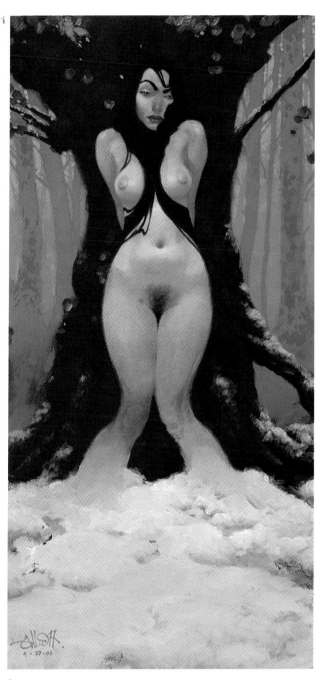

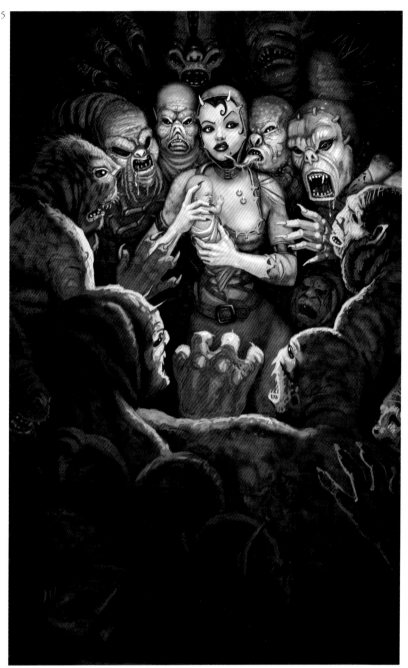

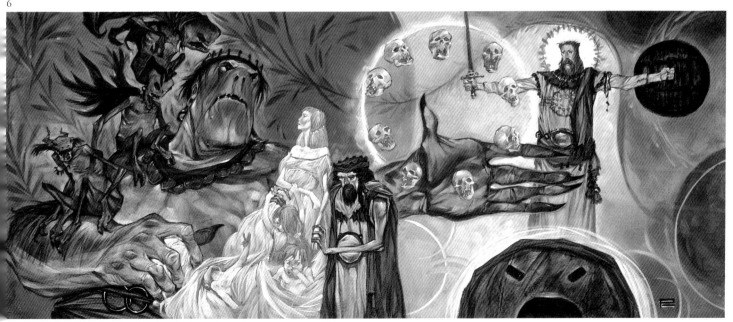

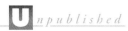

1
artist: **Donato Giancola**
title: On the Steps of Mount Doom
medium: Oil on paper on panel
size: 27"x30"

2
artist: **Colin Fix**
title: Vuelo del Mosco
medium: Mixed/digital
size: 9³/₄"x15"

3
artist: **Steve Stone**
art director: Steve Stone
client: Nexus DNA Ltd.
title: Bedruthan
medium: The medium
size: 42cmx55cm

4
artist: **Matthew Stewart**
title: Eowyn and the Nazgul
medium: Oil on board
size: 34"x24"

2
artist: **David T. Wenzel**
art director: David T. Wenzel
title: The Mines of Aegol
medium: Watercolor
size: 19³/₄"x11¹/₂"

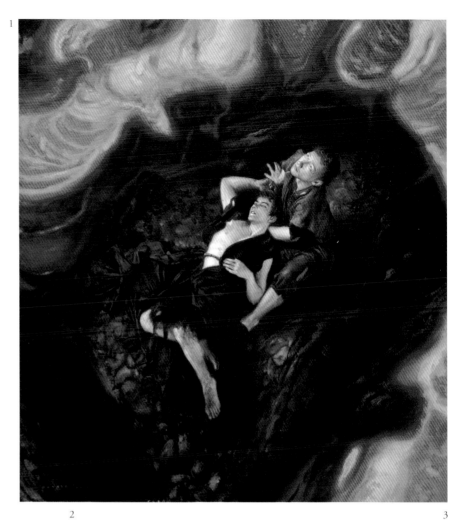

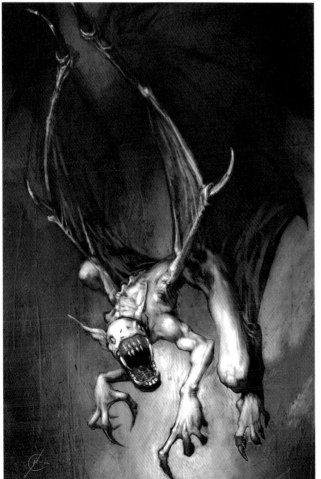

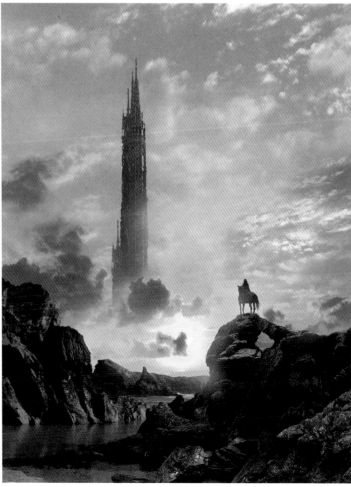

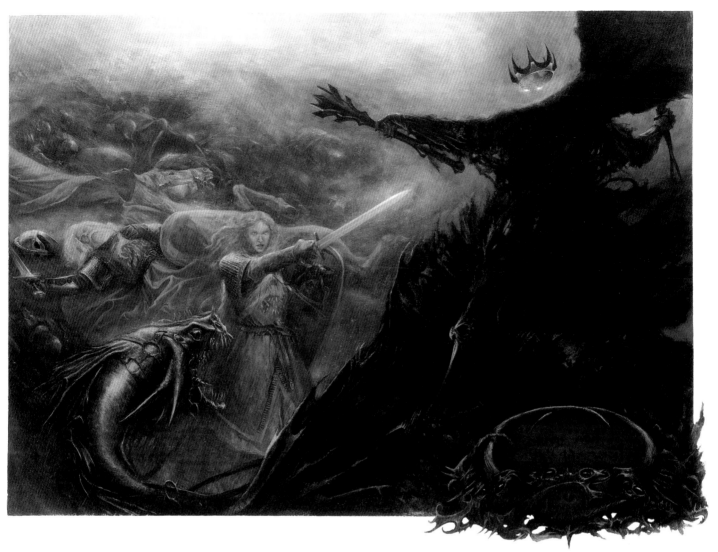

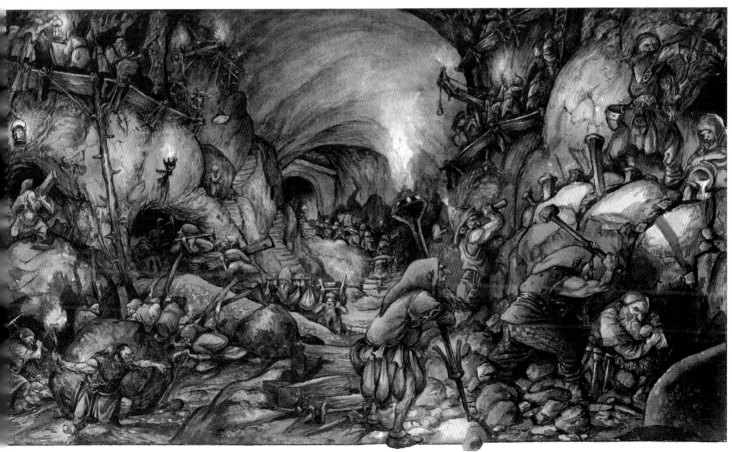

1
artist: **David Bowers**
title: The Butterfly Collectors
medium: Oil
size: 21"x20"

2
artist: **Atilio Pernisco**
title: Malena
medium: Oil on canvas
size: 18"x24"

3
artist: **Juan Manuel Fuentes del Ama**
title: Morgana's Garden
medium: Oil on canvas
size: 73cmx92cm

4
artist: **David Bowers**
title: The Rainbow Catcher
medium: Oil
size: 24"x23"

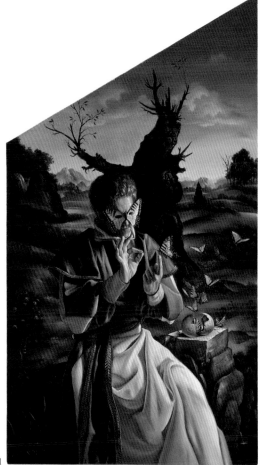

1

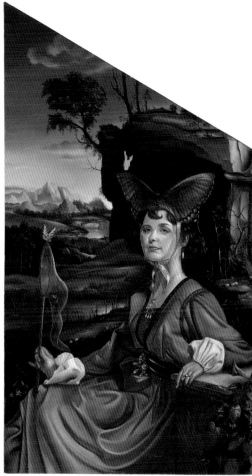

2

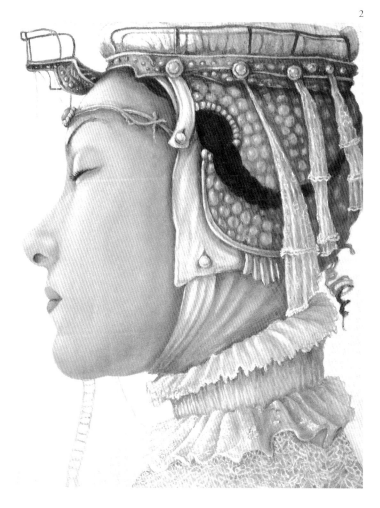

3

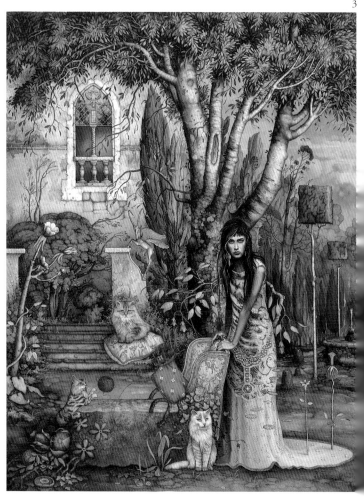

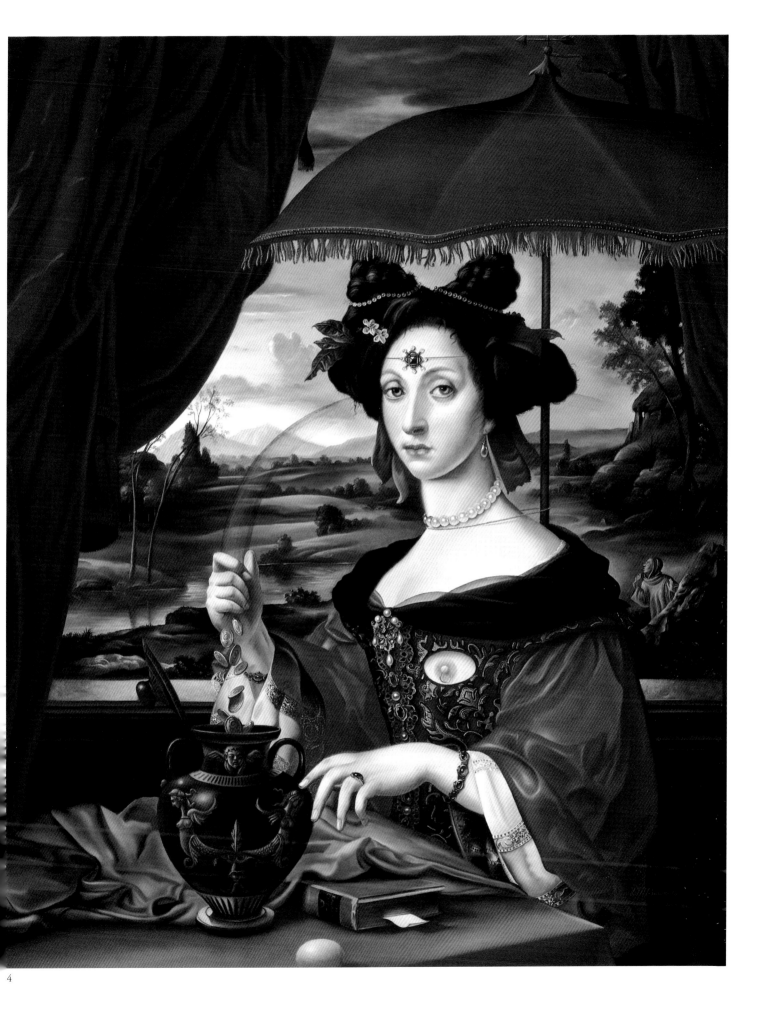

4

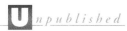

1
artist: **Cathy Wilkins**
art director: Cathy Wilkins
title: Mothman
medium: Digital
size: 5"x5"

2
artist: **Kari Christensen**
art director: Daniel Kaufman
client: Sabertooth Games
title: Blown Away
medium: Digital
size: 10"x12"

3
artist: **Christian Alzmann**
art director: Christian Alzmann
title: Alliance
medium: Digital
size: 10^{1}/$_{2}$"x16^{1}/$_{2}$"

4
artist: **John C. Berkey**
art director: John C. Berkey
title: Expanding Conflict
medium: Casein Acrylic
size: 18"x24"

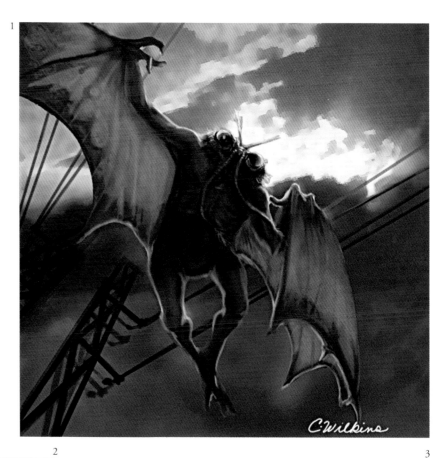

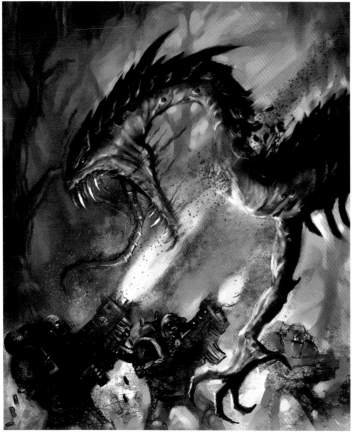

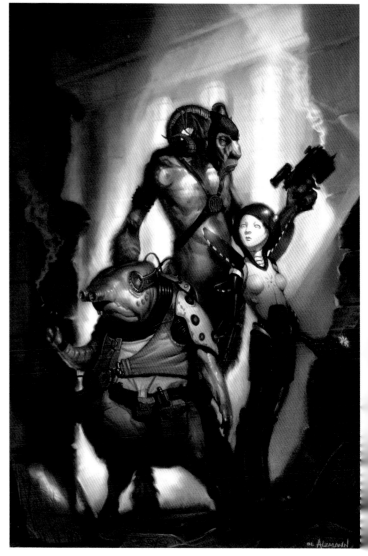

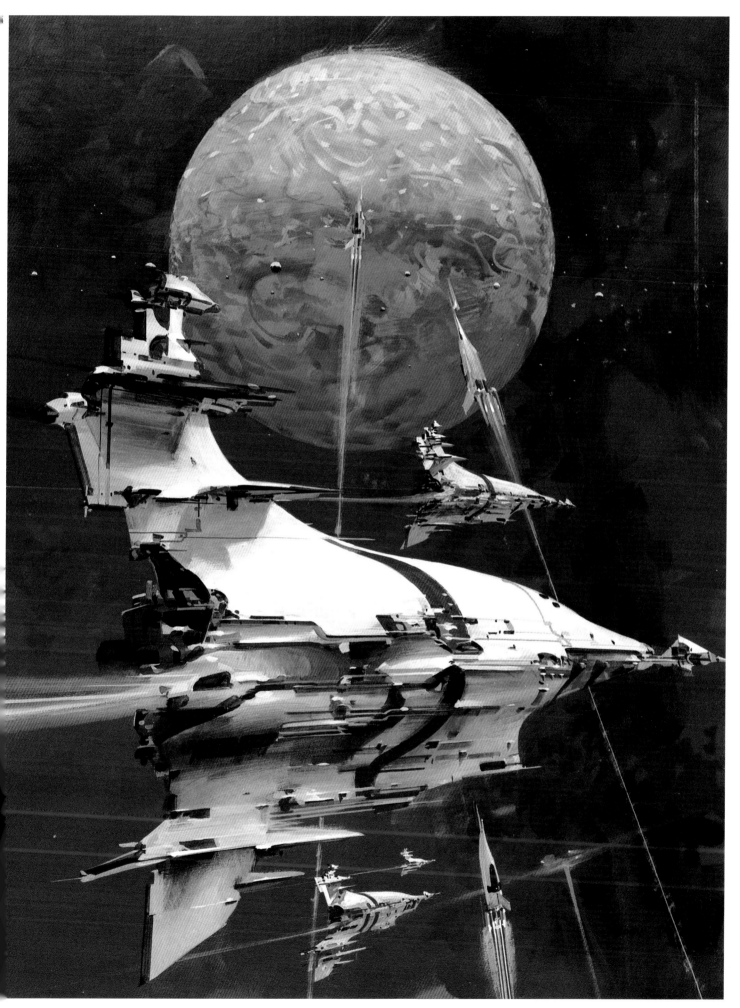

1
artist: **Jim Burns**
client: Richard Lee
title: Children of Forgotten Gods
medium: Acrylic
size: 36"x32"

2
artist: **Allen Douglas**
title: The Artificial Cloud
medium: Oil on paper on masonite
size: 15"x12^1/$_2$"

3
artist: **Chad Michael Ward**
art director: Chad Michael Ward
title: The Empress Revealed
medium: Mixed/digital
size: 11"x17"

4
artist: **Dave DeVries**
title: Anvil
medium: Mixed
size: 12^3/$_4$"x19"

5
artist: **Joel Thomas**
art director: Joel Thomas
title: The Luciferian I: Ecantoella
medium: Digital
size: 4"x6"

6
artist: **Juni-ichi Fujikawa**
title: Dawn
medium: Digital
size: 11^1/$_2$"x16"

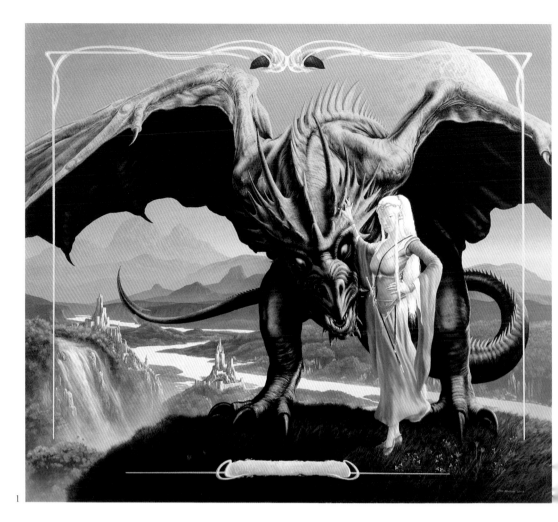

1

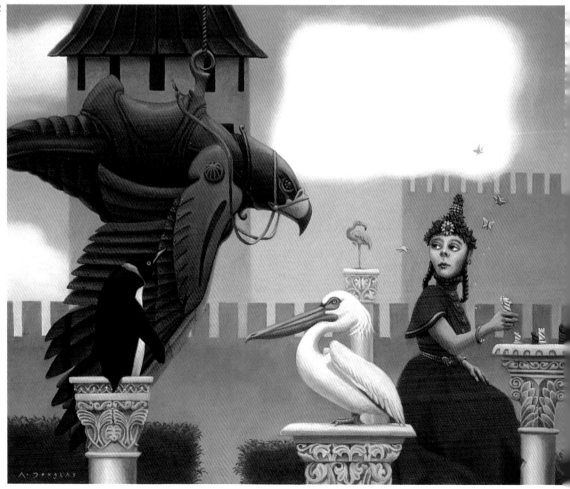

2

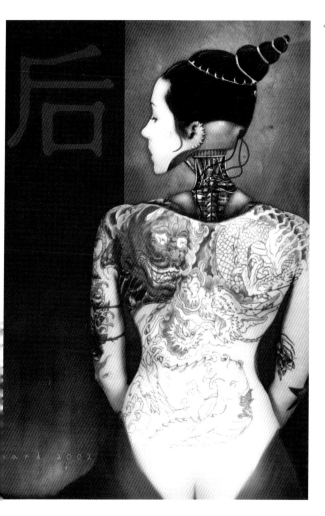

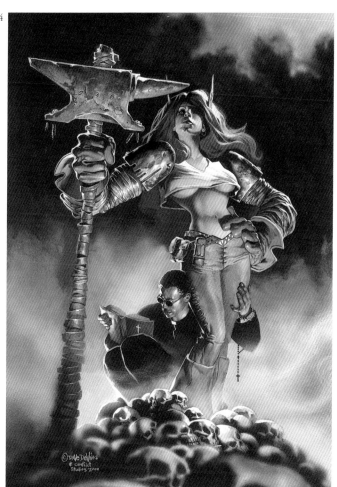

4

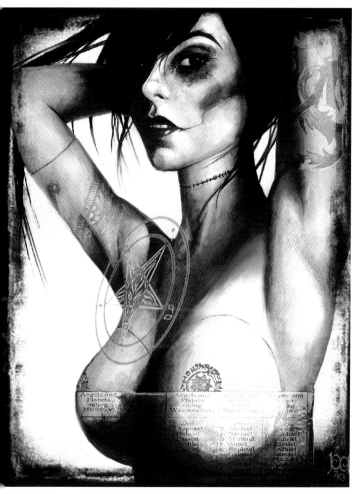

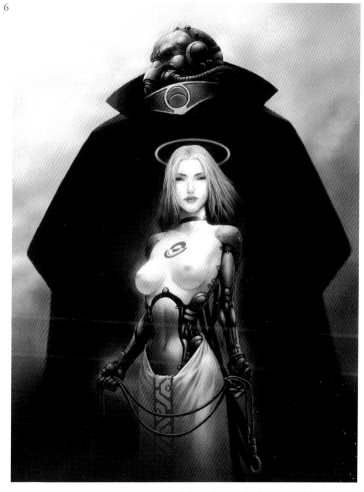

6

1
artist: **Rick Price**
title: You Will Never Love Me
medium: Mixed
size: 10"x10"

2
artist: **Forest Young**
art director: Kerry Talbott
designer: Forest Young
client: Virginia Commonwealth University
title: The Treehouse
medium: Graphite

3
artist: **Socar Myles**
title: The Rat Queen's Wedding Party
medium: Digital
size: 11"x14"

4
artist: **Juan Manuel Fuentes del Ama**
title: Sorcery
medium: Oil on canvas
size: 73cmx92cm

1

2

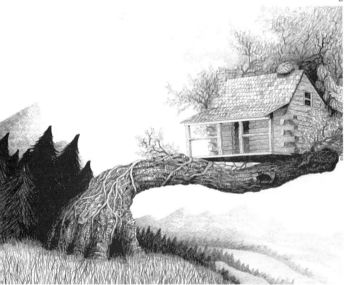

3

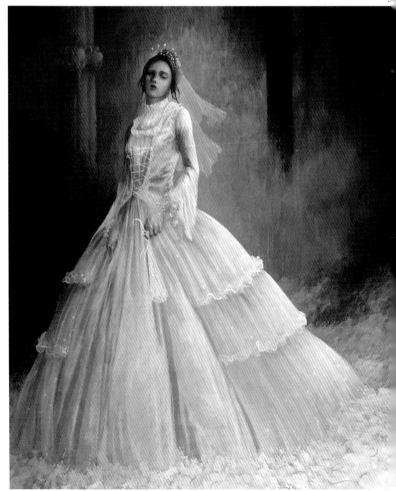

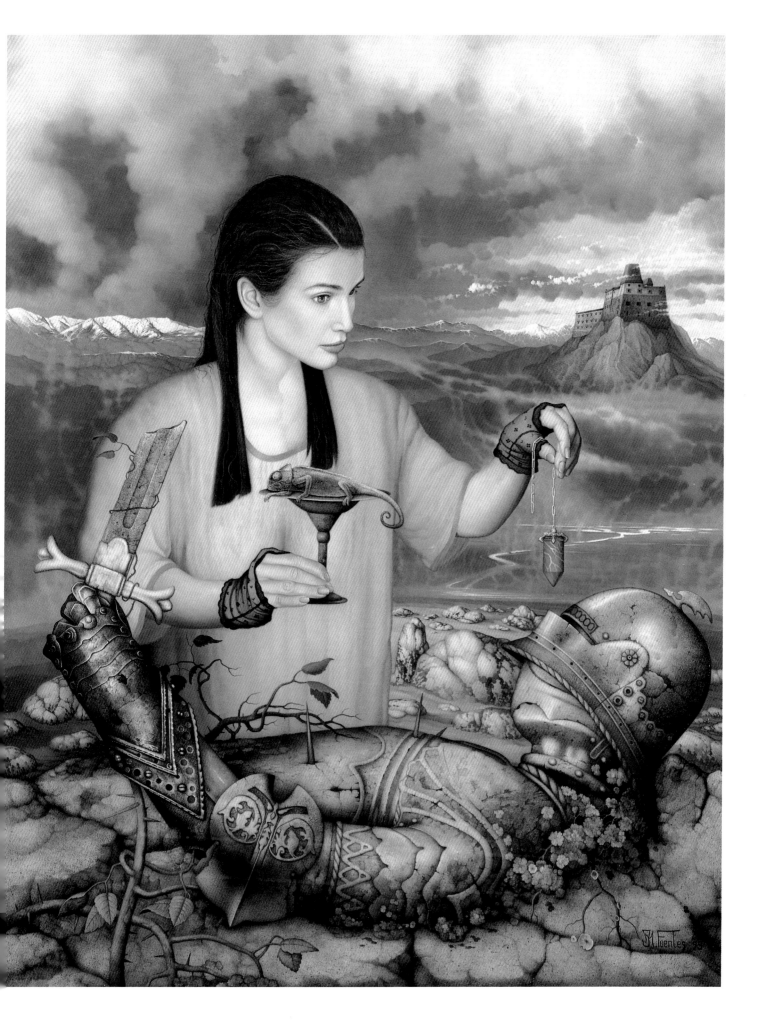

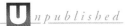
1
artist: **Chet Phillips**
title: Crossing Over
medium: Digital
size: 9¹/₂"x4"

2
artist: **Paul Pham**
title: Grandma
medium: Oil
size: 16"x9"

3
artist: **José Emroca Flores**
art director: Craig Nelson
title: I Love My Boss
medium: Acrylic
size: 4'x2'

4
artist: **Will Bullas**
title: Puppet Boy and the Red Rocket
medium: Watercolor
size: 13¹/₂"x14"

5
artist: **Anita Kunz**
title: An Anthropomorphic ABC:
 "C is for Cat"
medium: Mixed
size: 10"x10"

6
artist: **Kip Omolade**
title: Fly
medium: Oil
size: 22"x48"

7
artist: **LeUyen Pham**
title: Le Cirque du Bonheur
medium: Watercolor
size: 8¹/₂"x12"

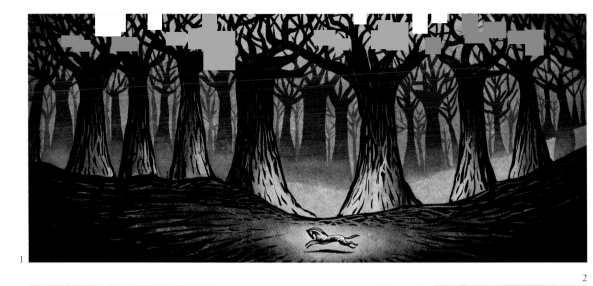

1

2

3

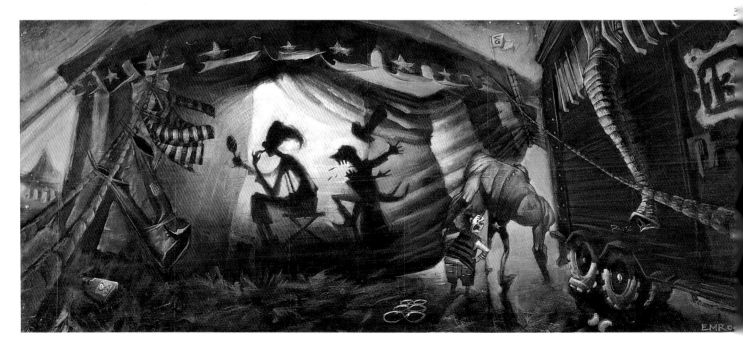

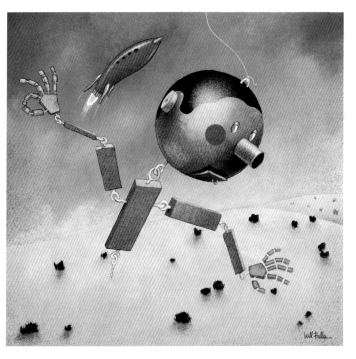

5

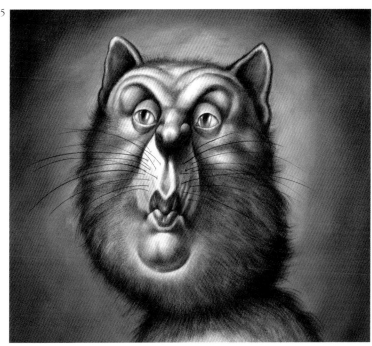

7

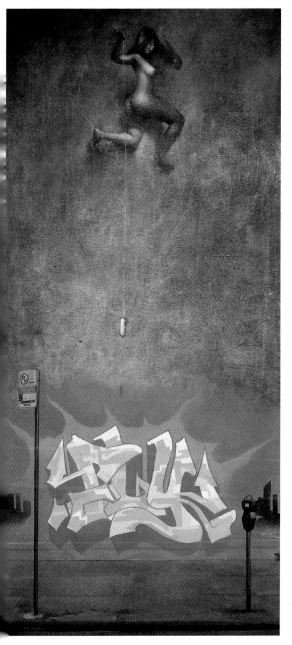

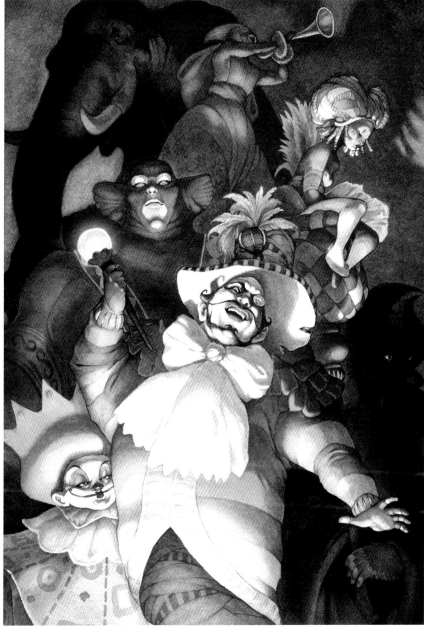

1
artist: **Christophe Vacher**
title: Endless Dream
medium: Oil
size: 20"x24"

2
artist: **Christopher Lee Donovan**
title: Java
medium: Mixed
size: 15"x36"

3
artist: **Eric Bowman**
title: 911 Angel
medium: Oil
size: 13"x18"

4
artist: **Christophe Vacher**
title: Mistress of the Winds
medium: Oil
size: 11³/₄"x16¹/₂"

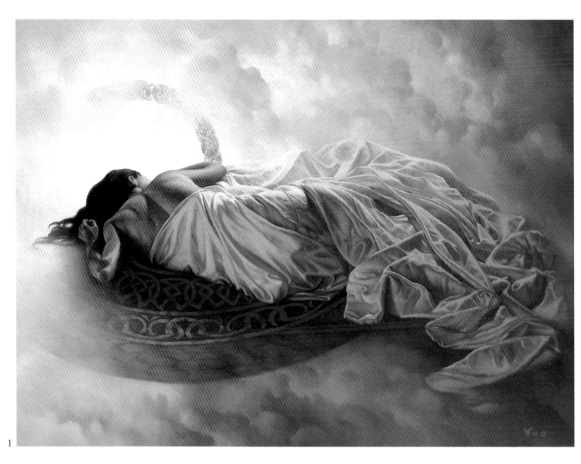

1

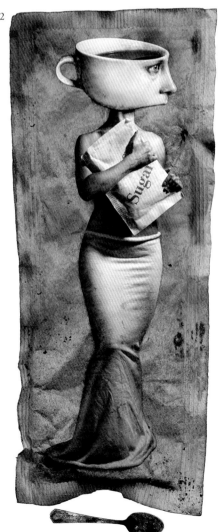

2

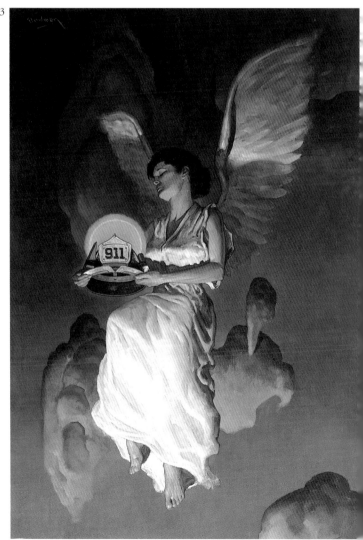

3

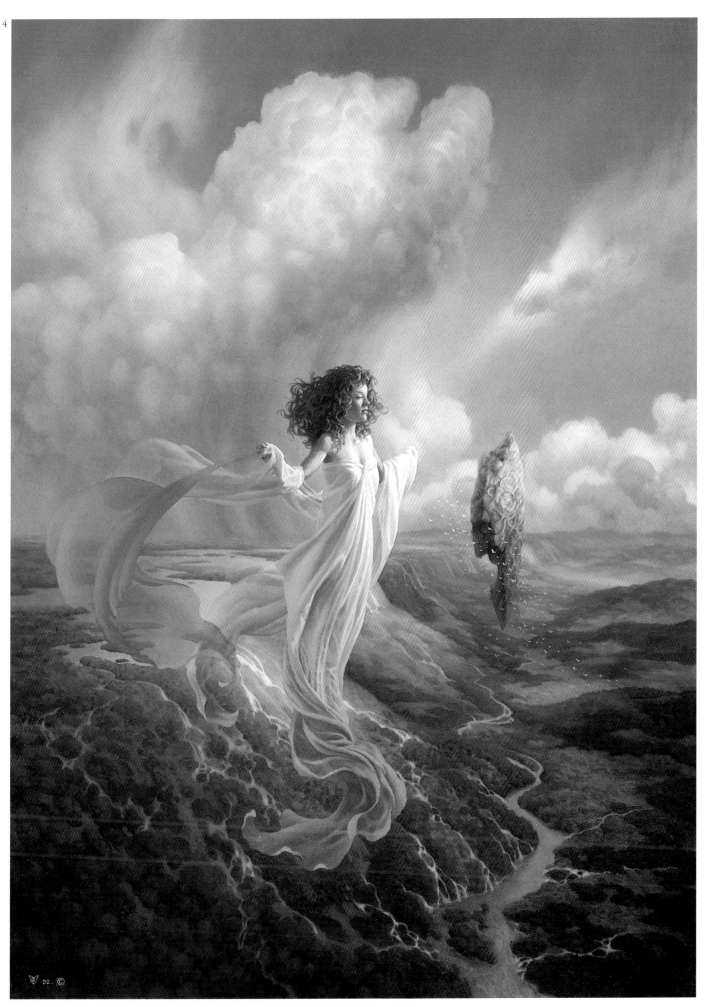

4

1
artist: **Todd DeMelle**
title: Dogfight
medium: Digital
size: 9"x8"

2
artist: **Eric Joyner**
title: The Fools Escape From Paradise
medium: Oil
size: 30"x20"

3
artist: **Dave McKean**
title: Sphinx
medium: Acrylic

4
artist: **Brad Weinman**
art director: Annarosa Pietrogiovanna
designer: Brad Weinman
title: La Mosca (The Fly)
medium: Oil on paper
size: 5"x5"

5
artist: **Gnemo**
art director: Tom Kidd
title: Cole Falls
medium: Oil
size: 30"x20"

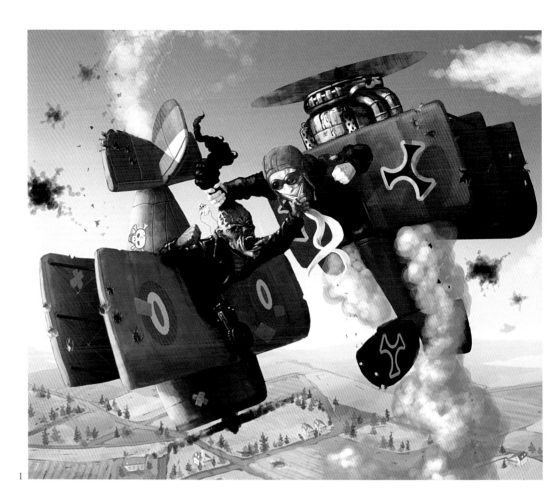

1

2

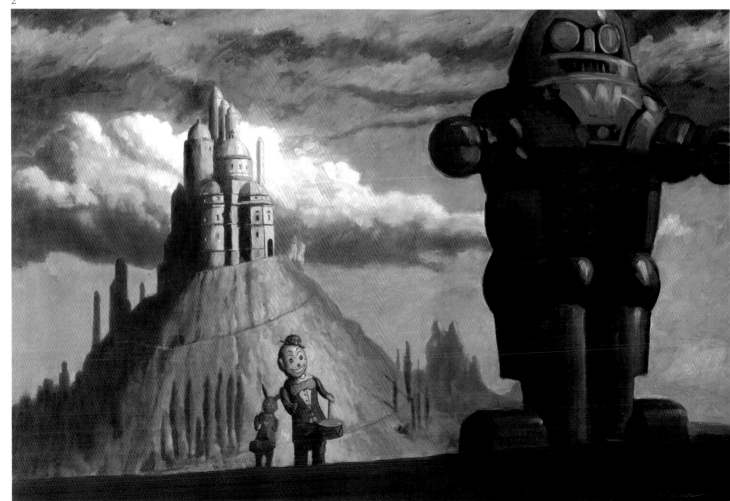

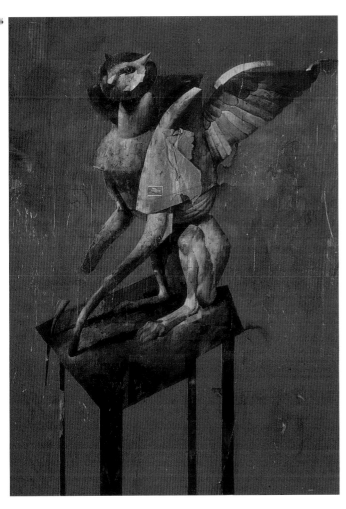

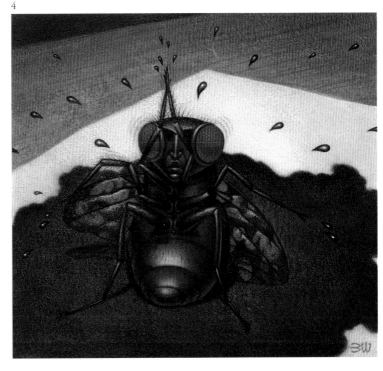

4

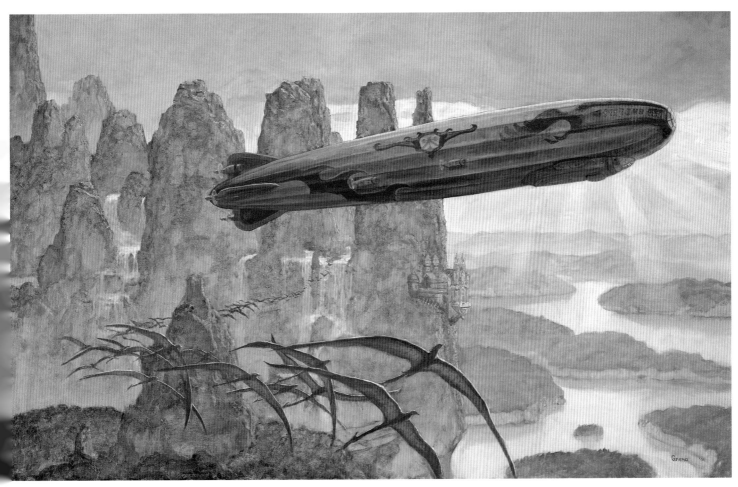

1
artist: **John Rush**
client: Robert & Annabel Moore
title: Metaphor
medium: Oil on Linen
size: 60"x38"

2
artist: **Greg Spalenka**
title: Star
medium: Mixed
size: 13"x15"

3
artist: **Vance Kovacs**
client: Black Isle
title: May
medium: Digital

4
artist: **Petar Meseldžija**
client: Ivan Kampel
title: Mother and Child
medium: Oil
size: 27¹/₂"x39¹/₄"

1

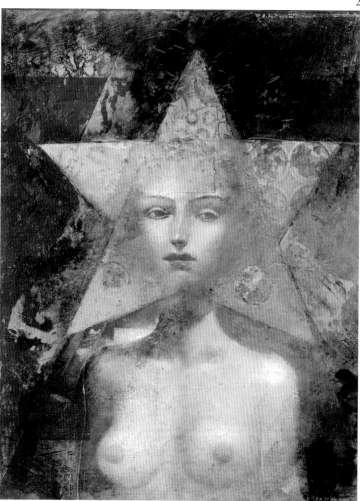

2

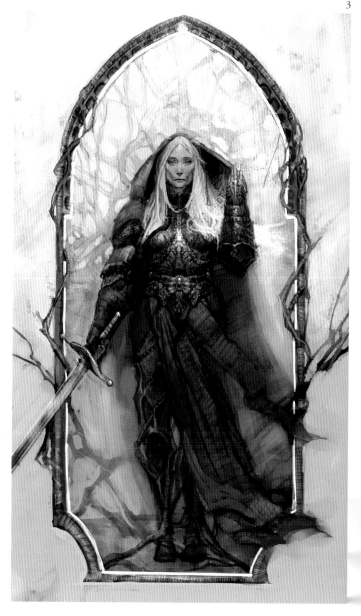

3

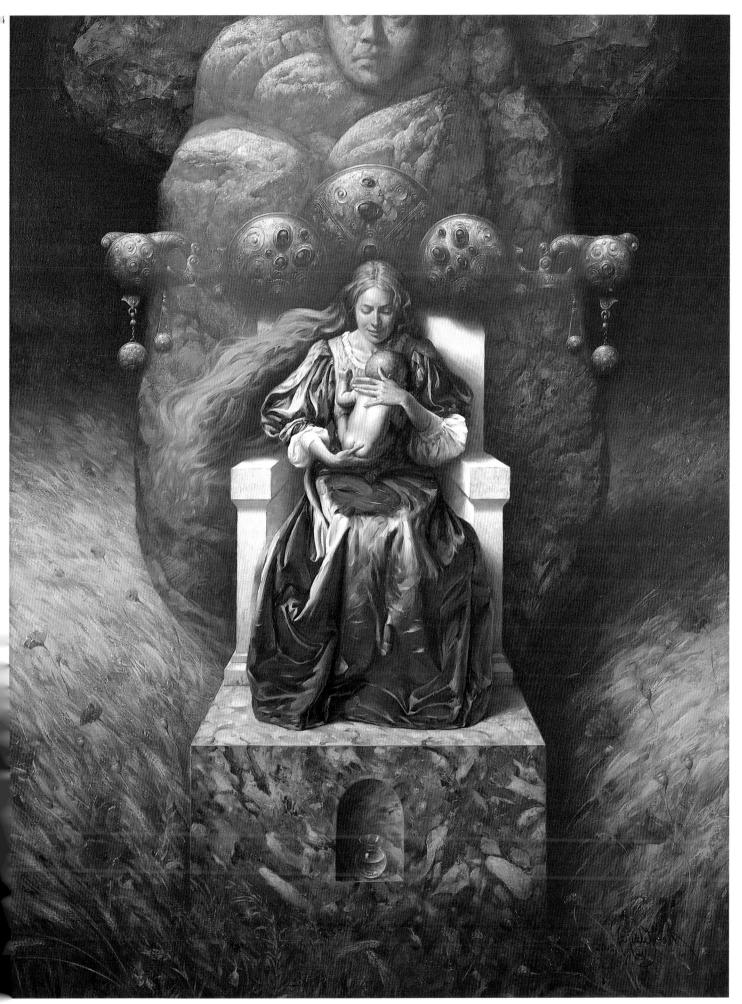

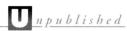

1
artist: **Nilson**
title: Gollum
medium: Mixed
size: 10cmx10cm

2
artist: **Raymond Swanland**
title: Bed of Ashes
medium: Digital
size: 13"x27"

3
artist: **Thomas Thiemeyer**
title: The Road to Samarkand
medium: Oil
size: 100cmx70cm

4
artist: **Eric Fortune**
title: 911
medium: Acrylic
size: 12"x16"

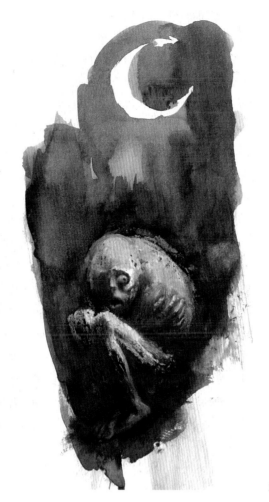

1

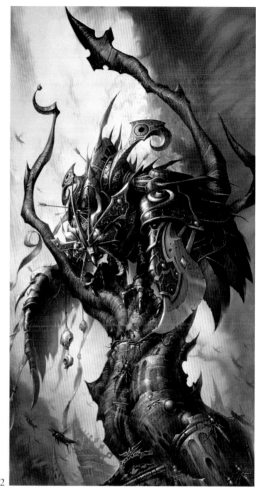

2

3

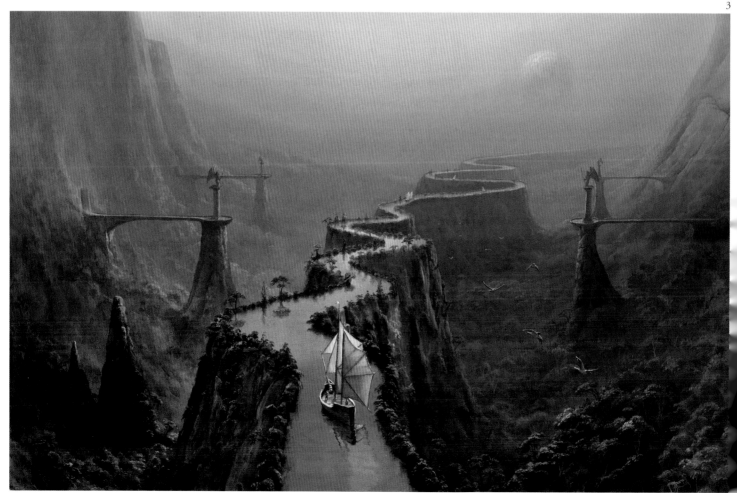

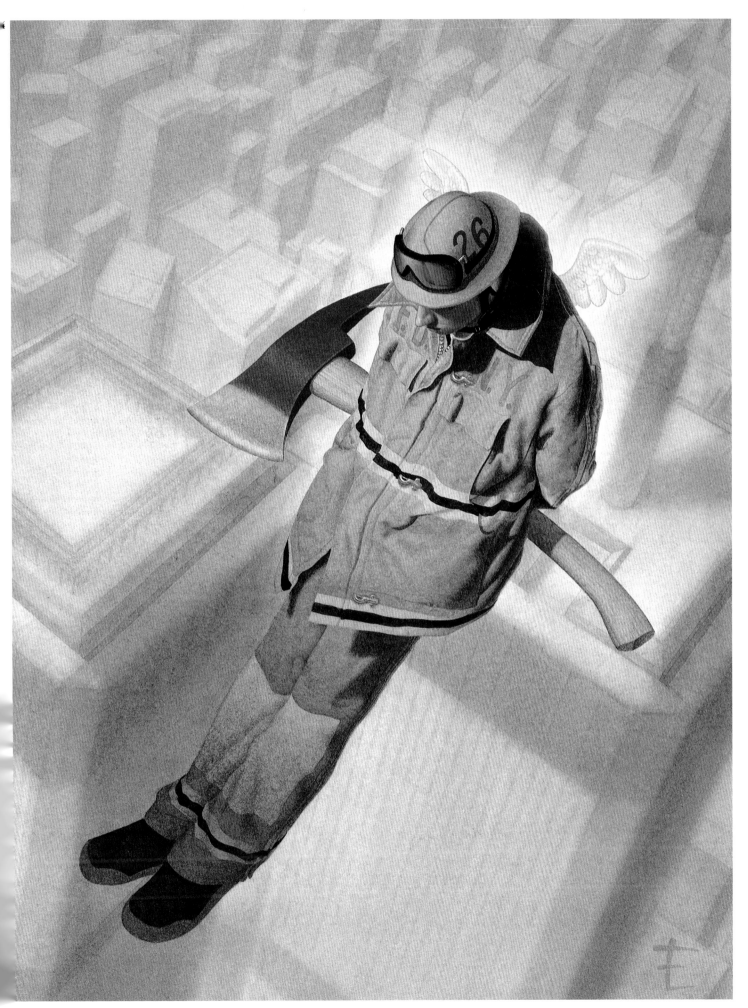

1
artist: **Justin Sweet**
client: Marshall Vand Ruff
medium: Digital

2
artist: **Thom Ang**
title: The Boxer As a Monument
medium: Oil on linen
size: 30"x40"

3
artist: **Steve Montiglio**
title: She Doesn't Water
medium: Mixed/digital
size: 35"x47"

4
artist: **Simon Thorpe**
art director: Mark Cox
client: Dark Horse
title: Black Lace
medium: Digital
size: 20"x30"

1

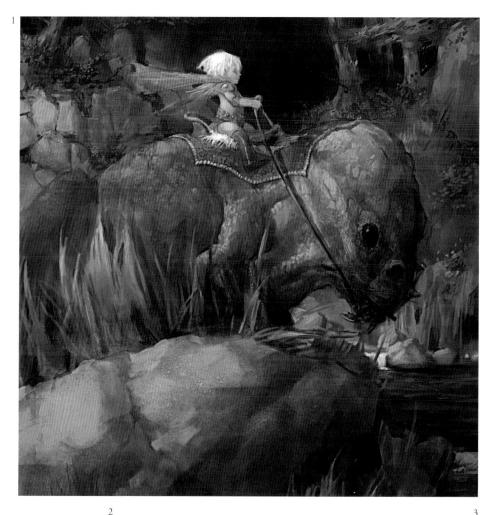

2

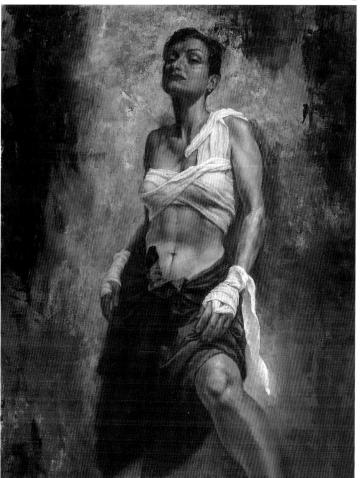

3

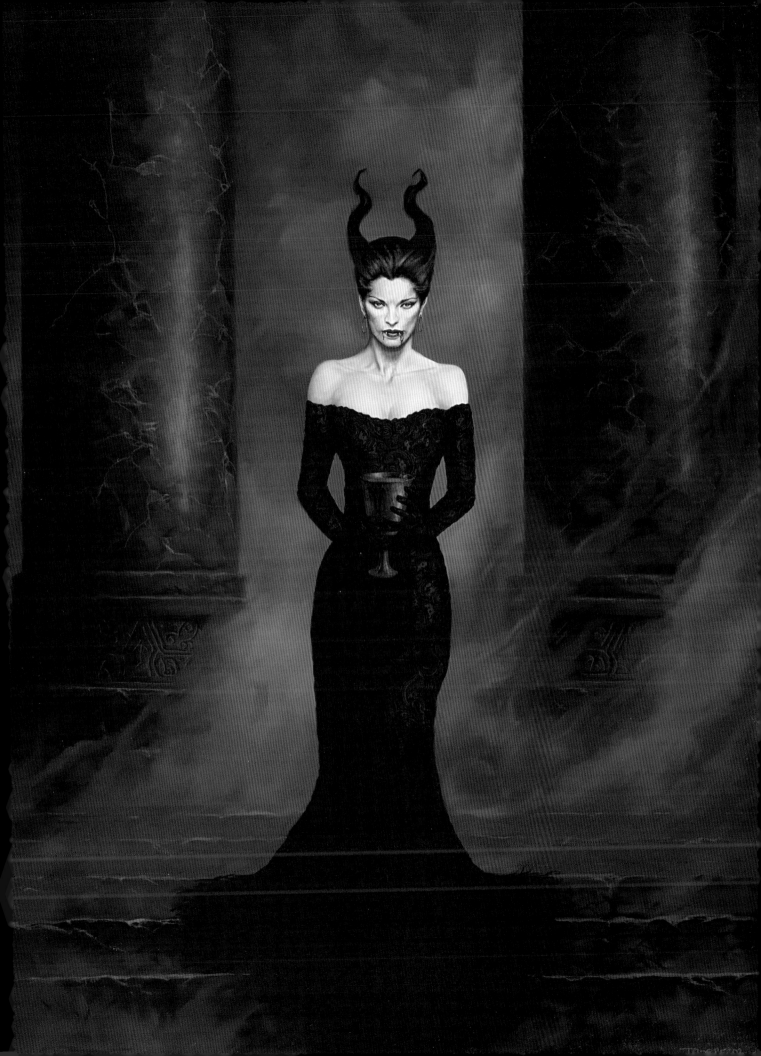

Juan Manuel Fuentes del Ama 154, 161
c/ Laurel 33A 6C
Madrid, Spain 28005
91-47-37-525
juanmanfuentes@mixmail.com

Jun-ichi Fukushima 105, 159
jun1f@nifty.com
members.jcom.home.ne.jp/devilkitten/

G

Siggy Galáen 24
Strandgata 21
9405 Harstad, Norway
www.siggyart.com

Donato Giancola 15, 28, 152
397 Pacific Street
Brooklyn, NY 11217
718-797-2438
donato@donatoart.com

Gary Gianni 29, 72
ggianni@sbcglobal.net

Gnemo c/o Tom Kidd 167
59 Cross Brook Rd.
New Milford, CT 06776
860-355-1781
tkidd@snet.net

Tanner Goldbeck 145
www.racecar13.com

Christian Gossett 74
818-754-0802
www.theredstar.com

Frank Grau, Jr. 150
13507 Chrystal Ct.
Fontana, CA 92336
909-899-0678
flooglemop@earthlink.net

Cheryl Griesbach & 103
Stanley Martucci
34 Twinlight Terrace
Highlands, NJ 07732
732-291-5945

Scott Grimando 33
6 Fifth Avenue
Westbury, NY 11590
516-876-9148
www.grimstudios.com

David Grove 56

James Gurney 22, 98
P.O. Box 693
Rhinebeck, NY 12572
845-876-7746
www.dinotopia.com

Scott Gustafson 37, 138
4045 N. Kostner
Chicago, IL 60641
773-725-8338
gustafsn@enteract.com

H Tom Hall 68

John Harris 33, 38

Daniel L. Hawkins 97
www.hawkinsdesignstudio.com

Mark Hendrickson 146
5034 Bradenton Rd.
Sarasota, FL 34234
941-351-5149
markhendrickson@mac.com

Stephen Hickman 109
10 Elm St.
Red Hook, NY 12571
845-758-3930
shickman@stephenhickman.com

David Ho 144, 145
3586 Dickenson Common
Fremont, CA 94538
510-656-2468
ho@davidho.com

Alex Horley-Orlandelli 82
c/o Spiderwebart
5 Waterloo Road
Hopatcong, NJ 07843
973-770-8189
spiderwebart@worldnet.att.net

Daren Horley/Framestore 20, 23
19-23 Wells St.
London, UK W1
daren.horley@framestore-cpc.com

Greg Horn 81, 85, 104, 105
1321 NW 129th Way
Sunrise, FL 33323
954-846-9586
greghornart@yahoo.com

Daniel R. Horne 30, 120, 133
900 Edgemoor Road
Cherry Hill, NJ 08034
856-779-8334
www.danielhorne.com

Brian Horton & Paul Lee 77
bri_sue@cox.net

John Howe 55
c/o Alan Lynch
116 Kelvin Place
Ithaca, NY 14850
607-257-0330
alartists@aol.com

Carlos Huante 144
1104 Michigan Dr.
Santa Rosa, CA 95405
415-448-3377
kletos1@yahoo.com

David Hudnut 138
1614 North Serrano Ave.
Los Angeles, CA 90027
david@hudnutart.com
www.hudnutart.com

Matt Hughes 30, 31
3716 McGuire St.
Kennesaw, GA 30144
770-795-5312
www.matthughesart.com

I Frazer Irving 83
frazer@frazerirving.com

J Bruce Jensen 106
3939 47th Street
Sunnyside, NY 11104
718-937-1887
www.brucejensen.com

Eric Joyner 140, 166
415-305-3992
www.ericjoyner.com

Joe Jusko 81
35 Highland Road, #4404
Pittsburgh, PA 15102
412-833-7528

K Gary Kelley 43

Steven Kenny 148
130 Fodderstack Road
Washington, VA 22747
540-675-2355
www.stevenkenny.com

Michael Kerr 134
#4, 1716-10 Street SW
Calgary, Alberta, Canada T2T 3E8
403-276-9740
wrong@wronghand.com

Douglas Klauba 128
9741 S. Hamlin Ave.
Evergreen Park, IL 60805
708-229-2507
www.douglasklauba.com

Brett Klisch 92
601 W 26th St./16th Floor
New York, NY 10001
201-220-7116
perumeridian@hotmail.com

Lori Koefoed 103
913 Old Topanga Canyon
Topanga, CA 90290
310-455-2220
lori@lorikoefoed.com

Viktor Koen 143
310 East 23rd St./Apt. 10A
New York, NY 10010
212-254-3159
www.viktorkoen.com

Vance Kovacs 168
7072 Cedar Creek Rd.
Corona, CA 92880
909-272-0911
horchata@earthlink.net

Anita Kunz 102, 129, 163
218 Ontario St.
Toronto, Ontario, Canada M5A 2V5
416-364-3846
akunz@globalserve.net

L Jean-Marc Laroche 94
16, rue Alexandre Dumas
78160 Marly le Roi, France
+33 1.39.16.16.58
www.jmlaroche.com

Richard Laurent 120
531 S. Plymouth Ct. #205
Chicago, IL 60605
312-939-7130
richer@ameritech.net

Jody A. Lee 48
P.O. Box 231
White Plains, NY 10605
jodylee@jodylee.net
www.jodylee.net

Gary A. Lippincott 114
131 Greenville Road
Spencer, MA 01562
508-885-9592
www.garylippincott.com

Jerry Lofaro 135
58 Gulf Road
Henniker, NH 03242
603-428-6135
jerrylofaro@mcttelecom.com

David Cheng Lu 93
c/o Monte M. Moore
18157 East Utah Place
Aurora, CO 80017
303-294-0146
www.mavarts.com

M Larry MacDougall 117
137 Broker Drive
Hamilton, Ontario Canada L8T 2B9
905-388-6514
underhillstudio@cogeco.ca

Daid Mack 78
c/o Allen Spiegel Fine Arts
221 Lobos Avenue
Pacific Grove, CA 93950
831-372-4672
asfa@redshift.com

Don Maitz 45
5824 Bee Ridge Rd PMB #106
Sarasota, FL 34233
941-927-7206
donmaitz@paravia.com

Gregory Manchess 1, 13, 45, 60, 116
13358 SW Gallop Court
Beaverton, OR 97008
503-590-5447
gtmanchess@aol.com

Manchu c/o Philippe Bouchet 67
6 Allee des Erables
Tours, France 37000
+33 024-737-1603
philippe.bouchet7@wanadoo.fr

Stephan Martiniere 38, 39
10500 Missouri Bar Rd.
Nevada City, CA 95959
530-478-0911
martiniere@neteze.com

Dene Mason 91

Meats Meier 126, 127
328 East 1700 So.
Salt Lake City, UT 84115
801-486-4966
meats@sketchovision.com

Dave McKean 14, 167
c/o Allen Spiegel Fine Arts
221 Lobos Avenue
Pacific Grove, CA 93950
831-372-4672
asfa@redshift.com

Petar Meseldžija 60, 141, 169
Kogerwatering 49
1541 XB Koog A/D Zaan
The Netherlands
+31-75-670-8649
www.petarmeseldzijaart.com

Yoko Mill 100
525-8-807 Oyabucho, Kuze,
Minamiku, Kyoto, Japan 601-8206

Kurt Miller 18
3503 Keene Ave.
Baltimore, MD 21214
410-319-9509
kmiller33@directvinternet.com

Edward Miller c/o Les Edwards 32
63 Mayfair Avenue
Ilford, Essex, UK IG1 3DQ
les.edwards7@btopenworld.com

Christopher Moeller 71,72
210 Parkside Avenue
Pittsburgh, PA 15228
412-531-3629
moellerc@adelphia.net

Steve Montiglio 172
1837 North La Brea Avenue #8
Los Angeles, CA 90046
323-573-7316
steve@montiglio.com

Clayburn Moore 91
3038 SE Loop 820
Ft. Worth, TX 76140
817-568-2620
delena@moorecreations.com

Scott Morse 81
c/o Allen Spiegel Fine Arts
221 Lobos Avenue
Pacific Grove, CA 93950
831-372-4672
asfa@redshift.com

Jon J Muth 72
c/o Allen Spiegel Fine Arts
221 Lobos Avenue
Pacific Grove, CA 93950
831-372-4672
asfa@redshift.com

Socar Myles 160
rats@gorblimey.com
www.gorblimey.com

N Vince Natale 45
36 John St.
West Hurley, NY 12491
845-679-0354
vnatale@hvc.rr.com

Mark A. Nelson 114
3738 Coachman Waq
Cross Plains, WI 53528
608-798-3783
mnelson@ravensoft.com

Terese Nielsen 44, 46
6049 Kauffman Avenue
Temple City, CA 91780
tanielsen7@earthlink.net
www.tnielsen.com

Nilson c/o Nils Hamm 170
Flügelstrasse 13
40227 Düsseldorf, Germany
nilshamm@hotmail.com

Lawrence Northey 86
www.robotart.net

O Tim O'Brien 38

Oddworld Inhabitants 131
[Raymond Swanland & Silvio Aebischer]
info@oddworld.com

Rafal Olbinski 42, 120, 129
142 E. 35th Street
New York, NY 10016
212-532-4328
rafal.olbinski@mindspring.com

Kip Omolade 163
284 Easter Parkway #2L
Brooklyn, NY 11225
718-789-7790
kipomolade@aol.com

Glen Orbik 76
818-785-7904
glenandlaurel@earthlink.net

Ed Org 121
104 Gloucester Rd, Cheltenham
Gloucestershire, UK GL51 8NS
edorg@woottonstudio.co.uk
www.ed-org.co.uk

P John Jude Palencar 24, 52, 53
508 Floral Valley W
Howard, OH 43028
740-392-4271
jjp33@core.com

Atilio Pernisco 154
323-256-8598
www.atiliopernisco.com

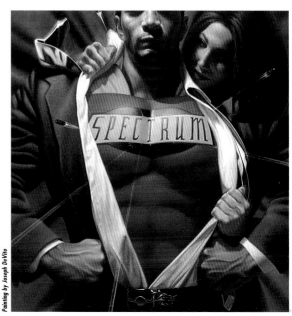

Painting by Joseph DeVito

*Artists, art directors, and publishers interested in receiving entry information for the next
Spectrum competition should send their name and address to:*

Spectrum Design, P.O. Box 4422, Overland Park, KS 66204

Call For Entries posters (which contain complete rules, list of fees, and forms for participation) are
mailed out in October each year.